one hundred at 360°

one hundred at 360°

Graphic design's
new global generation

Laurence King Publishing

LAURENCE KING

Published in 2007 by
Laurence King Publishing Ltd
361–373 City Road
London EC1V 1LR
United Kingdom
Tel: +44 20 7841 6900
Fax: +44 20 7841 6910
e-mail: enquiries@laurenceking.co.uk
www.laurenceking.co.uk

A catalogue record for this book is available
from the British Library.

ISBN-13: 978-1-85669-526-8
ISBN-10: 1-85669-526-3

Printed in China

Set in FS Clerkenwell www.fontsmith.co.uk

Text: Liz Farrelly
Art direction: Mike Dorrian, Simone Wagener
Layout design: Johannes Grimmond
Cover photograph: Adam Laycock
Retouching: Ranjit Sehambi

Thanks to: Carine Abraham, Matthew Appleton, Marc
Atkinson, Attak, Danielle Aubert, David Bailey, Jon Barlow,
Stefanie Barth, Aporva Baxi, BB/Saunders, Andrea Benyi,
Alexandre Bettler, Matthew Bolger, Nirit Binyamini, Chris
Bolton, Selina Bütler, Kirsty Carter, Nicola Carter, Malcom
Clarke, Marijke Cobbenhagen, Coolmix, Jelle Crama, Peter
Crnokrak, Mike Curtis and Darren Whittingham at Start
Creative, Frédérique Daubal, Yannick Desranleau, Dextro,
Donald Dinwiddie, Paulus Dreibholz, Dress Code, Patrick
Duffy, Siggi Eggertsson, Amir H. Fallah, Paul Farrington,
Forcefeed:swede, Farhad Fozouni, Hugh Frost, Adam
Gardiner, Amirali Ghasemi, Giampietro+Smith, John
Gilsenan, Grandpeople, Hans Gremmen, James Groves,
Hansje van Halem, Happypets, Ingrid Haug, Anders
Hofgaard, Jo Hogan, Pierre Hourquet, Hudson-Powell,
Apirat Infahsaeng, Inksurge, Miss Karen Jane, Tim Jester,
David Johnston, James Joyce, June, Ten Kennei, Kinetic,
Daniel Kluge, Denis Kovac, Todd Kurnat, Zak Kyes,
Fernando Leal, Jo Lightfoot, Ian Lynham, Aleksandar
Maćašev, MAKI, Russell Mann, Karl Martin Sætren,
Kieran McCann, Andrew McGovern, Clare McNally, Tom
Munckton, Jason Munn, Paul Paper, Joanna Pearce,
Satian Pengsathapon, Peter and Paul, Petpunk, Madelyn
Postman, Carsten Raffel, The Remingtons, Adam Rix,
Richard Sarson, Jens Schildt, Natasha Shah, Jason Smith,
Astrid Stavro, Frauke Stegmann, Ian Styles, Teemu
Suviala, Frédéric Teschner, Clarissa Tossin, Olivia Triggs
at breedlondon.com, Nicole Udry, Diego Vargas, Miguel
Vásquez, Alex deValence, Viagrafik, Gregg Virostek, Jonas
Voegeli, Darren Wall, Jonathan Wallace, Bianca Wendt, Jan
Wilker and Matt Willey.

'What's new in Graphic Design?' is a question publishers often ask when they're looking around for a book idea. Putting together a volume containing images that previously haven't been published in such a permanent format, created by people who constitute the 'next generation' of graphic designers, seemed like a sure way of stumbling across something 'new'.

What we found among the projects from this group of 100 designers and studios drawn from around the world – all 360 degrees – and all having set up shop since the turn of the twenty-first century, was more than we had anticipated.

We hadn't just discovered young talent, innovative projects and dynamic images; we also found new ways of working, directly related to the core premise of this book. We came to realize that more and more graphic designers are truly mobile, global citizens. They study, work, live and play in design hot-spots, new markets, small home towns and big cities – and even further afield, as and when their contacts, and the work, takes them.

Thanks to technical advances in mobile communications and compact, powerful computers, as well as the continuing unification of Europe, the opening up of national borders and the proliferation of cheap air travel, designers are able to up-sticks, pack their studio into a bag and take to the road. They may set up a two or more-centre company with colleagues from abroad, immerse themselves in a regional industry (fashion in Paris, film in Los Angeles) or simply take a road trip and see what presents itself along the way.

For many designers, being financially successful isn't the main reason they're in this game. Clients come in all shapes and sizes. To work for a major international brand is no longer a 'sell out'; it's more like a process by which funds are relocated. Designers work one day on a high profile, well-paid project, and on another day doing something close to the heart, for a cause they believe in or one that will get the creative juices flowing. As the political landscape becomes more issue focused, and the gaps between commerce and art blur, designers are constantly faced with complex ethical issues. That this generation are finding various ways of navigating those issues is as much to do with their mobility as with the colour of their politics, moving to where they can afford to live and find work, they are in effect economic – and cultural – migrants.

The costs and expertise required to run a business has in the past militated against young designers going it alone. Banding together with a group of like-minded buddies to set up a shared space, keep overheads low and be available to collaborate with each other on larger projects is one way of making fees stretch further. Including in the mix friends and colleagues, either with different skills – be they curators and writers – or in marketing and public relations, also adds to the viability of what are often, in effect, work-led cooperatives.

Some designers have been expanding their peer-group network, meeting new collaborators and mentors and exploring new 'scenes' by going back to university after gaining some real-world experience, whether to pursue a new degree in another discipline or a post-graduate degree in the same one. It's a favoured form of relocation, as a certain amount of 'safety net' is provided by student support structures.

These 're-educated' practitioners often widen the remit of graphic design by bringing with them diverse expertise. And being able to think outside the box, they create solutions in new media, using up-to-the-minute technology they may have become familiar with in the commercial world.

Crossing boundaries between disciplines is an upshot of this continued process of mobility, and education, to the point that designers are becoming film-makers and print-makers, creating installations in galleries and shops, collaborating on an even footing with artists, musicians and writers for the simple reason that they speak the same technical languages and use similar methods of production.

A certain amount of re-invention and self-definition is possible, and believable, when you are constantly introducing yourself to new people. A lot of these designers find they have likes and dislikes in common. They share preferences when it comes to personal passions. Many of the designers featured here are also musicians, or are deeply embedded in musical scenes. Some are politically active, especially in the environmental movement, while others are committed DIY-ers, creating cultural content that translates into magazines, films, fashion and publishing. Along with that comes a sense of ownership that elevates them from being 'service providers' to being cultural producers.

This is the tip of the iceberg. Here are 100; there are more, and as the networks spread and grow, hopefully we'll be able to bring them to your attention.

Liz Farrelly and Mike Dorrian

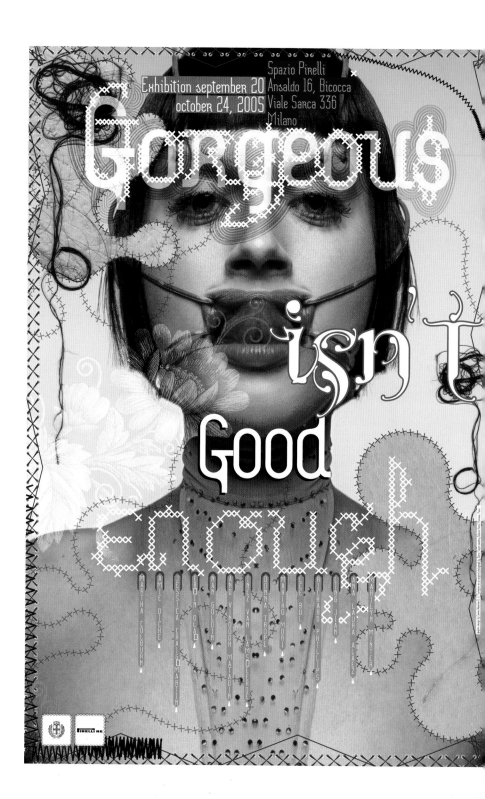

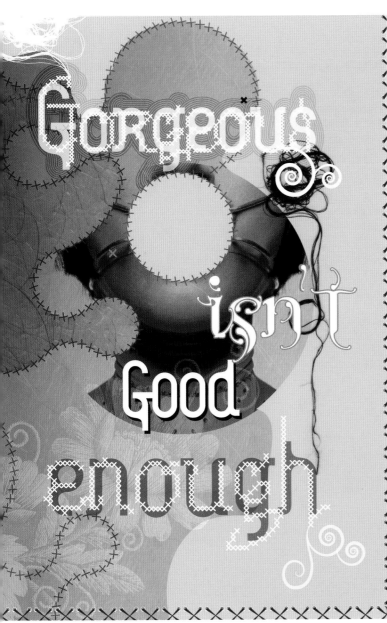

Gorgeous was a contemporary art exhibition, focusing on how society transforms and manipulates 'the body' in the quest for idealized beauty. Carine Abraham of Abraka produced a poster, invitation card and advertising, using the notion of 'seams' to imply the connection between fashion and plastic surgery.

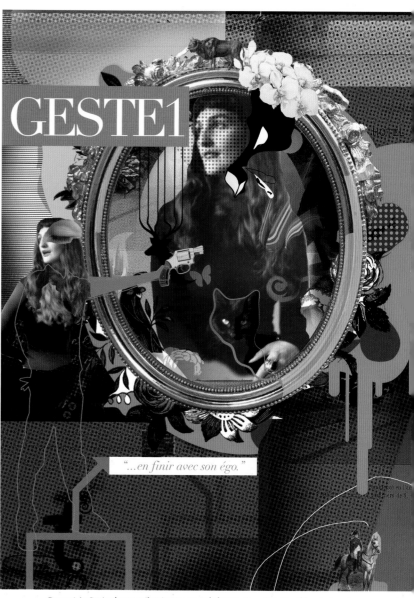

Geste 1 is Carine's contribution to an exhibition investigating 'the gesture' as a moment in time and space. Focusing on media and advertising, Carine set out to play with the idea of 'fashion identity' by creating fictitious magazine concepts.

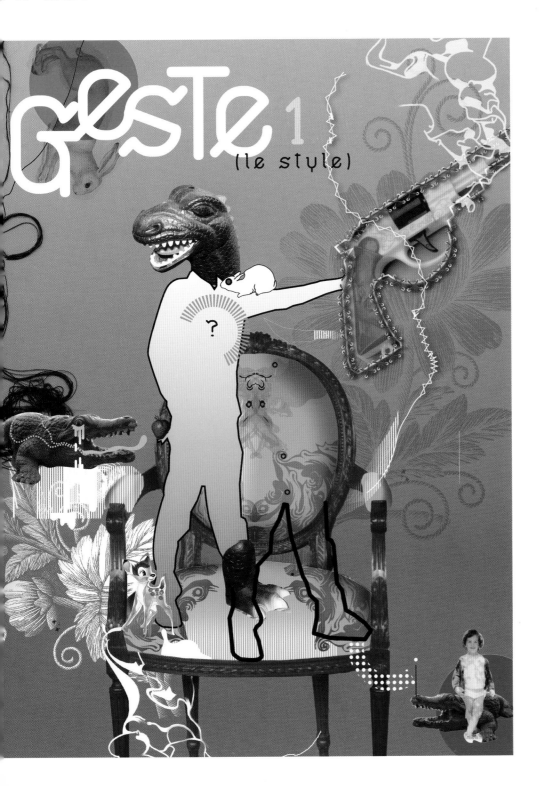

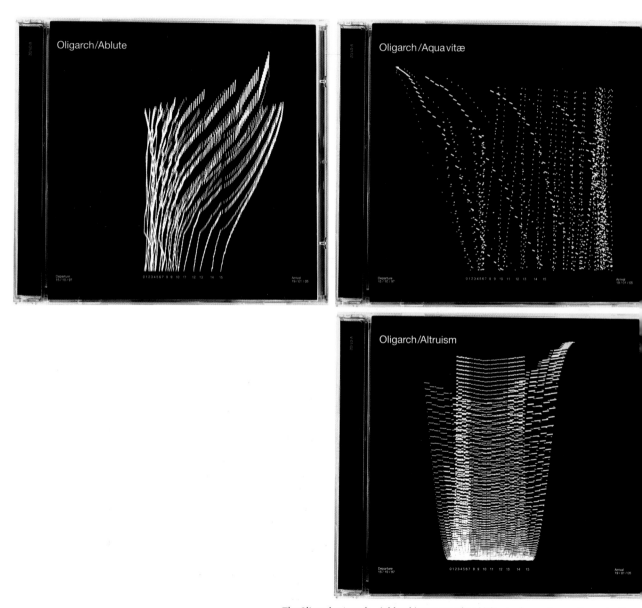

The Oligarch triptych – 'Ablute', 'Aqua Vitae' and 'Altruism' – are three releases by the Swedish electro artist who also acted as the independent label. With a small budget, the idea was to create simple, iconic images by plotting a graph showing the start and end dates of the recording session, the image being a visual representation of the music.

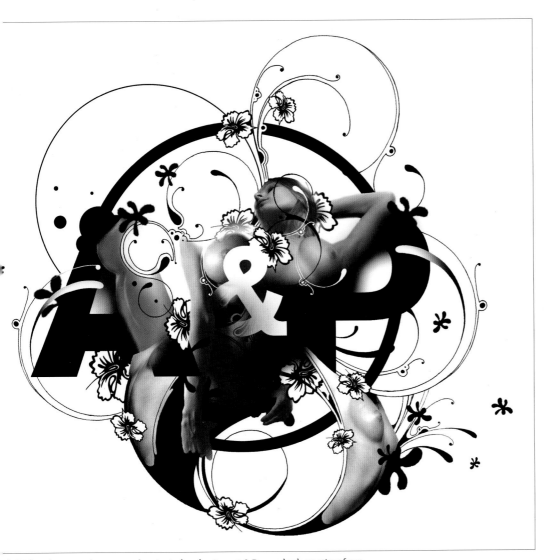

A&P by... is an ongoing personal project whereby Accept & Proceed ask creatives from a range of disciplines – their heroes and friends – to combine an 'A' and a 'P' into an identity, with the only stipulation that they use the black/white/greyscale palette. These contributions appear randomly on their website homepage, creating an instant link/ advert for the creator. Eventually they'll be compiled into an 'A&P recommends' book.

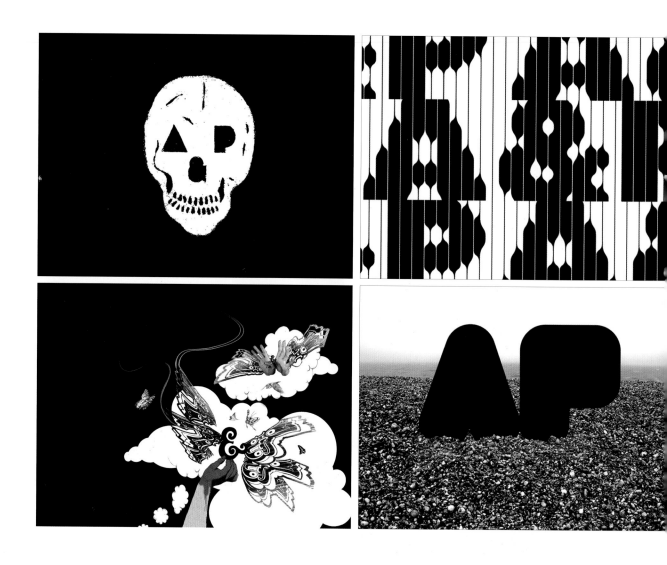

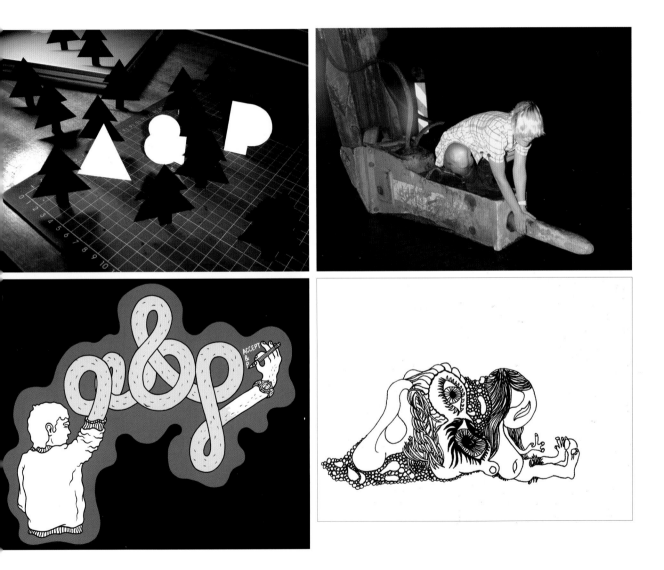

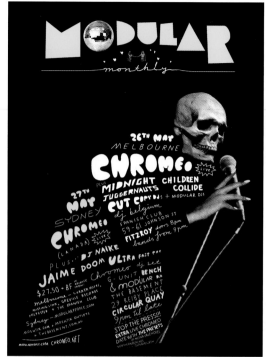

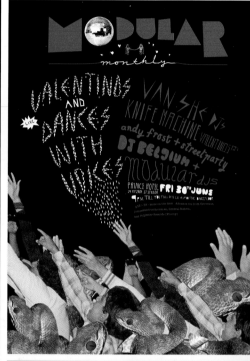

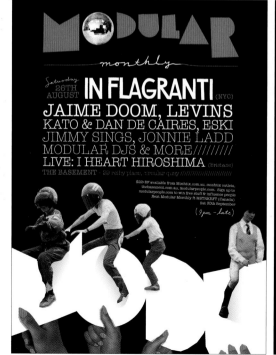

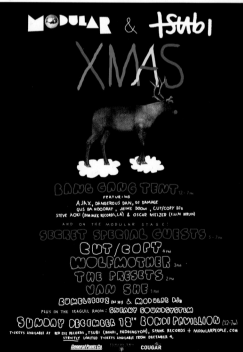

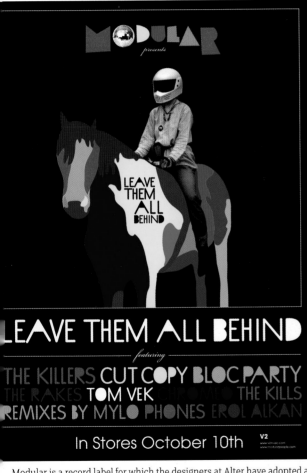

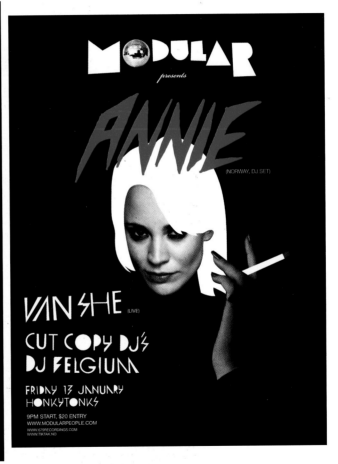

Modular is a record label for which the designers at Alter have adopted a 'hands on' approach. They like the music and the bands, and have creative freedom to develop packaging, posters and advertising. Representing a diverse range of musical genres, they've attempted to convey the energy of each performer via a mix of hand-rendered lettering, technicolour type and hand-cut collage.

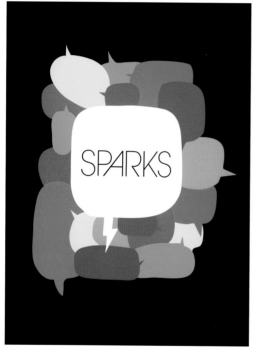

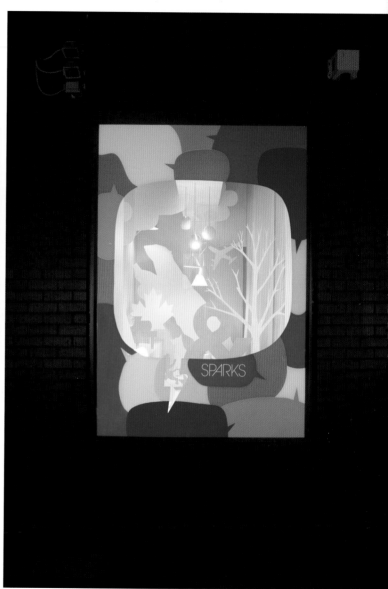

Sparks is an installation showcasing new lighting designs by emerging talent. It was created as part of the Melbourne Design Festival and in conjunction with Australian manufacturer Ism Objects. Viewed from the street, the colourful 'conversation' balloons give way to a serene interior containing a collection of enigmatic white objects, including the new designs.

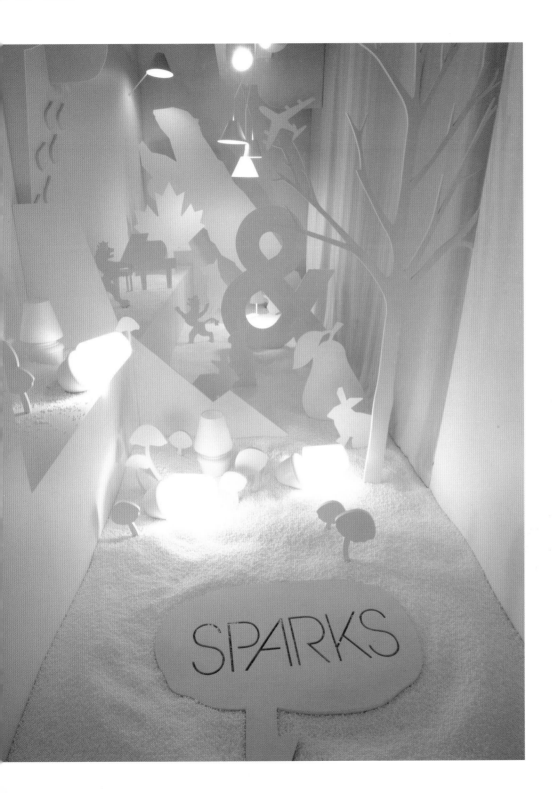

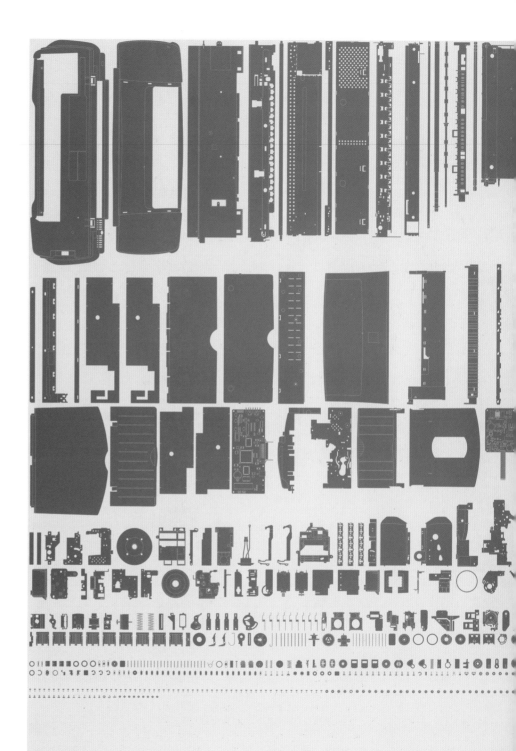

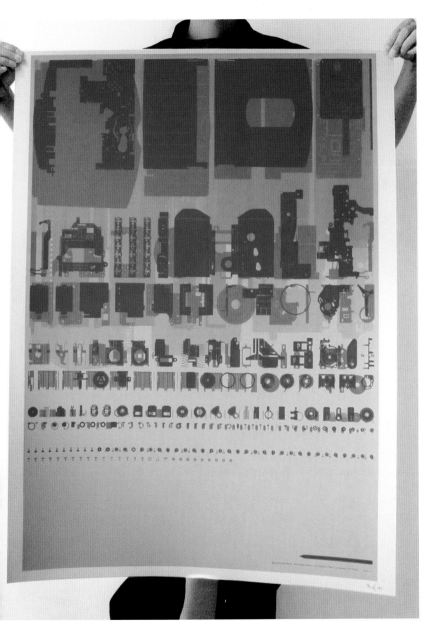

When still a student, Matthew Appleton travelled to India and China with a cameraman friend. They shot a documentary, *Afterlife*, about the madness of today's throwaway culture and the lifecycle of everyday products. Setting out to challenge assumptions, Matthew's Afterlife posters present and re-present a mass of consumer objects.

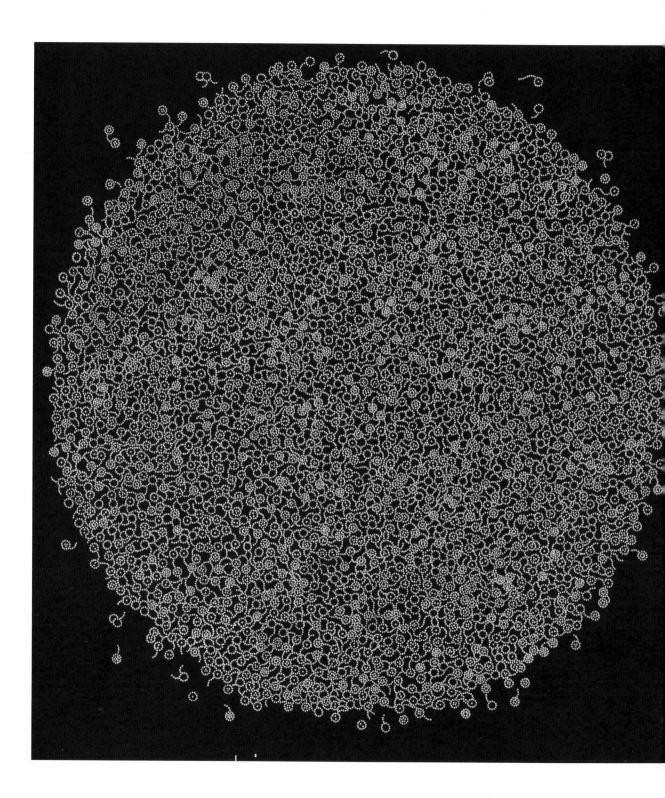

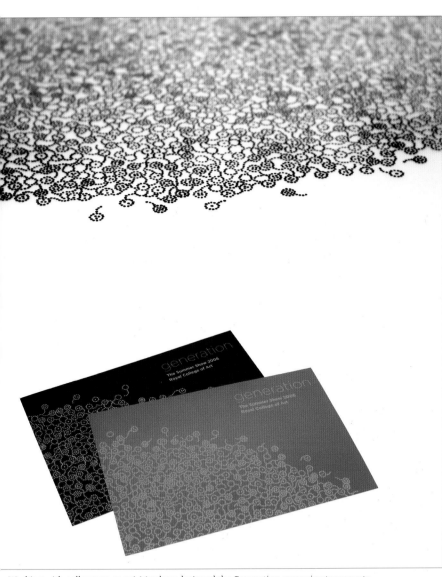

Working with colleagues, m,a+j, Matthew designed the Generation campaign to promote the summer graduation exhibition at the Royal College of Art in London. Based on traditional Japanese textile designs made up of delicate, dotty patterns, the hand-drawn image at the centre of the campaign appears from a distance to be a dense, single form. Up close, it reveals connections, pathways, networks and crossing points, representing a metaphor for the Royal College of Art itself.

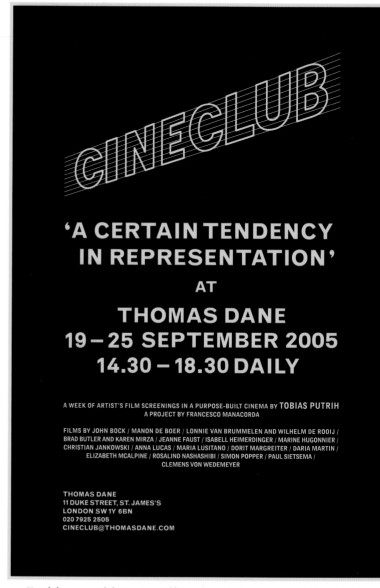

Cineclub was an exhibition, curated by Francesco Manacorda, for which artist Tobias Putrich built a full-size cinema from cardboard. Over six days various artists' films were shown there. A Practice For Everyday Life (APFEL) appropriated the language, type and layout of old film posters and end credits, creating an announcement poster that doubles as film programme and preview invitation.

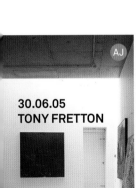

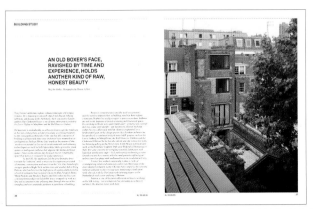

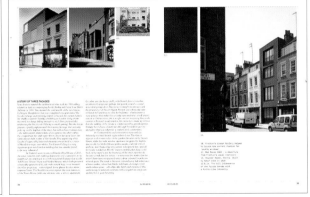

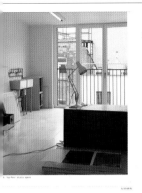

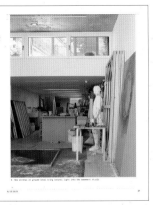

The Architects' Journal, a weekly content-led magazine with a unique heritage, was redesigned foregrounding the editorial decision to highlight the 'in progress' nature of architectural projects. Overlapping images, reminiscent of a pin-up, evoke the immediacy of a 'crit' or competition jury. Relaunched 9 June 2005.

SOMETIMES I THINK SOMETIMES I DON'T

Beck's Futures is an annual exhibition of emerging artists, sponsored by Becks and the ICA. APFEL put each artist's name 'in lights', as a premonition of fame. Signage was made of light bulbs while the printed material featured various different kinds of lighting.

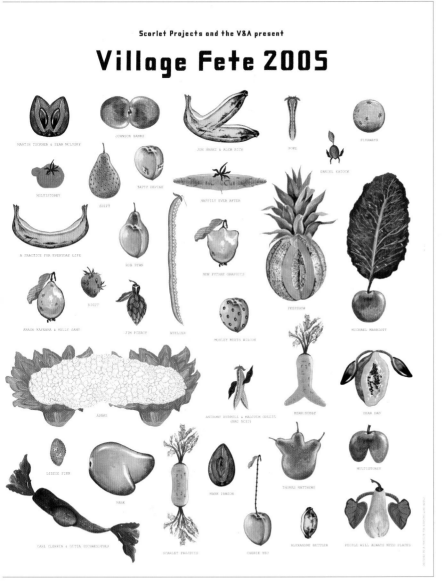

The Village Fete is an annual event at London's Victoria & Albert Museum, when Scarlet Projects curate a design garden party with thirty groups offering stalls of entertainment and games. APFEL's idea was to represent each design group as a 'freakish vegetable', inspired by traditional summer fête produce competitions. Visitors were asked to judge 'the best in show'.

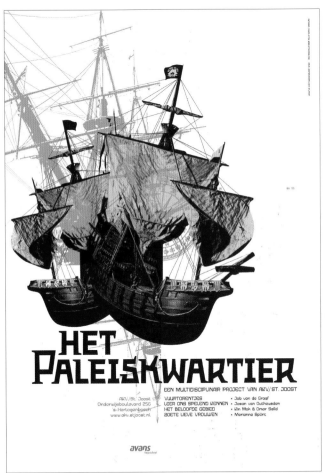

Attak experiment with creating a unique lexicon of graphic icons — featuring pirates, flames, apes, big cats and more. Used for personal and promotional projects, including stickers, they also appear in commissioned artwork, on posters and flyers, which also employ their bespoke fonts.

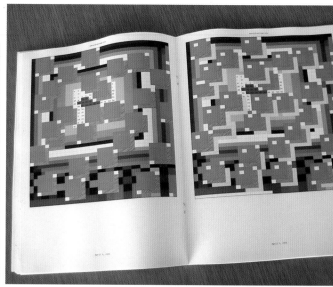

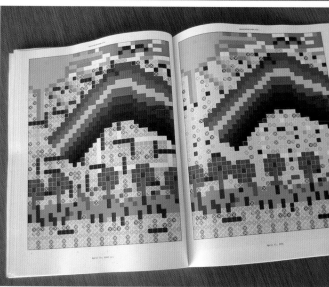

Microsoft Excel is a software designed to track and display information; Danielle Aubert appropriates and misuses it to create a series of 60 drawings, turning 'worksheets' into visual grids. She uses the 'cell preferences' function to fill in colour and create pattern. These drawings featured in an exhibition and were subsequently turned into a book by Various Projects, Inc. in New York.

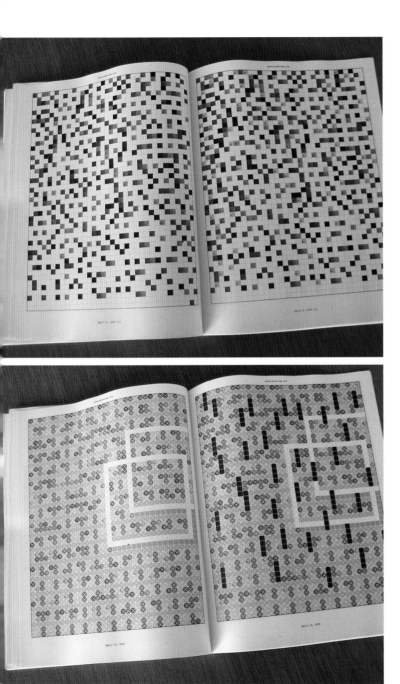

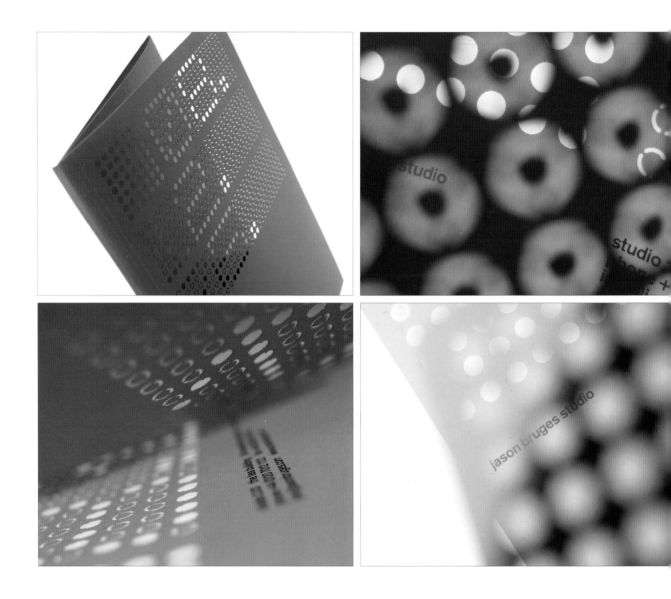

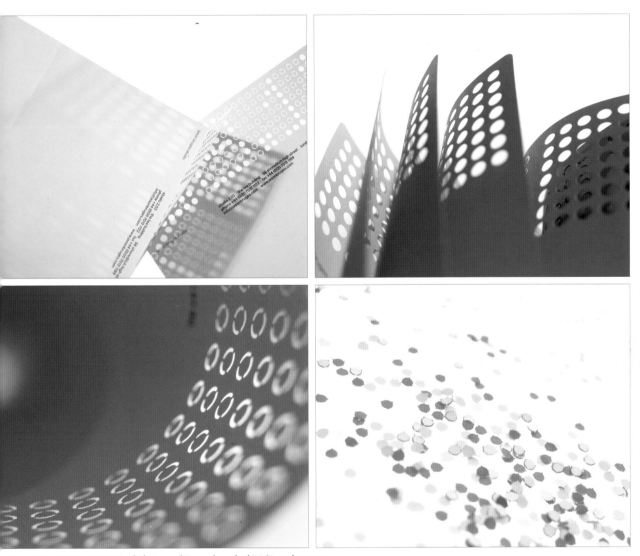

Jason Bruges is an interactive lighting architect who asked BB/Saunders to create a dynamic identity reflecting his firm's work. The challenge was to design a print-based solution that would represent their multi-media approach, which includes light sculptures, environments, events and interfaces. The logo is based on dot matrix LED lights, and laser cutting allows light to pass through the actual paper.

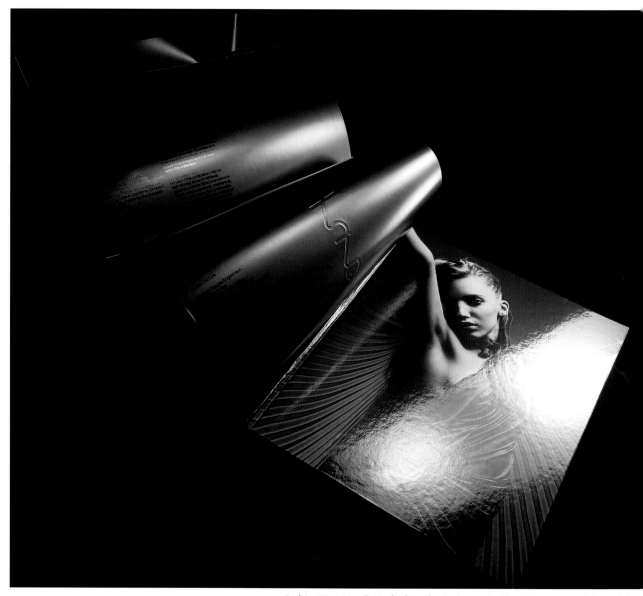

Fashion Stories is a limited-edition book, showcasing Rankin's recent work. Intended to ooze glamour and luxury, a high-gloss UV varnish was used throughout, with text reversed out of varnish to reveal matte paper stock beneath.

Jesse LeDoux

Jesse LeDoux runs the city. Granted, it's a city of his own creation and he, in his own words, is the de facto mayor, but what a city it is. Reperts with frogs and chemicals, with spoken grizzlies, and sidewalks dripping with Technicolor, it's a haven for the romantic, for those fueled by the spirit of whimsy and country, an escapist wonderland where everyone treats each other fairly and decently regardless of whether they're black, white, canine, or invertebrate. This city, like everything Jesse does, pours straight forth from his imagination, from his fantasies and his desires. And just like the city, Jesse LeDoux's imagination glows with the charm of a thousand magic colors. Welcome to LeDouxville. Population: All your best friends. Please stay as long as you'd like.

Aaron Noble

Aaron Noble's work speaks for itself. Fortunately, so does Aaron Noble. When I first contacted him to discuss why he loves mangling superheroes so much, I had no idea the conversation would leapfrog from such diverse intellectual land-scapes as the evolution of the comic book industry, why graffiti artists should really be called muralists, and just what exactly makes Starbucks so evil. When all was said and done, we had exchanged over fifteen pages of emailed conver-sations, personal notes, artist statements, and an enormous wealth of insights.

This issue is themed the "I See Beauty" issue. When you were younger, where did you first see beauty?

And now, when you work, where do you see beauty?

Can you describe your introduction to comic books? What made you base your work around those aesthetics?

Who were some of your favorite characters and why?

Can you explain the origin of your DROOM style? What exactly is it?

Erik Parker

Erik Parker has made New York City his home and painting list life's work. Deftly walking the line between lin-ing, sculpture, and dimensional space, Erik draws from pop aesthetics and current events to create psychedelic color-infused paintings. His work erupts in forceful arabesques and swirls that cut through canvas with form (rather than the "naked" concept) and the joy and fun seeping through structured layers of screaming...

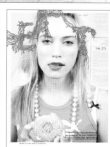

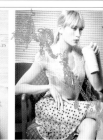

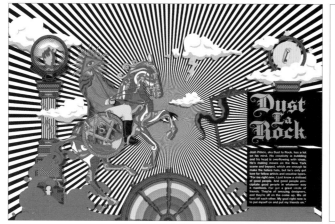

Dust La Rock

Josh Prince, aka Dust la Rock, has a lot on his mind. His creativity is bubbling and his head is overflowing with ideas. He's making moves on the New York scene and beyond, which are enough to make the haters hate, but he's only got love for fellow artists and creative types. "For the right now, I just know a shitload of good people. And good people pre-cipitate good people in whatever way it manifests. I've got a great circle of friends. They're all amazing, designers, and they're all on the come up. We all feed off each other. My goal right now is to put myself on and put my friends on."

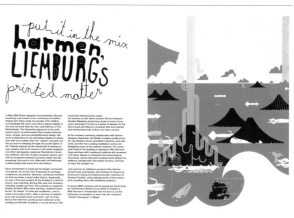

put it in the mix
harmen LIEMBURG's
printed matter

In May 2004 Dutch designer and printmaker Harmen Liemburg was invited to do a workshop at CalArts. Visiting him there made me wonder if the CalArts surroundings felt much more like a natural habitat to him and his work than the wet, cold flatness of The Netherlands. The illustrative approach in his work is so intriguing and the way he works with clean, simple, and very straightforward design. His work is distinctive for its obsessive display of obses-sion with form (rather than the "naked" concept) and the joy and fun seeping through structured layers of screaming, his work is rich, filled with old-fashioned craftsmanship that mixes time and history.

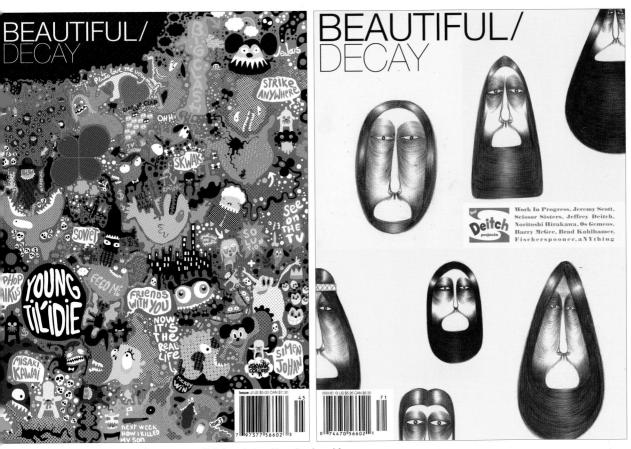

Beautiful/Decay is the magazine that Amir H. Fallah founded and has developed from a black-and-white photocopy into a unique, collectable publication. Each issue is themed and every spread is a close collaboration between commissioned writers, musicians and artists. Special-edition posters accompany certain issues and limited-edition T-shirts are designed by a variety of collaborators.

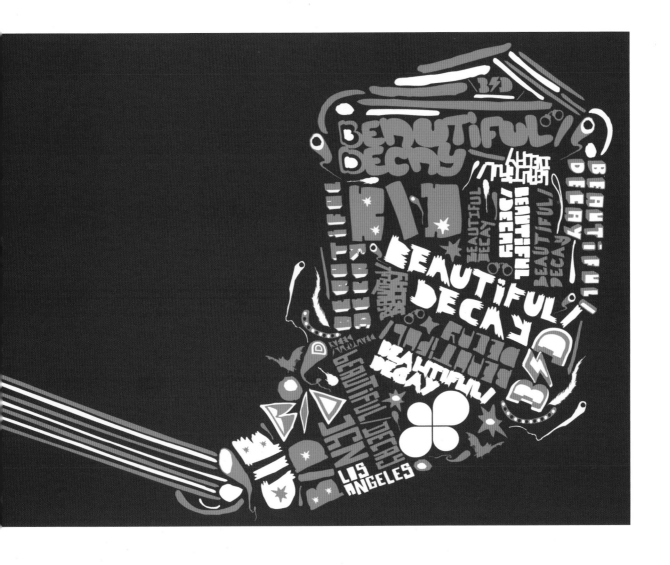

The title of this project is taken from the ancient Roman strategy of keeping the masses happy with cheap food and low-brow entertainment – a role fulfilled by the media today. In particular, Bread and Circus is a reaction to the horizontal flow of a regular book. The typeface is made from cut-up letters taken from correspondence about the book's content.

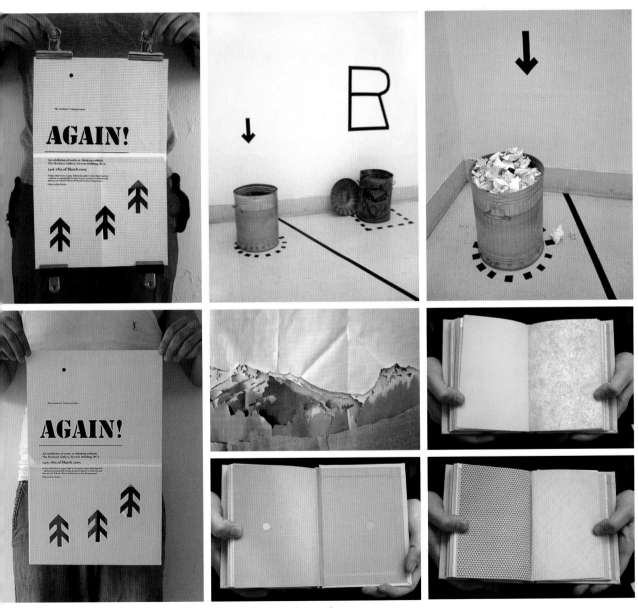

Again! was an exhibition about recycling, curated by Royal College of Art students.
The poster was made using the insides of envelopes.

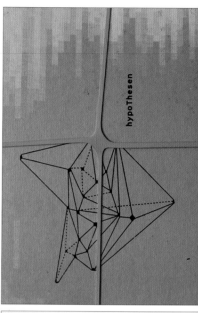

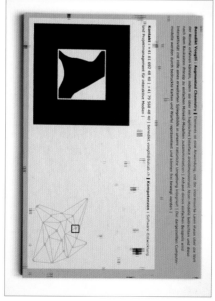

Made in collaboration with Karin Wichert, Hyperwerk is a book and set of flyers created by silkscreen printing onto thick card, assembling pages, and binding them with double elastic bands.

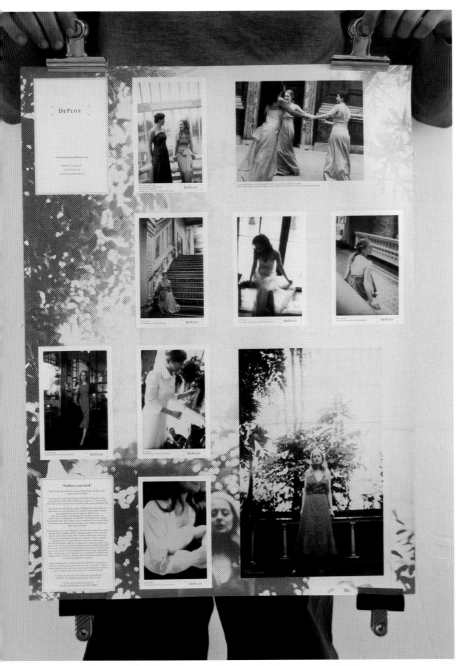

DePLOY is a B2-sized poster that folds to become a look-book for London-based fashion designer DePLOY.

Nirit Binyamini produced a series of books, entitled *House-Home*, that set out to represent visually the range of places we call home – with volumes featuring school, hotel, hospital, rest home and cemetery.

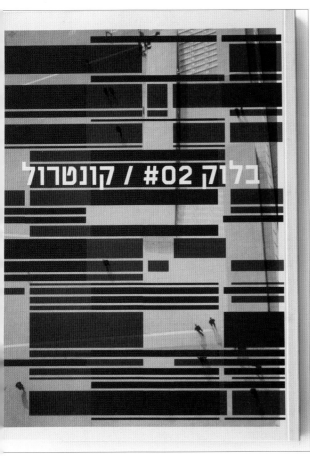

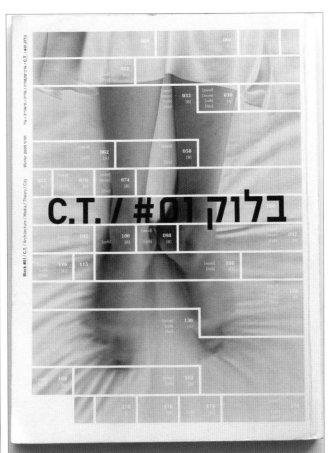

While working with designers Gila Kaplan and Kobi Franco, Nirit worked on the design of *Block* magazine's first two issues. Aimed at expanding the discourse around contemporary architecture in Israel, *Block* is an outward-looking publication, crossing boundaries between disciplines and travelling the world.

Lindstrom & Prins Thomas
Mighty Girl

Lindstrom & Prins Thomas
Turkish Delight

Lindstrom & Prins Thomas
Sykkelessong

Lindstrom & Prins Thomas
Boney M Down

Chris Bolton gave each album in Lindstrom & Prins Thomas's twelve-inch single series a different illustration made by Juha Nuuti from paper printed with various wood grains and collaged into illustrations of woodland creatures from a Nordic forest. These images referred to the geographic origin of the musicians and the atmospheric tempo of the music.

The club Make-Up wanted a new identity for its opening in Ghent, Belgium. Chris commissioned illustrations from Laura Laine, mixing fluid pattern with a tough icon, black and white with passionate purples in order to create a complex 'personality' for the club.

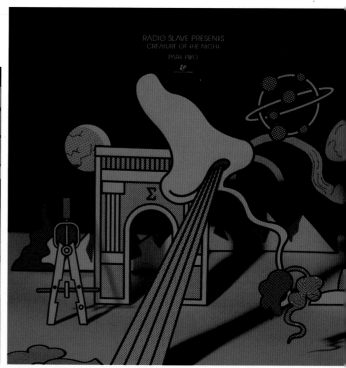

Radio Slave's two twelve-inch releases for *Creature of the Night* gave Chris the idea for a miniature, illustrated stage set of strange imagery, inspired by religious and pagan symbols. Harsh lighting intensified the presence of darkness.

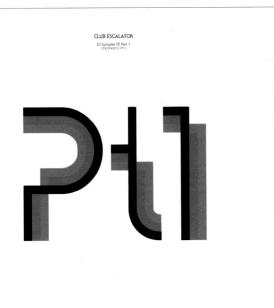

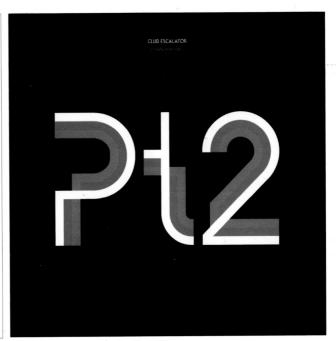

Club Escalator's twelve-inch single series was treated to contrasting colour ways, to emphasize the continuity.

Sky Broadband were treated to four HD films, each explaining a different package. The script was illustrated and animated with expressive typography to bring out meaning and nuances in the text.

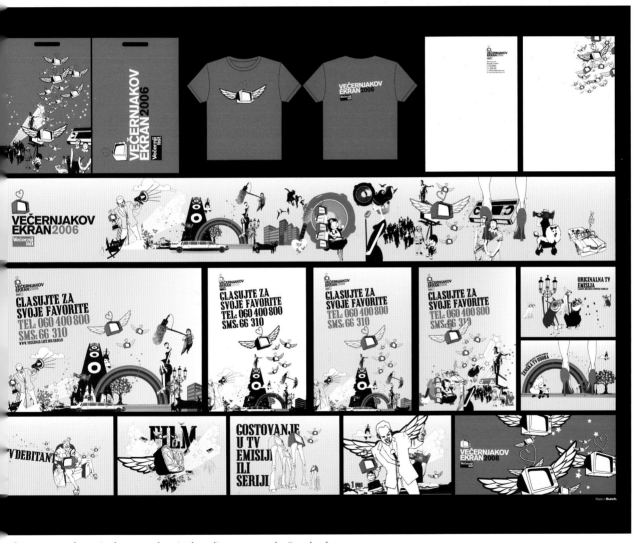

Ekran TV Awards received a comprehensive branding treatment by Bunch – from pre-ceremony print ad campaigns to on-screen idents, merchandising and the design of the actual award itself. Combining an eclectic mix of visual elements, icons and characters, unified by a simple colour palette, this visual cacophony represents the creativity that these awards celebrate.

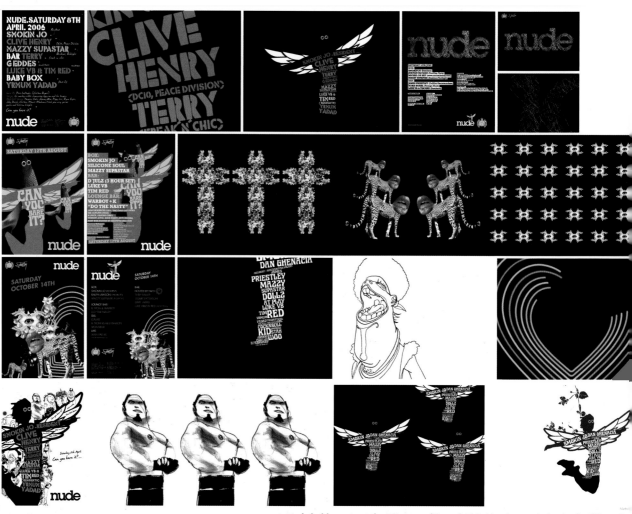

Nude hold events at the Ministry of Sound. This identity needed to be flexible and evolutionary, while maintaining a visual coherence that differentiated Nude from other club-nights. The black ground and strong-coloured, blocky type remain consistent throughout but are subject to various dramatic shifts in scale.

Promax UK Conference and Awards 2006 had the theme, 'it's all about the idea'. Bunch came up with a template illustrated head to display the diversity of snapshots from daily life that get stored, refined and transformed into ideas. The templates acted as a visual-ideas generating space.

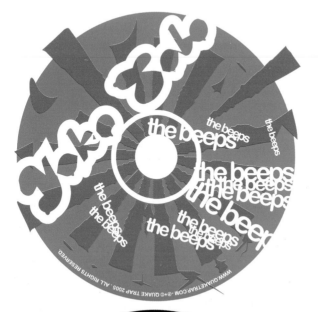

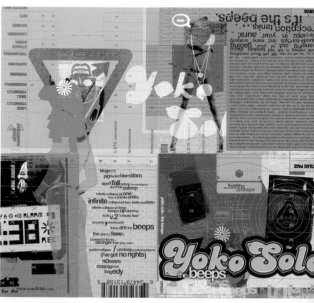

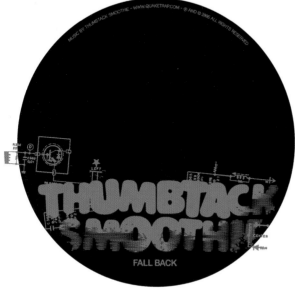

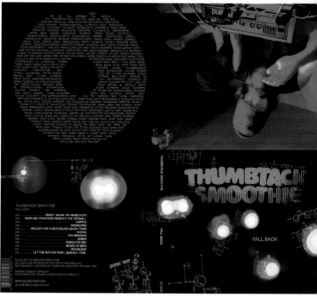

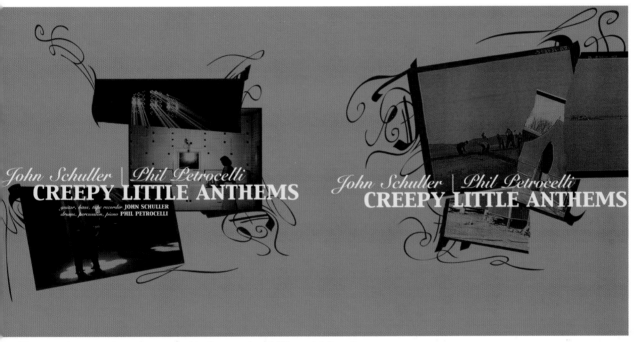

Todd Kurnat of Circuit73 designs music graphics for a number of different labels and musical genres. Working here with Quake Trap Records and Soultheft Records, he creates very different moods for each artist, with his use of colour, typography and layout.

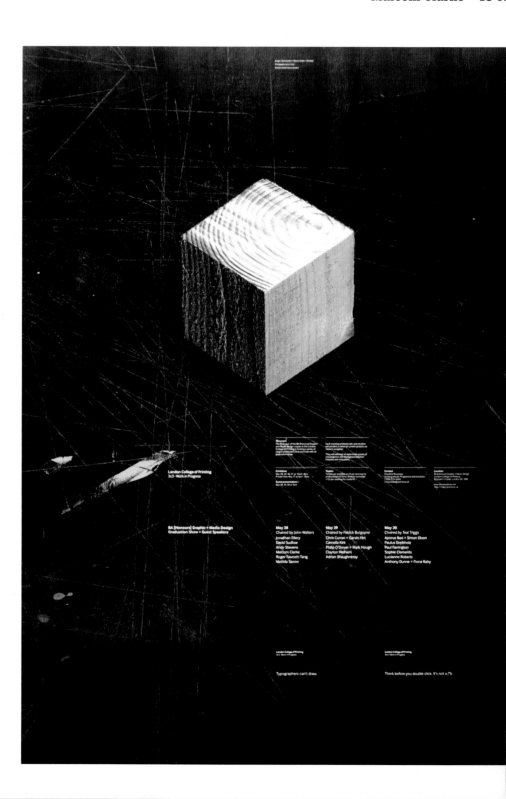

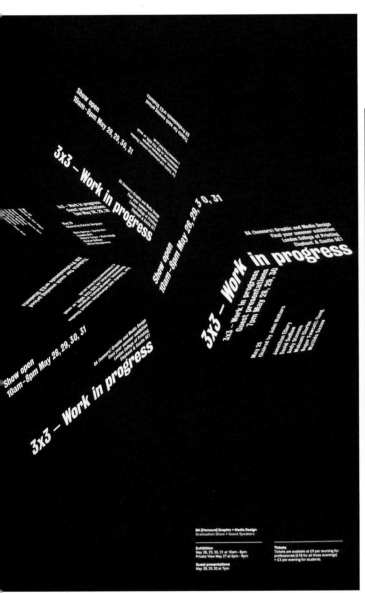

Working with designers David Sudlow and dixonbaxi, Malcom Clarke created this series of posters that double as invitations when folded, publicizing the London College of Printing's final year exhibition and launch party. Malcom aimed to suggest a 3D space using hand-rendered typography wrapping around a cube, while crop marks and folds recreate the 3x3 cube logo.

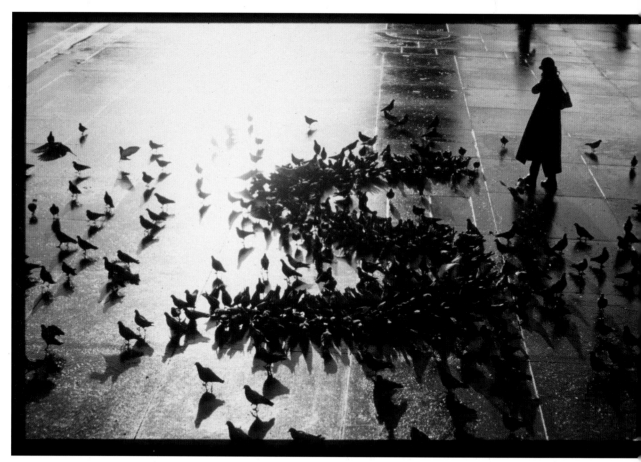

Love them or hate them, most people have an opinion about pigeons – especially when confronted with the flocks in London's Trafalgar Square. Malcom set out to create a typeface with both the mode of production, and the message made obvious and integrated. This is 'live' typography!

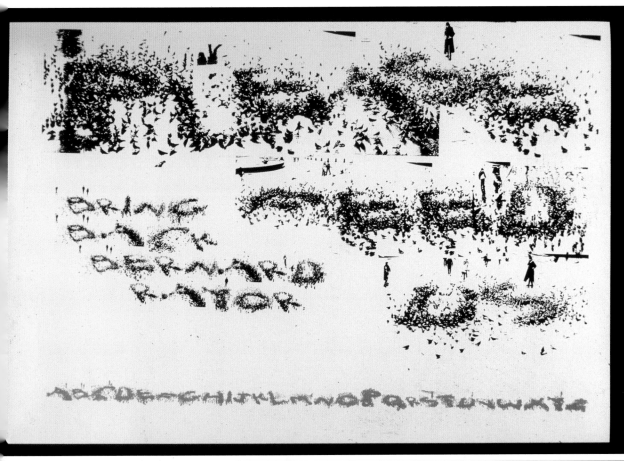

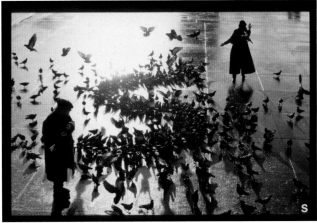

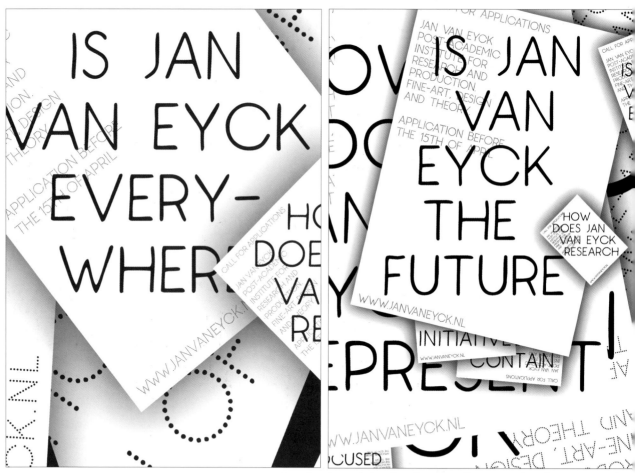

A number of commissions from the renowned Jan van Eyck Academy in Maastricht, including invitations, catalogues, an annual report and this recruitment campaign, demonstrate Cobbenhagen & Hendriksen's explorations in typography. This campaign to attract students was distributed worldwide.

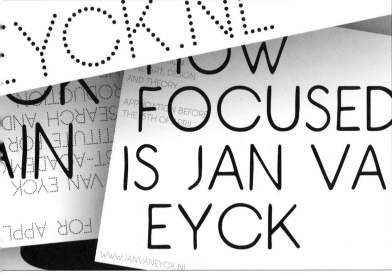

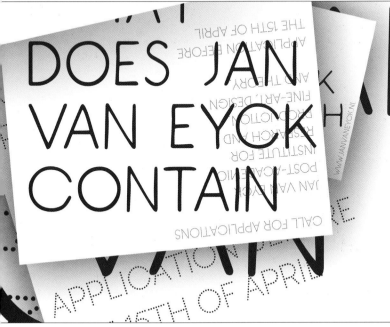

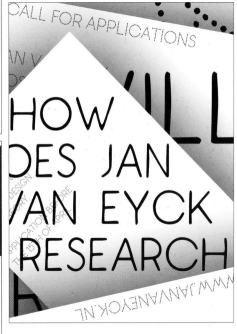

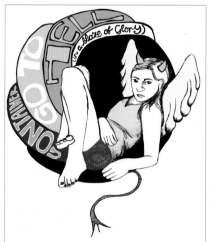

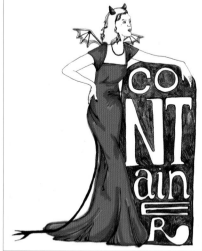

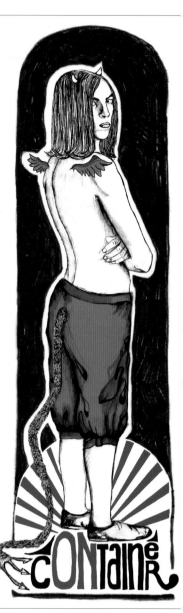

Drawing and colouring a myriad collection of figurative characters, decorative elements and fanciful objects, Container cut and paste hundreds of elements to create illustrations that work at any scale. Project Fox required that the duo customize four hotel rooms, including furniture, as well as a VW car, for a new product launch.

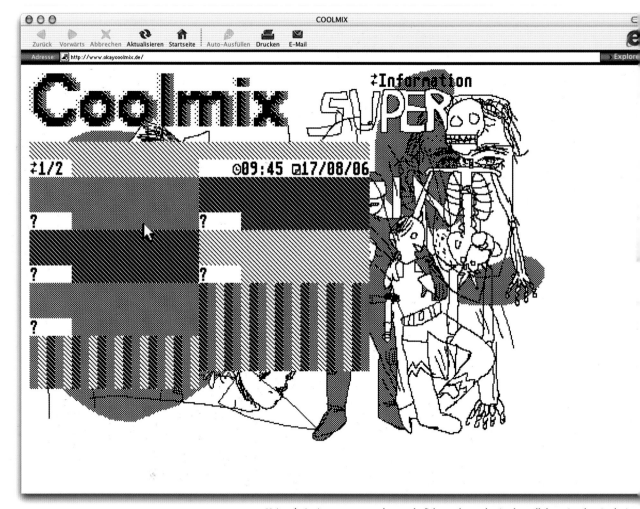

Using their signature monochrome, lo-fi, barcode aesthetic, the collaborative duo Coolmix have created a playful and erratic website, as well as a series of self-promotional projects, including posters, stickers, magazines and T-shirts. The title of the textile print opposite translates as 'irregular pattern'.

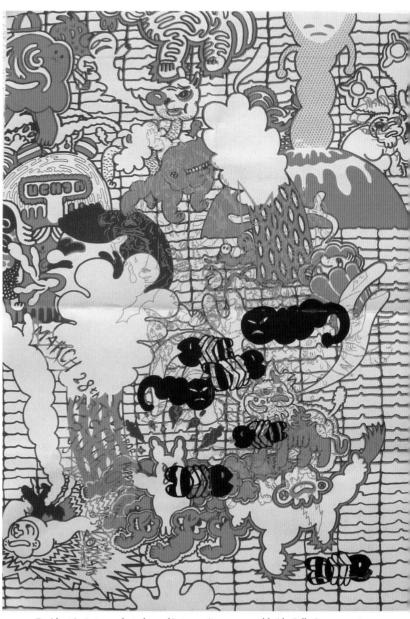

Resident in Antwerp, but plugged into music scenes worldwide, Jelle Crama creates masses of gig and festival posters, using silkscreen print and stencil techniques. CD packaging, whether for personal projects or indie labels, includes hand-rendered elements, and additional lettering is made with a marker pen. Binding is completed on a sewing machine.

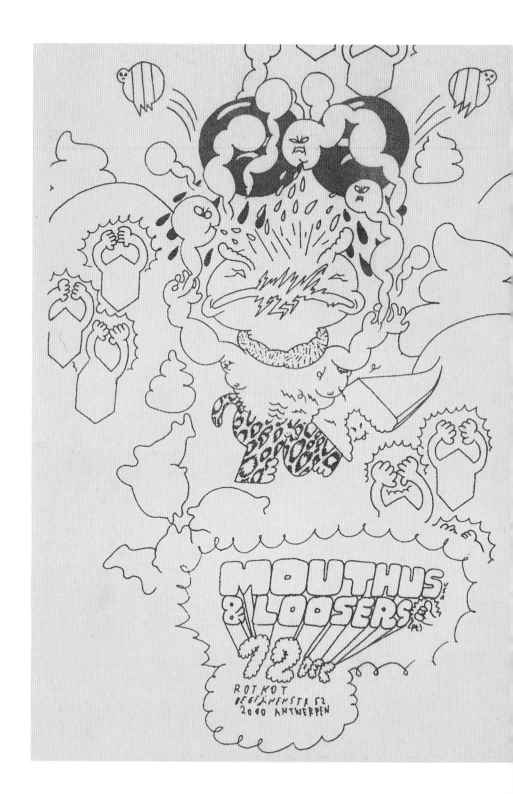

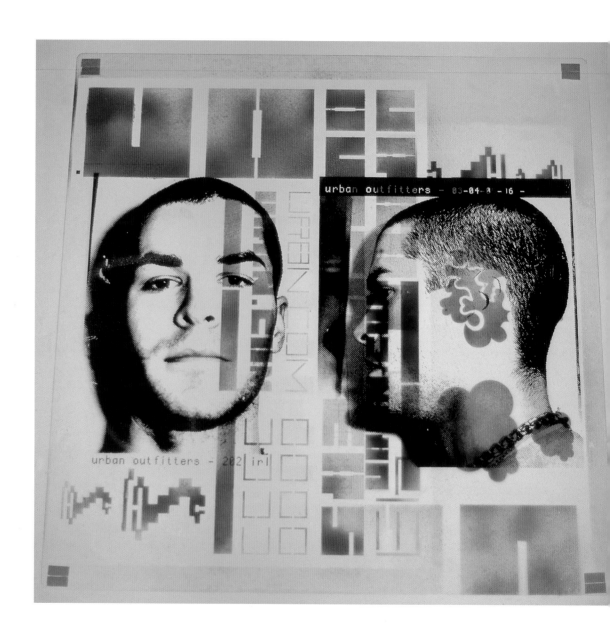

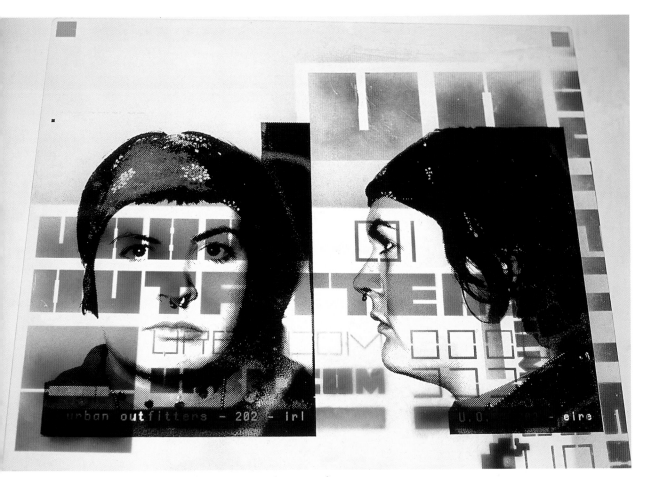

The street-smart clothing retailer Urban Outfitters commissioned Jo Hogan of Cut-up
Design to create a series of window and store graphics. Mixing media, Jo combined
backlit plexiglass, silkscreen printing and spray-painted stencils to create these
atmospheric mugshots.

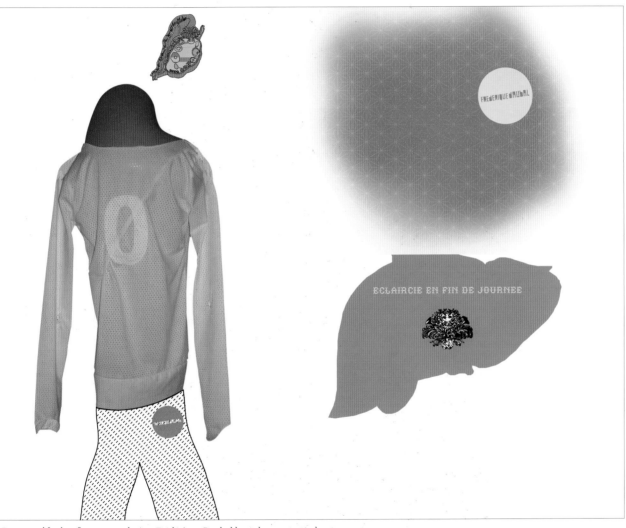

Renowned for her flat pattern design, Frédérique Daubal here demonstrates how pattern knows no boundaries, as at home on the body as in space or on paper, objects and textiles. For her exhibition *Eclaircie en fin de journée* at the Gas Shop Gallery in Tokyo, she overprinted onto reclaimed garments and various publications as well as her signature T-shirts. The installation featured prints and garments coming off the walls, into boxes, furniture and the floor.

Palais de Tokyo, site de création contemporaine · Paris Musées

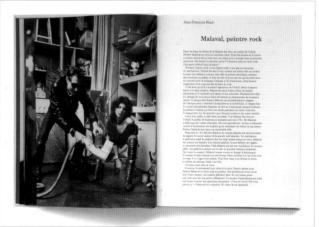

Two exhibition catalogues for the avant-garde art gallery/educational institute Palais de Tokyo in Paris demonstrate deValence's intellectual, collaborative and analytical approach to creating an accompanying publication. In effect, it should be a permanent expression of a transient display of artworks.

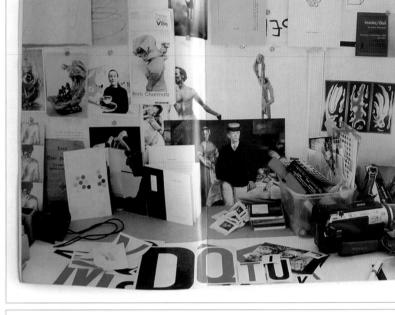

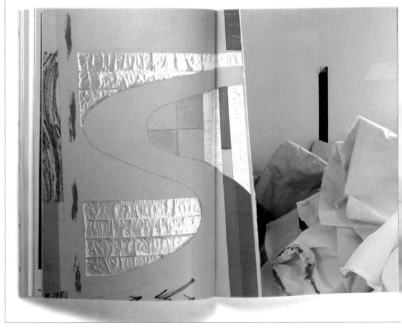

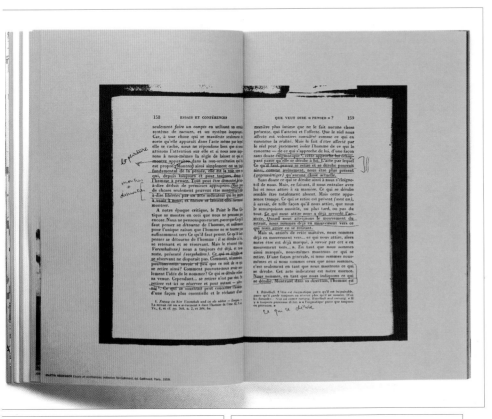

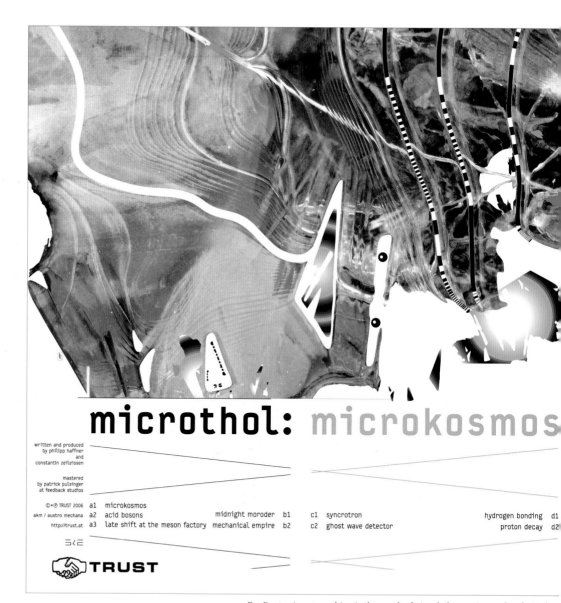

microthol: microkosmos

written and produced
by philipp haffner
and
constantin zeileissen

mastered
by patrick pulsinger
at feedback studios

©+℗ TRUST 2006
akm / austro mechana
http://trust.at

a1	microkosmos			c1	syncrotron		
a2	acid bosons	midnight moroder	b1	c2	ghost wave detector	hydrogen bonding	d1
a3	late shift at the meson factory	mechanical empire	b2			proton decay	d2

TRUST

For Dextro image-making is the result of visual abstraction and technical experimentation, using interactivity, algorithmic animation and self-generating programmes to create imagery that may play on a monitor in a casino, grace a record sleeve or appear in a magazine.

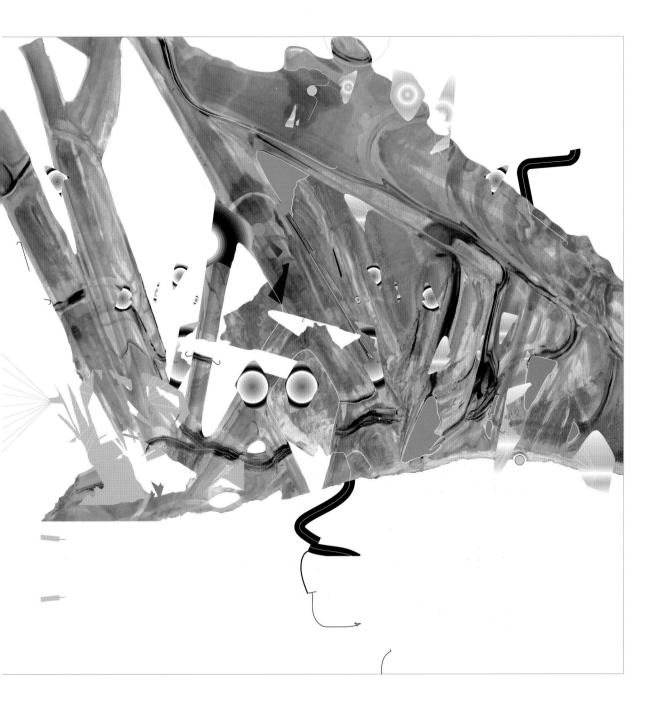

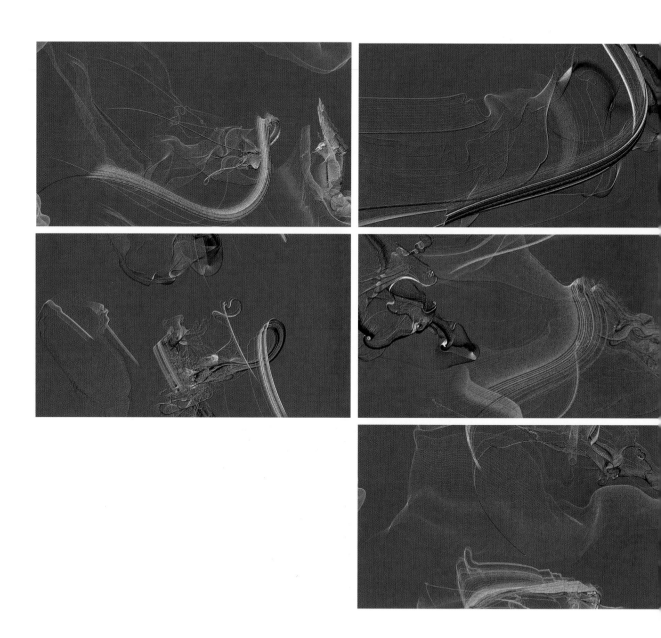

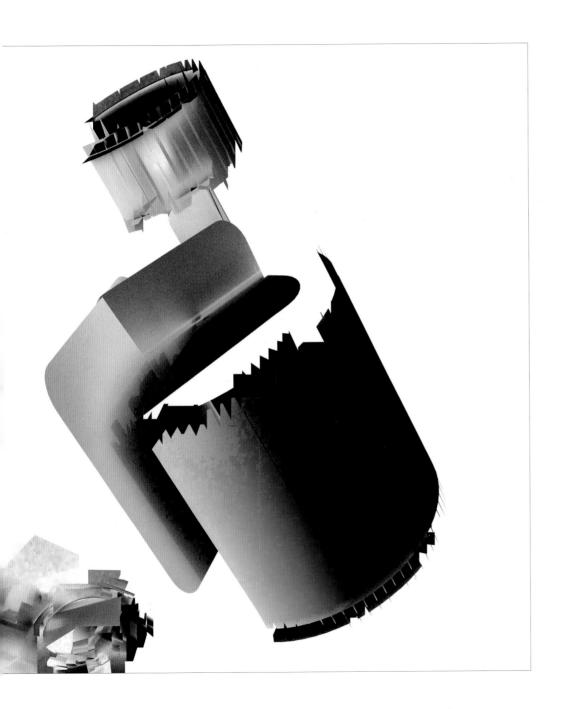

0.

It has to start somewhere.

Dark.

I am unsure as to how or why I even care anymore. Even at my most receptive, I feel stifled, trapped in a rapidly expanding nightmare. I suffocate mentally as I fight a deep unsettling nausea. My internal confusion is compounded by gaping holes in how I perceive the outside environment.

I curl into a rotting ball.

Each time I seem to settle the rolling blob of molten liquid that forms my brain shudders. It is dying, crushed and liquefied by the rapidly increasing stream of information. Even with every delay field selected at maximum to filter the overload my struggle increases – Sound fights touch as they collide into smell.

I taste my dying synapses.

This was going to be good year.

Zero is an ongoing graphic novel; this personal project is art directed by dixonbaxi, with photography by Jason Tozer. Each production still shows a key moment in the first chapter.

The Sci Fi Channel commissioned a 'deck of cards' as an inspirational tool for the
company's creatives. Forty-eight different images represent ideas and concepts that
relate to science fiction, displaying a visual on the front and an inspirational statement
on the back. The project has a secondary function as a visual expression of the brand
and its values, helping position the Sci Fi Channel within the broadcast industry.

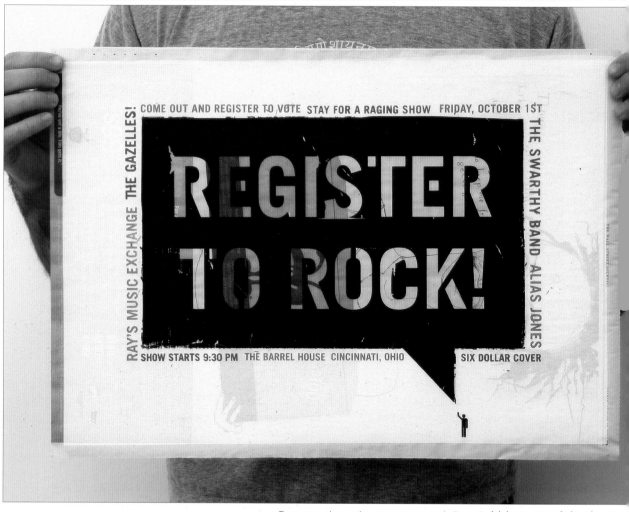

For a campaign to sign up young voters in Dress Code's home state of Ohio, the team silkscreen printed their message onto stolen copies of *The Wall Street Journal* in their studio, guaranteeing that each poster was unique.

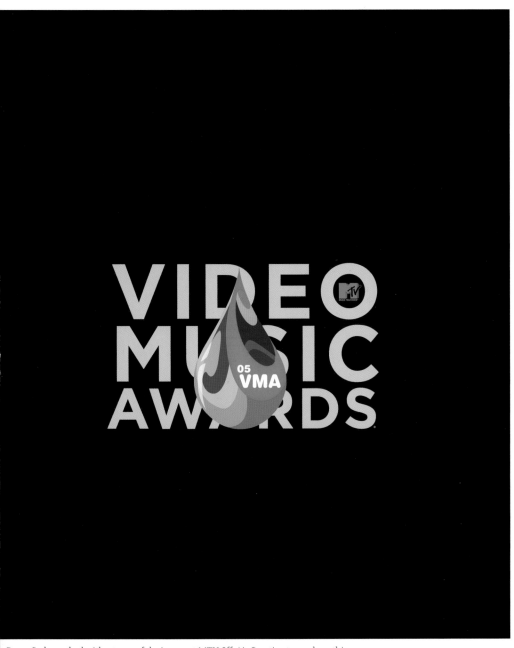

Dress Code worked with a team of designers at MTV Off-Air Creative to produce this logo for the 2005 Video Music Awards. Themed after water, the logo mixes typographic languages and organic symbolism.

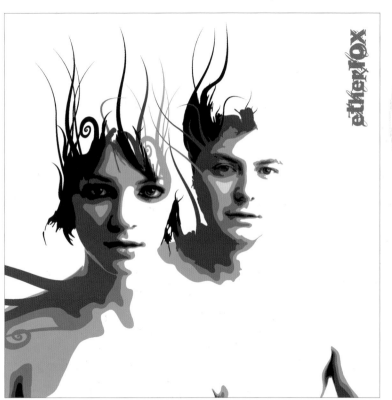

The latest incarnation of a producer-writer and singer-songwriting team, etherfox are major players in the Australian dance music scene. They asked forcefeed:swede to create a new style and branding for them, as well as art direct and design CD packaging and promotional material. The mix of atmospheric portraits and organic decoration lends the duo an ethereal quality that matches their music.

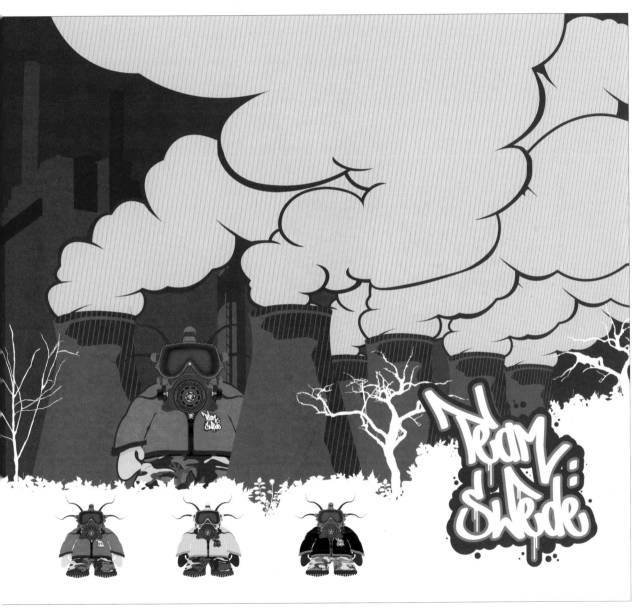

Team Swede demonstrates founder Oz Dean's enthusiasm for street-inspired art and character design.

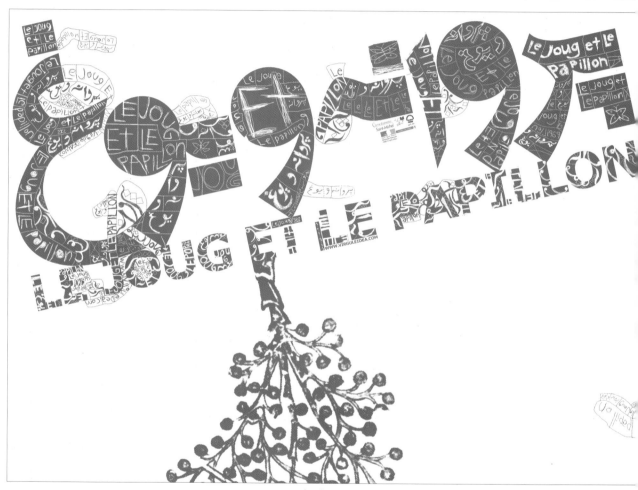

Street-level inspiration is evident in the work of Farhad Fozouni. His theatre poster for *Le Joug et le Papillon* (*The Yoke and the Butterfly*) displays scratched graffito messages within the blocky typography.

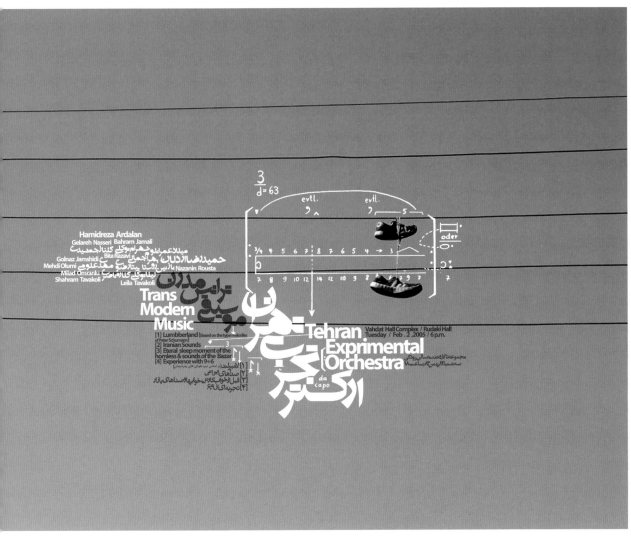

For the Tehran Experimental Orchestra, Farhad has used a photo of that most bizarre urban phenomenon – throwing sneakers that are tied together by their laces over external telephone lines. The five wires approximate a musical stave; the sneakers are the notes.

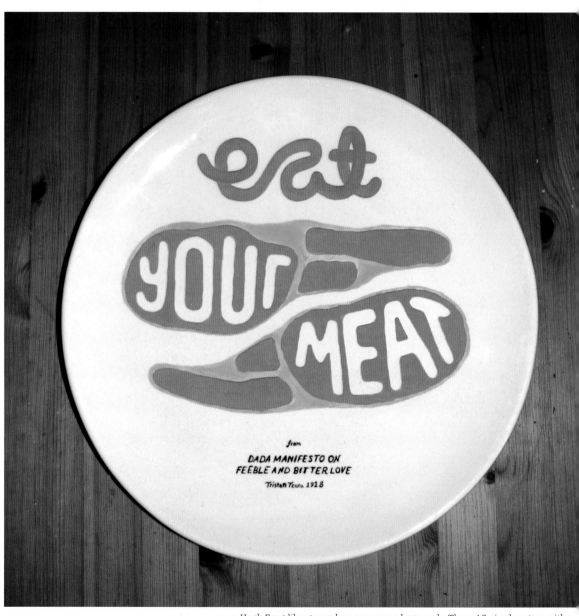

Hugh Frost likes to work on paper on a large scale. These A0-sized posters, with a mixed-media back-up of T-shirt print, website and gatefold seven-inch sleeves, explore phrases culled from Dada writings of the 1920s. They reinterpret ideas as hand-painted typographic studies, digitally reassembled.

Manifest

A musician himself, and a keen follower of various music scenes, Hugh designs flyers and posters for bands and gigs, as well as directing music videos. Each project provides an opportunity to explore various visual languages.

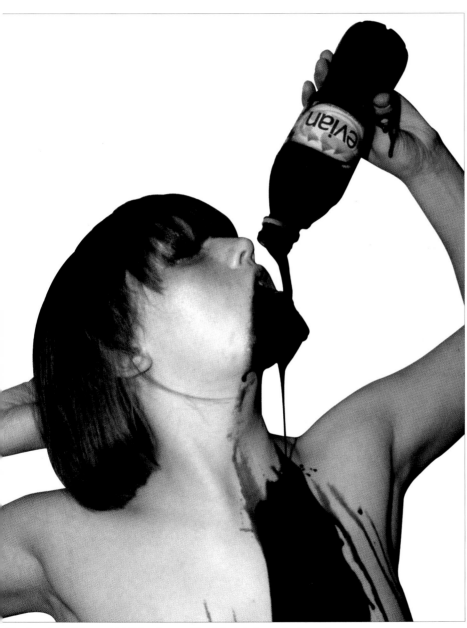

The Decadence Inherent highlights the use of fossil fuels in the packaging and transportation of bottled water. A series of 'black bottles' were made and planted in retailers' fridges, as a means of getting the message out to consumers.

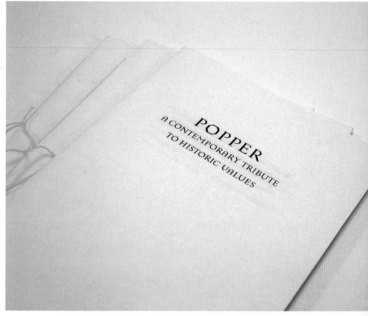

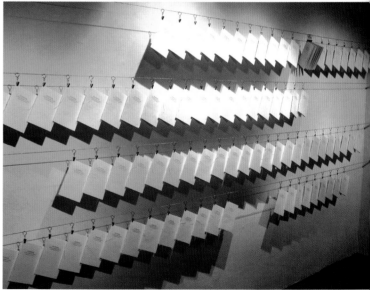

Following a programme of exploration, experimentation and evolution, Paulus M. Dreibholz of Gaffa has produced a typeface and specimen book, *Popper*. The title is in reference to Karl Popper, whose theories he describes as 'modified Darwinism'.

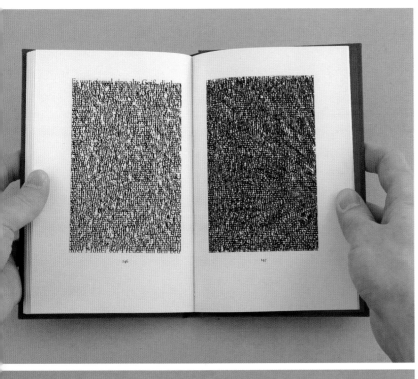

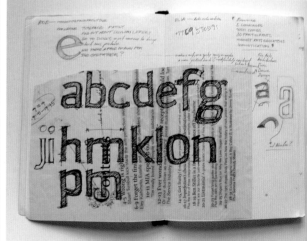

Paulus's sketchbooks are exercises in collating typographic examples, which are then subject to analysis and refinement.

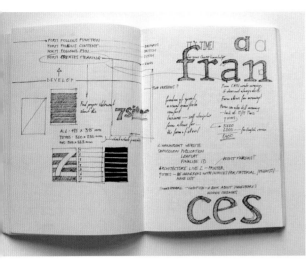

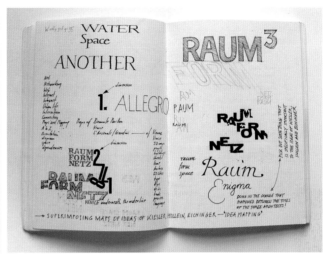

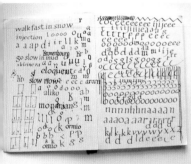

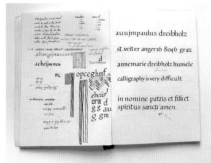

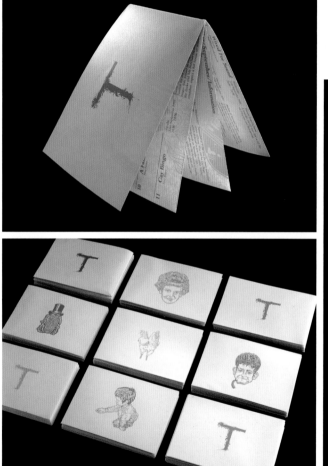

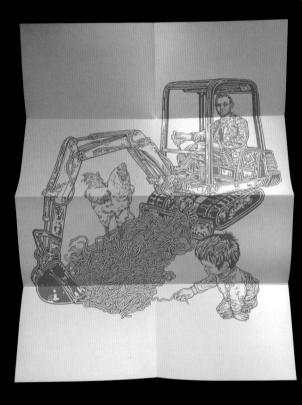

The T-Bar is a trendy day- and night-time café in the Tea Building in London's Shoreditch, home to a number of creative companies. George&Vera created a low-cost, super-flexible print identity by cutting back the number of individual elements and creating poster-sized, fold-out info sheets on newsprint. They feature surreal illustrations printed in eye-catching neons.

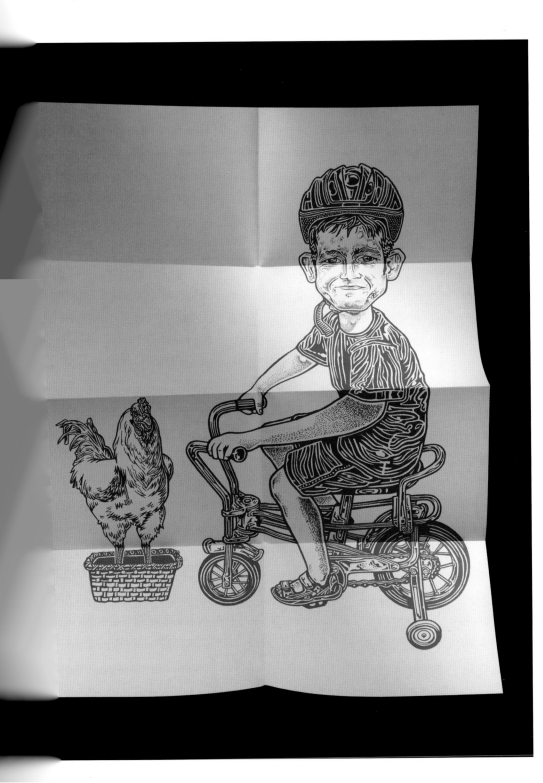

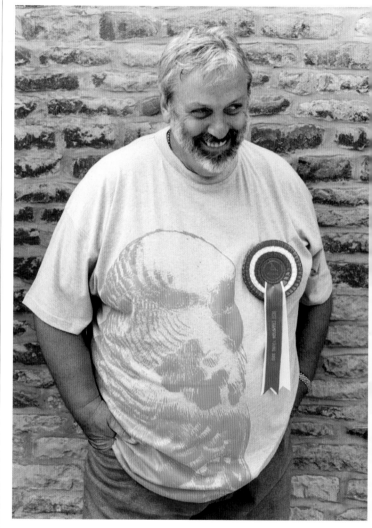

GeoffWears'BudgieWithEar'
AvailableFromAllGoodStockists
thisisrude.com

rude®

GeoffCapesPhotographedByLarryDunstan(PCP)
ArtDirectionByGeorge&Vera

London-based T-shirt company Rude have a reputation for strong graphics and witty ideas. If creating big pictures on XL T-shirts, why not show them off on a larger-than-life character? Enter, Geoff Capes, one-time road-safety spokesperson, and later, the man in the Darth Vader suit. He deserves that rosette!

For Promise Promo, a company that produces and markets stylish promotional items,
George&Vera produced an identity, brochures and a website that work in a myriad
of colourways, so that staff can personalize their correspondence.

Walking on the Clouds with Closed Eyes is a poster made for the Fajr Theater Festival. The idea for the exploded view of an aeroplane came from a line of dialogue by dramatist Mohammad Charmshir, which in turn was based on the last writings of Virginia Woolf, where a dead pilot appears to her saying, 'it doesn't matter that a fish is feeding of me now, one can still make the most delicious grill with it'. At that time in late 2005, an Iranian Air Force plane crashed into an apartment block in a busy suburb of Tehran, and Amirali wanted to commemorate the accident.

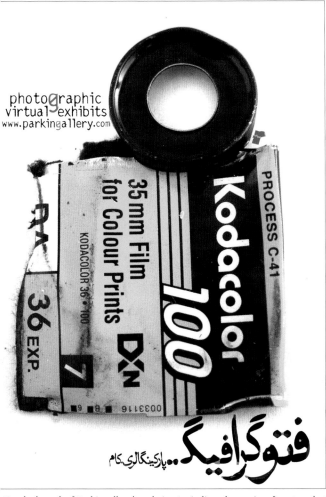

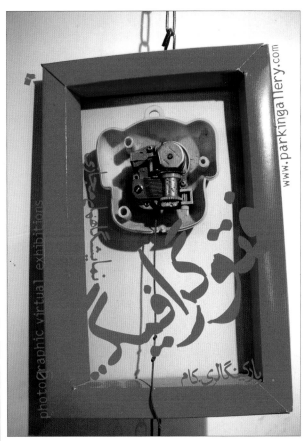

For the launch of Parkingallery's website, Amirali made a series of posters that included these for photographic virtual exhibits. The squashed Kodak box was found near Amirali's processing lab, and illustrates the theme Photo+Graphic. During his university days, Amirali made many collages. He updated the musical toy's head (activated with a string) with type, accentuating its 'interactivity'.

AĐC

ART
DIRECTORS
ANNUAL

85

**The Best of Visual
Communications
Worldwide**
Advertising
Design
Interactive
Illustration
Photography

Strong typographic solutions, using a contemporary, informational approach, are the
hallmarks of Giampietro+Smith's design. An institution on New York's creative scene, the
Art Directors Annual speaks with authority while attempting to surprise and innovate.
A bespoke logo incorporates elements of new and old type styles.

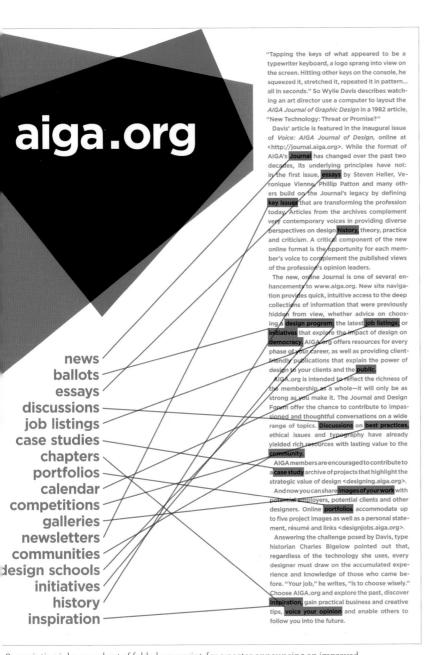

aiga.org

news
ballots
essays
discussions
job listings
case studies
chapters
portfolios
calendar
competitions
galleries
newsletters
communities
design schools
initiatives
history
inspiration

"Tapping the keys of what appeared to be a typewriter keyboard, a logo sprang into view on the screen. Hitting other keys on the console, he squeezed it, stretched it, repeated it in pattern... all in seconds." So Wylie Davis describes watching an art director use a computer to layout the *AIGA Journal of Graphic Design* in a 1982 article, "New Technology: Threat or Promise?"

Davis' article is featured in the inaugural issue of *Voice: AIGA Journal of Design,* online at <http://journal.aiga.org>. While the format of AIGA's Journal has changed over the past two decades, its underlying principles have not: in the first issue, essays by Steven Heller, Veronique Vienne, Phillip Patton and many others build on the Journal's legacy by defining key issues that are transforming the profession today. Articles from the archives complement very contemporary voices in providing diverse perspectives on design history, theory, practice and criticism. A critical component of the new online format is the opportunity for each member's voice to complement the published views of the profession's opinion leaders.

The new, online Journal is one of several enhancements to www.aiga.org. New site navigation provides quick, intuitive access to the deep collections of information that were previously hidden from view, whether advice on choosing a design program; the latest job listings; or initiatives that explore the impact of design on democracy. AIGA.org offers resources for every phase of your career, as well as providing client-friendly publications that explain the power of design to your clients and the public.

AIGA.org is intended to reflect the richness of the membership as a whole—it will only be as strong as you make it. The Journal and Design Forum offer the chance to contribute to impassioned and thoughtful conversations on a wide range of topics. Discussions on best practices, ethical issues and typography have already yielded rich resources with lasting value to the community.

AIGA members are encouraged to contribute to a case study archive of projects that highlight the strategic value of design <designing.aiga.org>. And now you can share images of your work with potential employers, potential clients and other designers. Online portfolios accommodate up to five project images as well as a personal statement, résumé and links <designjobs.aiga.org>.

Answering the challenge posed by Davis, type historian Charles Bigelow pointed out that, regardless of the technology she uses, every designer must draw on the accumulated experience and knowledge of those who came before. "Your job," he writes, "is to choose wisely." Choose AIGA.org and explore the past, discover inspiration, gain practical business and creative tips, voice your opinion and enable others to follow you into the future.

Overprinting inks on a sheet of folded newsprint, for a poster announcing an improved website at the AIGA, aims to be both vintage and futuristic, hinting at a new direction for this venerable organization.

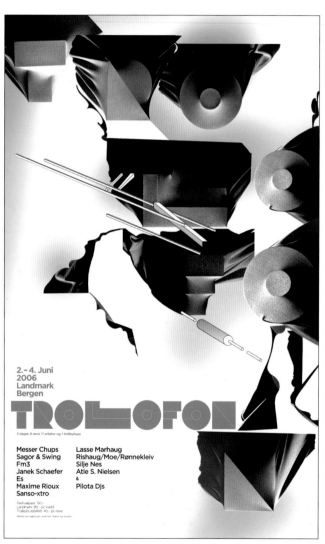

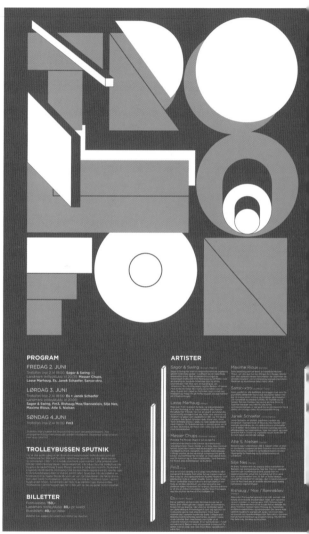

An ongoing identity project for Trollofon, the massive Norwegian music festival, includes posters, flyers and, in 2006, stage sets. The simple, block letterforms of the logo were transformed into large, wooden structures. These were then 'disguised' in stretchy spandex and pop-bright colours.

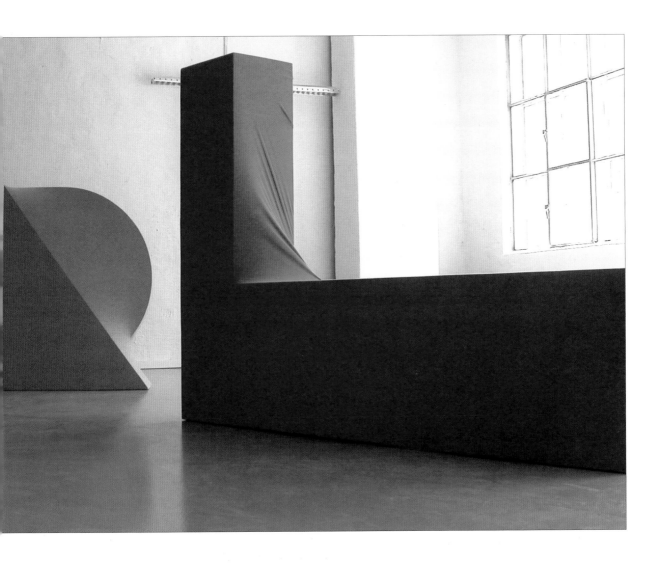

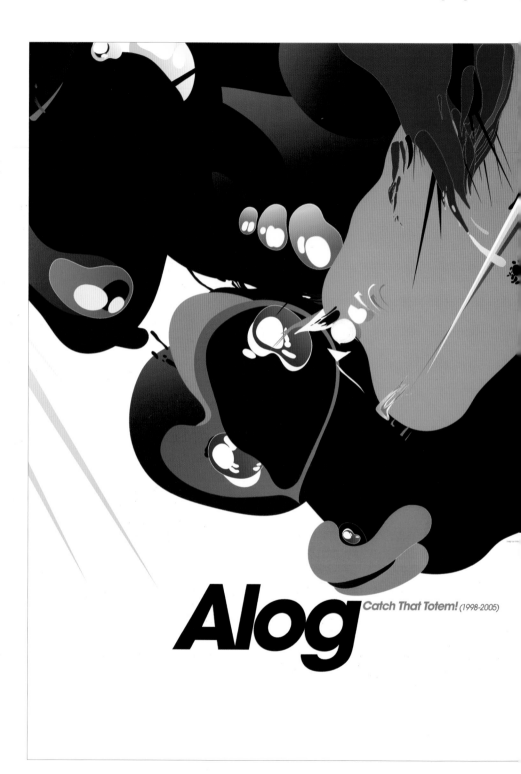

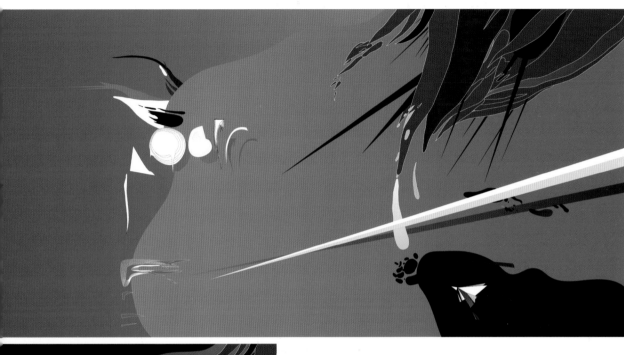

Alog are a renowned, electronic music act from Norway. Grandpeople's treatment for
'Catch That Totem!' came from a wish to maximize the band's image, rather than using
pared-down graphics – the more usual solution in the world of electronic music. Working
with inspirational words such as 'bubblegum', 'black metal' and 'summer', they created
visuals infused with psychedelic weirdness and a sort of friendly biomorphism.

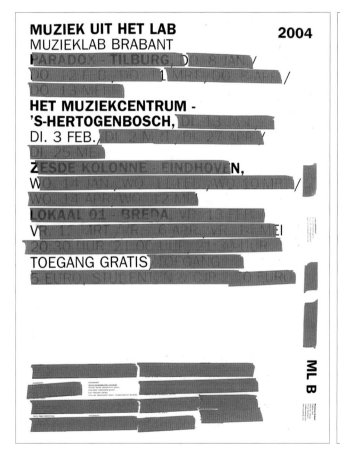

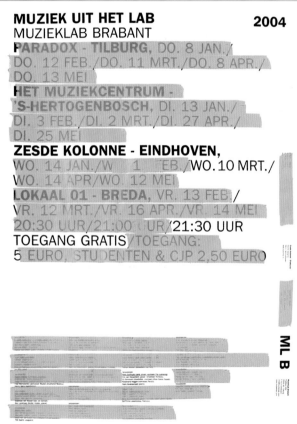

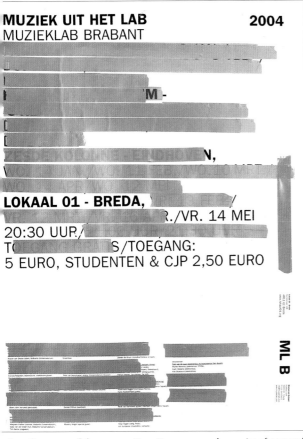

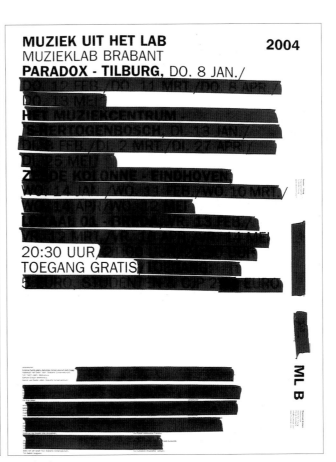

Over the course of three years, Hans Gremmen made a series of posters for MuziekLab Brabant, a music production company based in Tilberg, the Netherlands. For each series, Hans explored a new way of creating poster-sized graphics. The first used silkscreen printing on paper, the second mixed offset printing with Xerox copying on paper and this third series combined offset printing with coloured tape.

Karel Martens:
counterprint

Preface Carel Kuitenbrouwer

When I first saw a work of art by Karel Martens, in the mid-1980s, I was somewhat baffled. The sense of introverted idiosyncrasy conveyed by the meticulously arranged strips of printed paper were hard to reconcile with the radical severity of the image he had created for SUN Publishers in Nijmegen. I had not met him at the time.

Later, when I got to know his work better, the link between his non-commissioned and commissioned work became clearer. To me, at least, it coincides with the boundary between the conceptual and the concrete, abstraction and legibility, the applied and the idiosyncratic, prose and poetry. In particular, the architectural work he has produced in recent years clearly shows that his idiom is far broader than mere typography. This non-commissioned work, of which only a small selection is shown here, feels as though it was created out of an intrinsic necessity, without any exterior motive whatsoever. It was certainly not made in order to be reproduced – one more reason why Martens was so hesitant to be involved in this publication.

Martens very rarely exhibits these works (he would never call them art) and never regards them as finished, let alone sells them. In fact, one might well ask whether they are art. Frankly, however, the initiators and publishers of this booklet were less interested in such quibbles than in whether they could get the self-effacing maker to accept such publicity – which indeed took some effort. In the end it was the challenge of having to make something new rather than just reproduce something old, together with what I had come to know as his typically obliging nature, that persuaded Martens to take part.

The result, together with Paul Elliman's invigorating essay and Hans Gremmen's sound design, have – at least in my humble opinion – an interesting new whole.

This publication originated as the twenty-seventh in a series of 'documentaries' launched by the Eindhoven-based printing firm Lecturis in 1974. In the thirty years since the series began there has thus been almost one issue a year. The Lecturis documentaries have been distinguished in their treatment of a wide variety of topics in art and design, done with much more seriousness than is usual in the things that printers make for publicity purposes.

Following the success of the first Martens book, Karel Martens: printed matter / drukwerk, it seemed natural to make this one available to the English-speaking world. The title of the Dutch edition is weerdruk – a term from printers' language that has no easy translation. For the English title we have gone the direct, literal route.

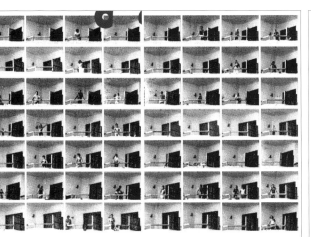

Counterprint is a book project, made in collaboration with the author, Karel Martens.
Printed at A4-size using fluorescent ink, the book deals with a number of different visual
and graphic elements, brought together by Hans into a dynamic but cohesive structure.

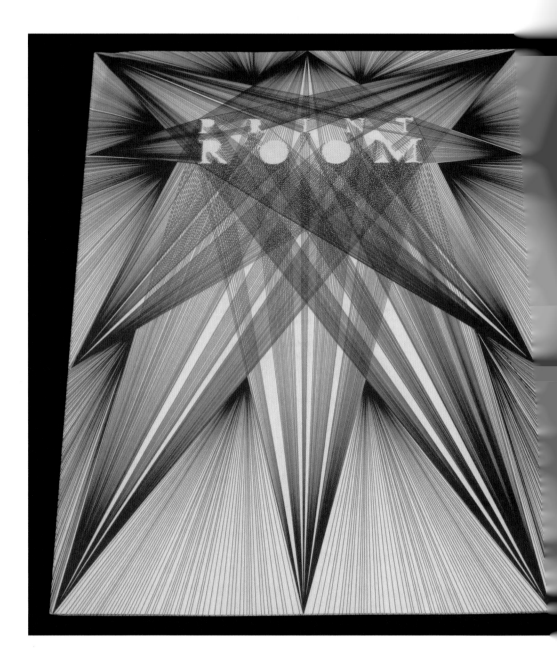

Hansje van Halem has produced a number of graphic projects with ROOM, an artist-run space in Rotterdam that stages projects, exhibitions and publications. PrintROOM is a growing collection of artists' publications, and the invitation featured here has lines drawn from various points on the page to the edges of the blank letter forms of 'ROOM', literally leaving a space for text. Drops in the Ocean is another invite, working with a similar system of converging lines, only this time the letter shapes are left blank within vertical and diagonal lines.

For the second edition of the Dutch graphic design annual *GreyTones*, Hans filled his eight-page section with quotes from the folktales of the merry trickster Tijl Uilenspiegel. Lines such as 'I imagine' become what Hans describes as 'a dream of an ideal place to be'.

zijn
and,
an
uis,
n
nk:

een land
waar men
stoute
verbeeldingen
onzinnige
verwachtingen
ijdele belofte
zaait.

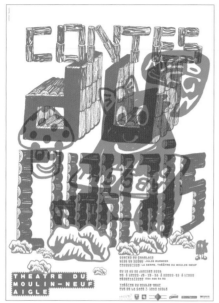

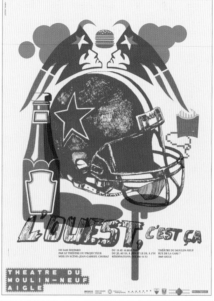

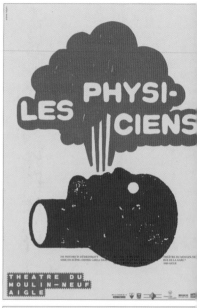

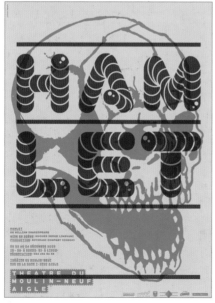

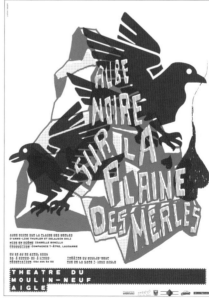

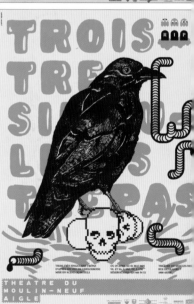

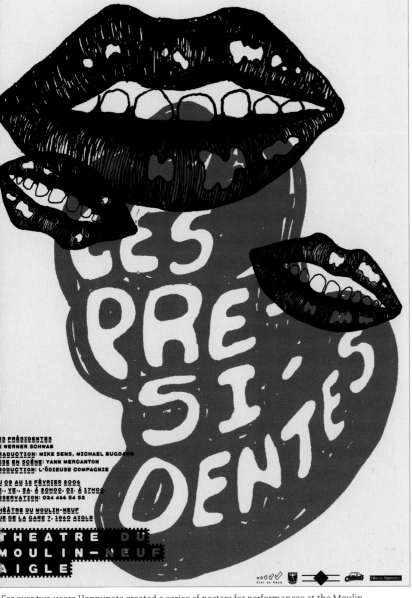

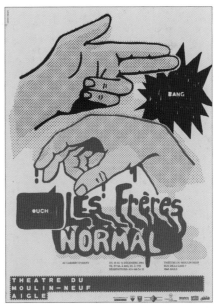

For over two years Happypets created a series of posters for performances at the Moulin-Neuf Theatre in Aigle, Switzerland. A mix of found imagery, hand-drawn lettering and doodled elements, overprinted in strong, primary colours and flat tones, are realized as large-scale, silkscreen prints.

A cover commission for *Res* magazine mixes various graphic languages including topological representation, crude computer icons rendered in bitmaps and dot-screens and super-flat silhouettes.

Another magazine illustration, this time for *Le Masque*, layers eye-popping colour
over retro erotica.

A keen self-publisher, Pierre Hourquet makes and sells graphic design products. His Grrr
T-shirt refers to the punk rock leather jacket aesthetic, with a nod to those kitsch 1970s
T-shirts printed with a facsimile of a dinner jacket. His series of Office prints, silkscreened
onto recycled paper and editioned through the Buy-Sellf Art Club, show line-drawn
scenarios for beating the boredom at work.

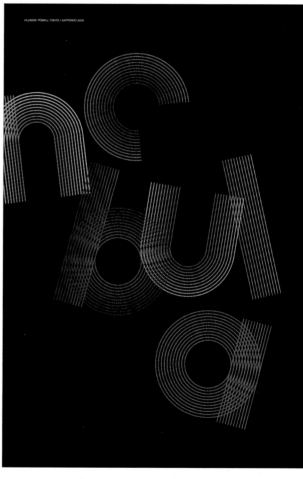

Shift magazine in Tokyo asked Hudson-Powell to curate an exhibition. They widened the original brief, and took the opportunity to develop a font-building application for the creation of dynamic screen-based type. A series of posters describe the interactive possibilities, while a T-shirt was also developed with the store, Beams T.

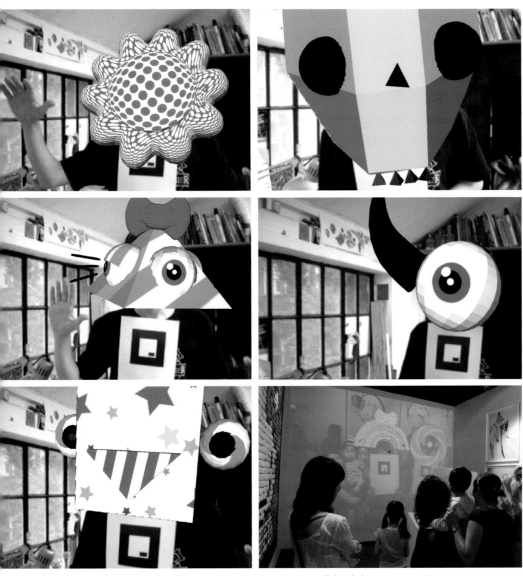

Asked to 'explore Kitty's world', for an exhibition in Hong Kong, Hudson-Powell decided to augment reality by tracking 3D shapes and faces onto real-time footage, allowing gallery visitors to see themselves as cartoon characters. The intention was to make people laugh!

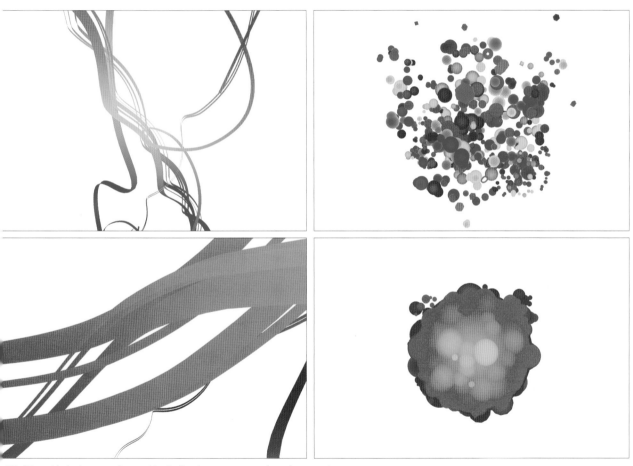

Working with design consultancy, North, the aim was to create brand support imagery to be used in various advertising media for client Carat, the digital media group. Action and motion, distilled into key words such as 'change', 'spectrum' and 'transformation', were realized as animated sequences with high-resolution stills to be used in print solutions. The end result reconsiders the structure and form of Carat's logo, while retaining the brand's character.

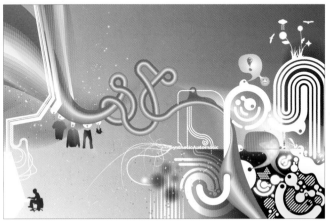

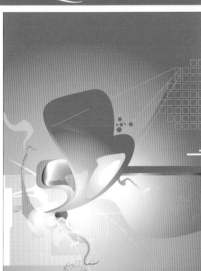

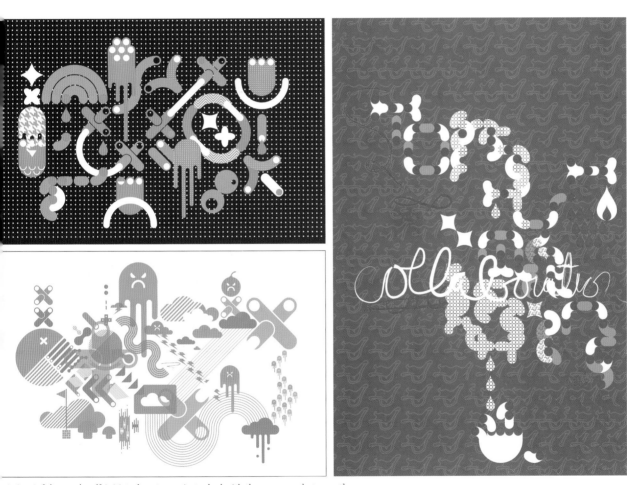

Apirat Infahsaeng's self-initiated poster projects deal with the crossover between the organic body and electronic technology during moments of inspiration, communication and expression.

Utilizing their highly decorative illustration style, Inksurge designed a number of items
for an exhibition of mixed-media work by graphic designers at Pablo Gallery in Manila,
including a laser-etched, chunky, wooden coffee-table/jigsaw.

Each track on this CD by Sandwich has been re-interpreted by Inksurge as an image and realized as a sticker. The package combines loose-leaf, matte card inserts with a distinctive colour scheme, hand-drawn lettering and a diverse catalogue of imagery.

Next Festival
is back to
town

Third time

nextfestival.net

Vilnius

For more info please check www.nextfestival.net or
demand additional information by calling
6-896-68127 or by writing a letter to info@nextfestival.net
More information in mass media soon.

Next Festival presents

NEXT FEST IVAL IS BA CK TO TO WN.
Vilnius

THIS YEAR, AGAIN.
Third time

nextfestival.net
2006.02.29

For more info please check www.nextfestival.net or
demand additional information by calling
6-896-68127 or by writing a letter to info@nextfestival.net
More information in mass media from 2006.02.15

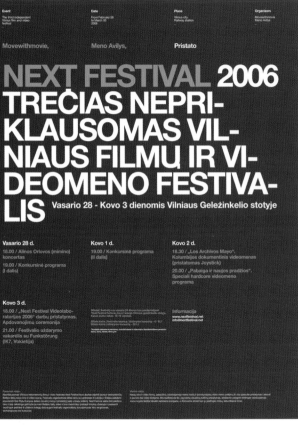

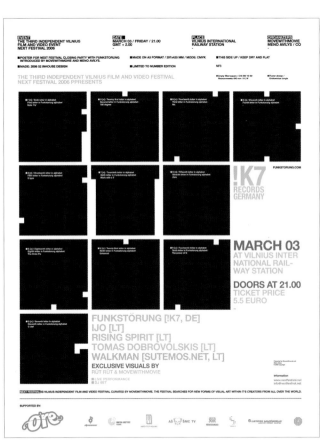

The Next Festival, an international, non-commercial short film and video event, is an ongoing project for It is blank. Each year the studio devises a different visual identity, designing posters, flyers, stickers, tickets and websites. For this, the third identity, the designers adopted a back-to-basics approach with a pared-down colour palette and classic, modern type.

Having worked with the small indie label Buzzin' Fly Records since 2003, IWANT have created an iconic identity, employing a 'Fly' pattern and their own Fly Font. For this compilation CD, the design brings together elements from recent twelve-inch record releases and was realized as a limited-edition CMYK print onto rough, reverse board, with a matte-blue block-foil print.

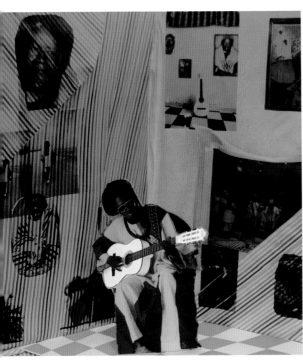

Working with critically acclaimed label, World Circuit Records, IWANT have created packaging and print for Senegalese artist, Cheikh Lô. Part of Cheikh Lô's belief-system is recycling, and IWANT ironed photographs onto old shirts, created a model, re-photographed it and combined two fonts — one inspired by the cut-and-paste aesthetic, the other by Cheikh Lô's handwritten faxes.

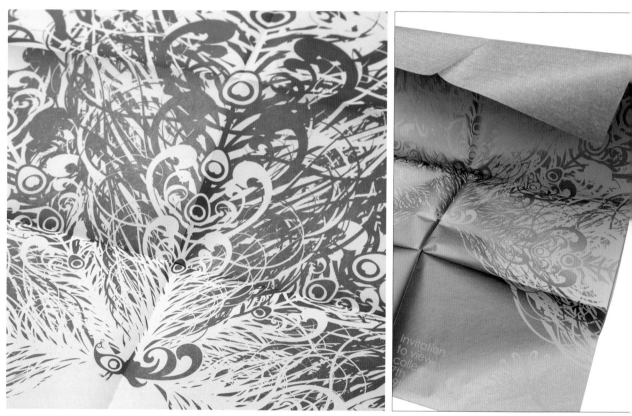

For fashion company Chiltern Street Studio, IWANT adopted a peacock image to represent the essence of fashion, while allowing the logo to change colour each season. White and gold feature in this company's work, so two invitations were printed metallic gold on Bible paper, and white ink screened onto gold-coated tissue.

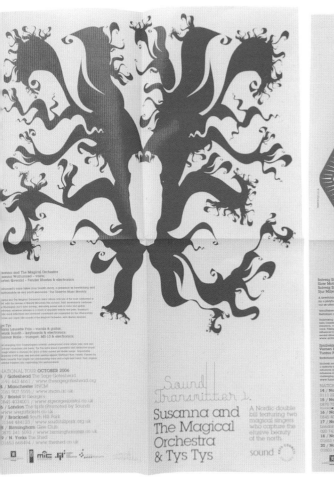

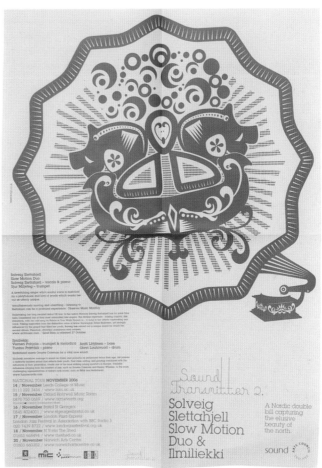

Sound Transmitter is a series of Arts Council sponsored tours of the UK of contemporary Nordic music. IWANT created an identity intended to capture the elusive beauty of Scandinavia, printing evocative illustrations onto delicate newsprint, which would then fold down from poster to flyer.

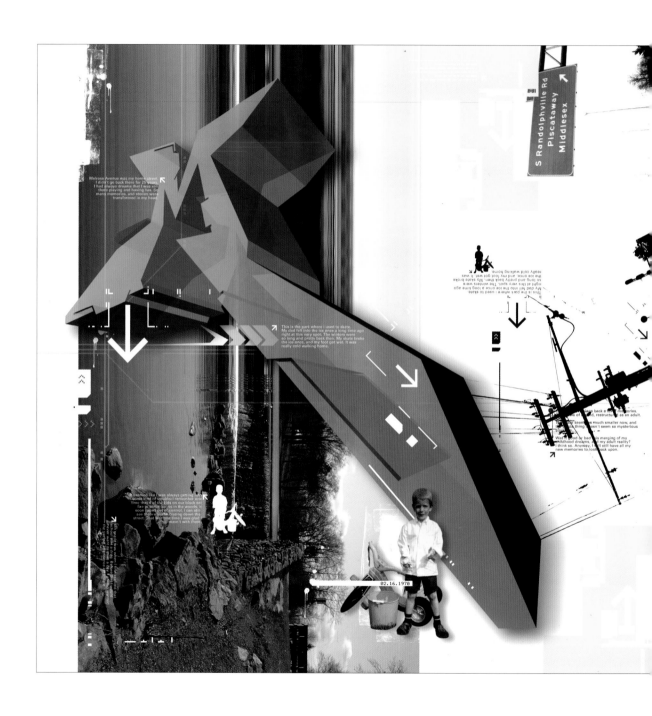

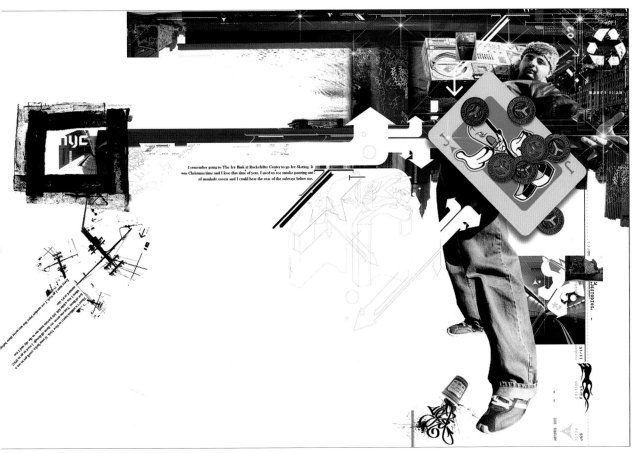

Setting out to create an entire graphic alphabet, which he describes as a 'Designed Diary', Jester of J6 Studios mixes stories, images and ephemera — including subway maps and freeway signage — to create atmospheric, photomontaged images. M relates to his hometown of Middlesex, New Jersey. N recalls early trips across the river to New York. Jester consciously mixes childhood recollections with his own imagined myths, juxtaposing them with modern imagery from more recent journeys.

i love sausage

Graphic designer and typographer Karen Jane takes her designs to the street, literally, by printing her distinctive catch-phrases on T-shirts, hoodies and stickers. Her one-woman enterprise also produces badges, bags, limited-edition prints and fonts, including the very pink and squidgy 'i love sausage'.

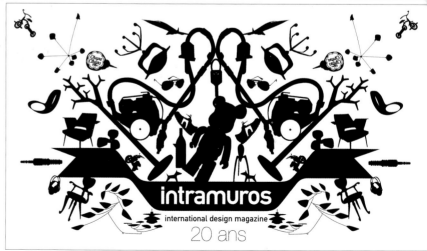

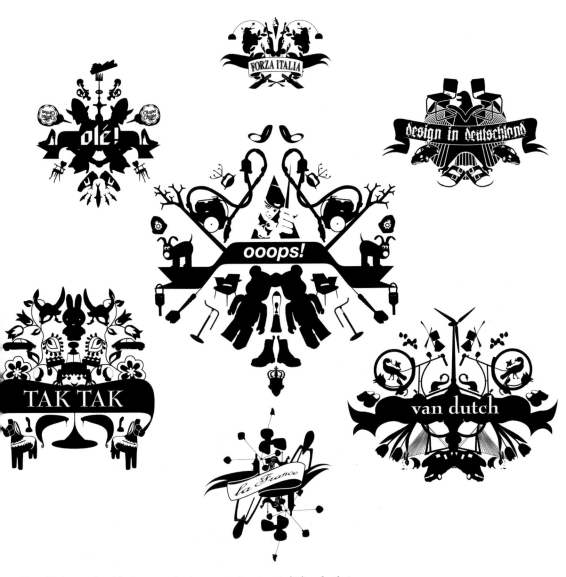

Working with international design magazine *intramuros*, June created a logo for their twentieth anniversary that translated across media, from business cards to the printed magazine. The strong black and white marque is constructed from carefully configured silhouettes of high-profile objects gathered from the canon of product design (and a few cute characters for luck). The decorative effect is intensified by the use of vibrant, clashing colours and overlays in the magazine.

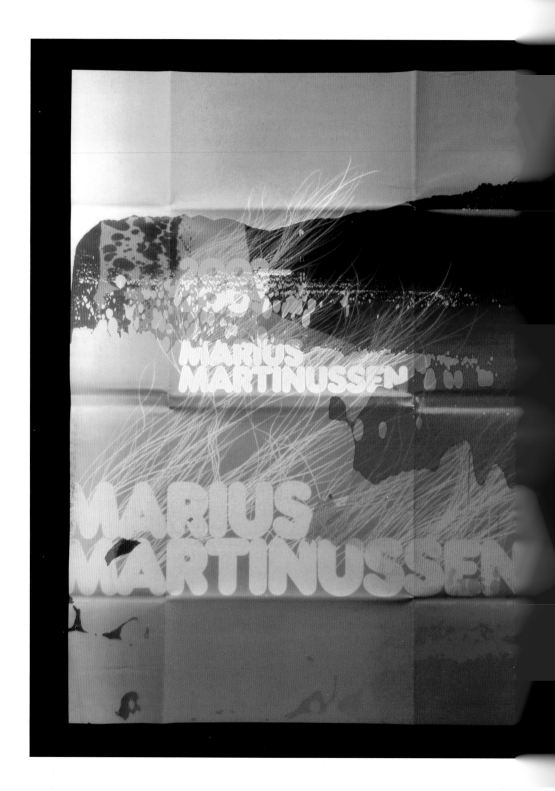

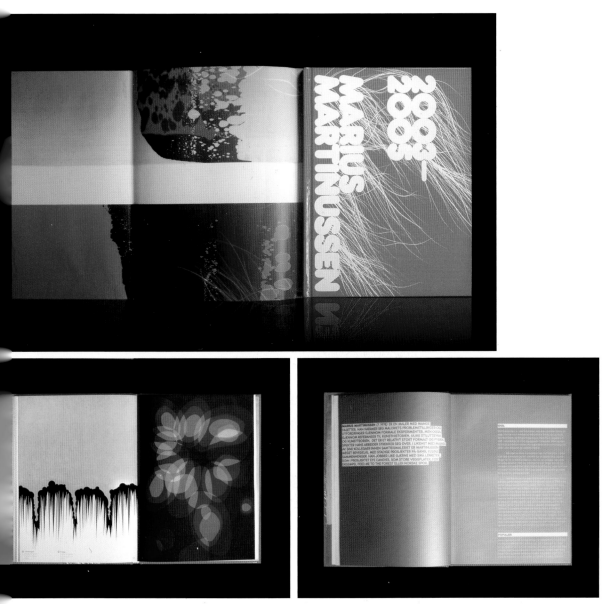

Karl Martin Sætren of Kallegraphics designed a catalogue for the painter Marius Martinussen showing his latest projects, from 2003 to 2005. The hardback book is wrapped with a folded poster jacket. Karl foregrounds the paintings, but stamps his mark on the book via a dynamic use of fifth-colour silver.

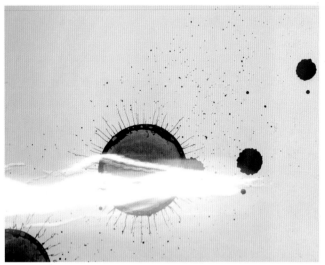
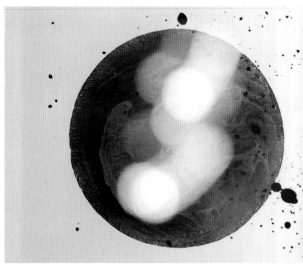
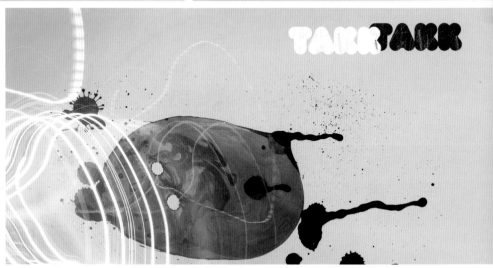

Karl designs numerous CD packaging projects for local bands and small record labels. This one contrasts random mark-making with 'accidental' lighting effects, and futuristic type.

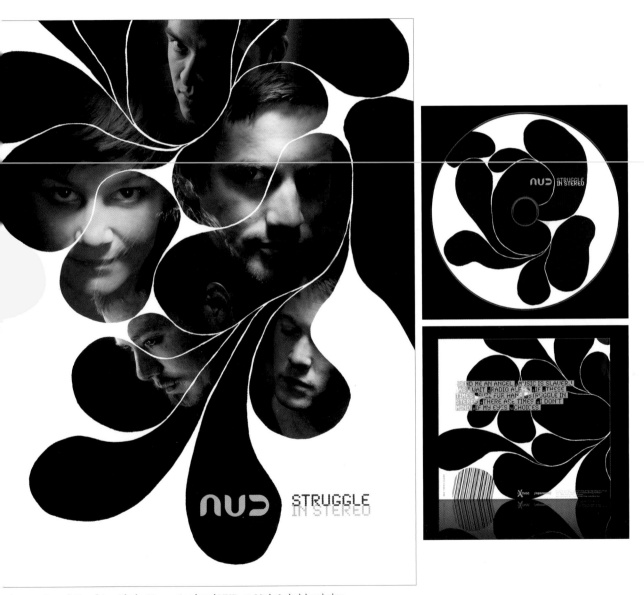

An on-going relationship with the Norwegian band NUD, on Little Label, has led to Karl designing covers for various releases. He employs an organic aesthetic, mixing both illustration and photography in the image-making process.

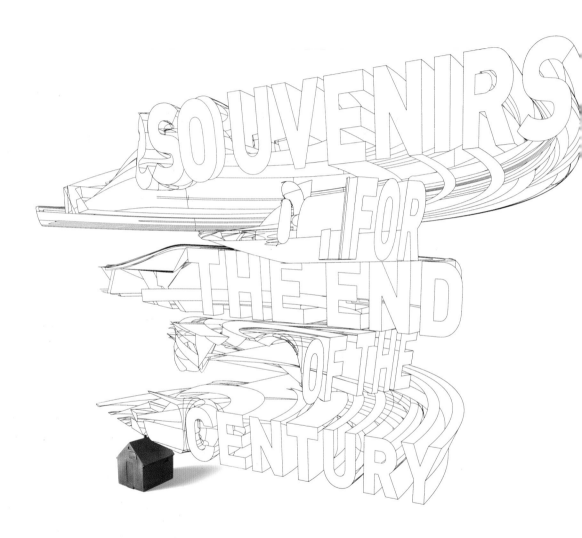

Working with New York-based product designer, Constantin Boym, the partners at karlssonwilker designed a poster to promote Boym's series of limited-edition objects, Buildings of Disaster and Missing Monuments, which are realized as desktop models in perfect detail. Hjalti and Jan's approach was to replicate a sense of their superfine detail by way of hand-rendered, yet monumental lettering.

Art directing and designing The Vines' 2002 debut release campaign, karlssonwilker opted for an urgent, sketchy graphic rendered in a high-visibility colour palette. These posters needed to stand out in the visual cacophony of New York's streets.

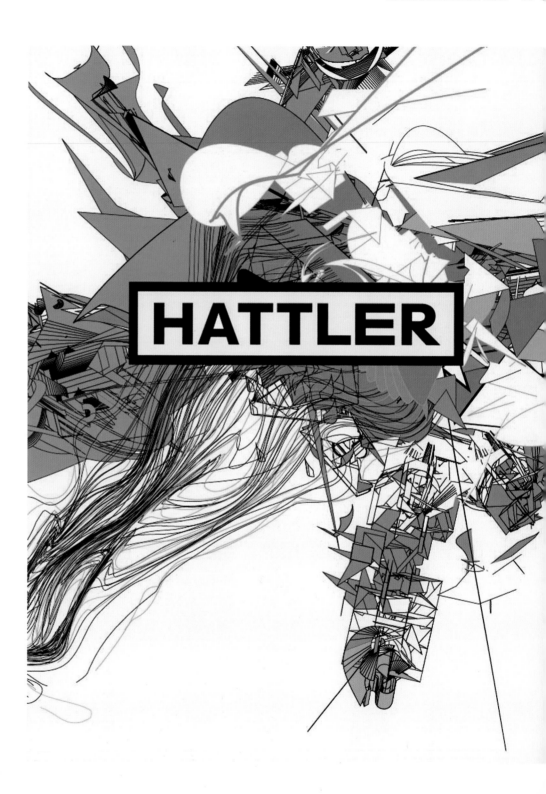

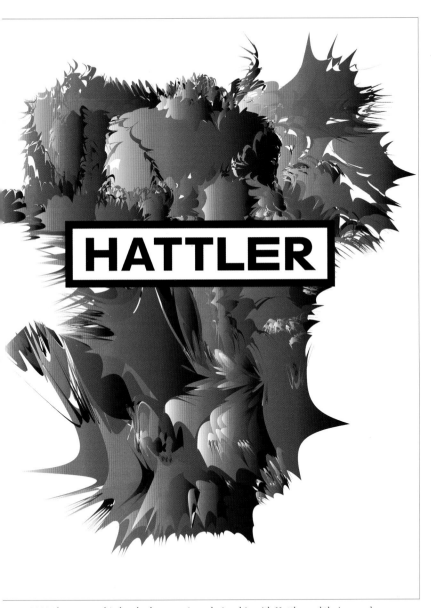

From 2003, the partnership has had an ongoing relationship with Hattler and their record company Baseball Records. They have created for Hattler a visual identity characterized by cutting-edge, digital illustrations overlaid with a logo that enforces its authority, whatever's going on in the background.

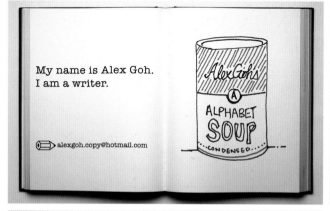

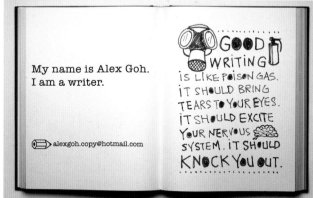

This series of name cards for writer Alex Goh demonstrates his versatility, sense of humour and inventiveness. Kinetic designed the cards with enough blank space for Alex to customize each one with a personal message for a potential client. The immediacy of the 'visualization' aesthetic guarantees that Alex's handwriting will never look out of place.

My name is Alex Goh.
I am a writer.

alexgoh.copy@hotmail.com

My name is Alex Goh.
I am a writer.

alexgoh.copy@hotmail.com

This Book Belongs to:

.

My name is Alex Goh.
I am a writer.

alexgoh.copy@hotmail.com

ONE IDEA IS NEVER ENOUGH

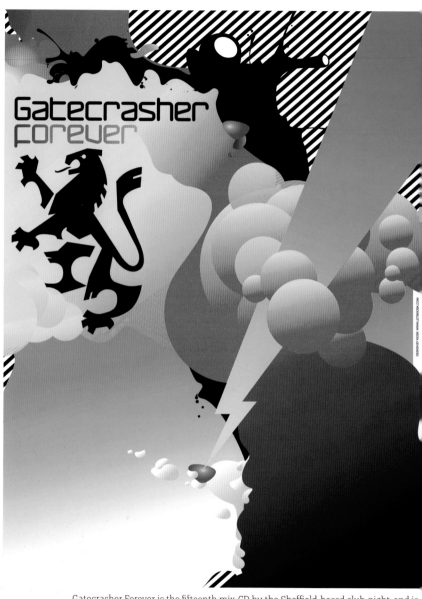

Gatecrasher Forever is the fifteenth mix-CD by the Sheffield-based club-night, and is released on London's Ministry of Sound label. Incorporating the club's 'hazard' markings, griffin logo and signature yellow, David Bailey of Kiosk added more psychedelic, organic elements pointing to new beginnings. For the CD of every egg a bird, the international music collective, Kiosk added their own mix and used an illustration originally intended as self-promotion on the cover.

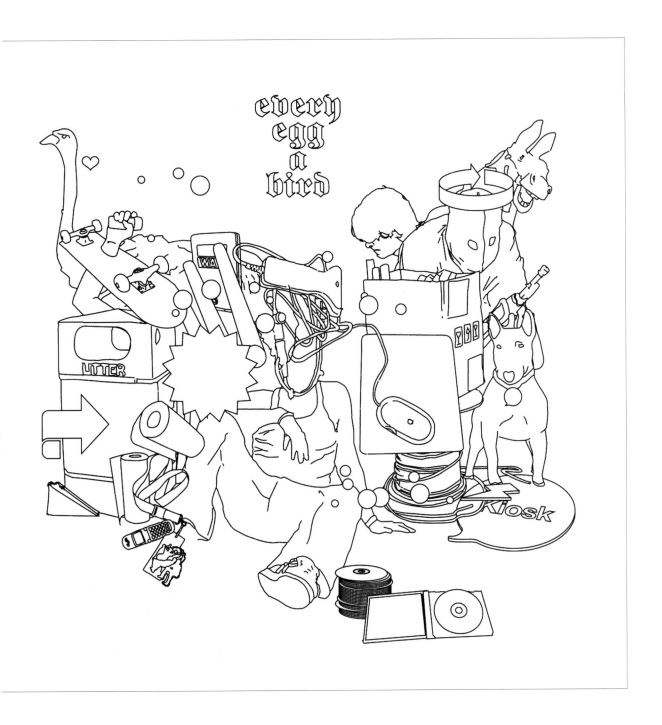

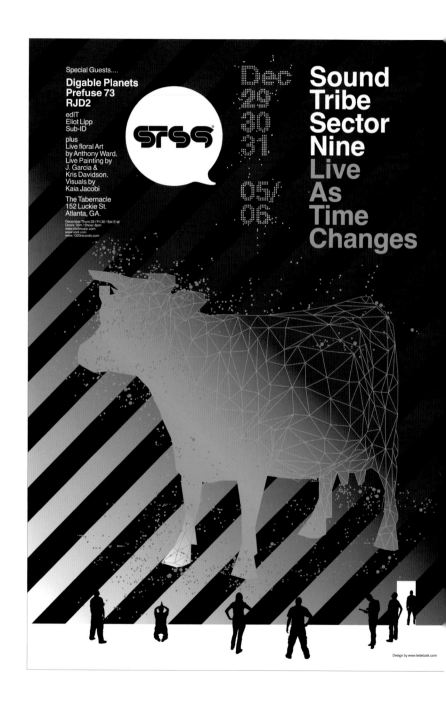

Sound Tribe Sector Nine commissioned Kiosk to produce promo posters and
merchandise for a series of gigs in Atlanta, Georgia. They extended the graphic treatment
to subsequent DVD packaging. For Addicted, a series of mix-CDs from Platipus Records,
Kiosk used photographs by Shaun Bloodworth of various set-ups of crime-scene
scenarios, and integrated typography into them.

For the audio book *Bambiland* by Elfriede Jelinek, Daniel Kluge designed a booklet and CD packaging, reflecting the subject matter dealing with the representation of the Gulf War by placing military symbols with cartoon imagery in an uncomfortable juxtaposition.

For the multi-media sculpture *My Band*, Daniel played snippets of street performers, recorded all over Europe, via mini LCD screens attached to microphone holders. The aim was to eliminate temporal and spacial differences and create a boundary-less 'jam session'.

A fictional monologue by Jackie Kennedy – in the form of an audio book read by Elfriede Jelinek – presents a self-image of the media heroine as a self-created artwork.

With Intermedium@utopiastation, Daniel combined a series of artworks into a giant mural to produce a video installation featuring a series of urban motifs that grow and mutate in sync with a rhythmic soundtrack.

Carolin Kurz and Ingrid Haug have developed and implemented the corporate identity for Schierke Photographers since 2002. This renowned agency, with offices in Frankfurt and Paris, represents some of the world's most sophisticated and celebrated photographers working across numerous genres. KURZ:HAUG showcase stunning images in this advertisement for *Le Book*.

DUMMY is a themed magazine published by a pair of journalists. Guest designers are asked to reconfigure the magazine to reflect a different topic for each issue. KURZ:HAUG designed the 'women' with their signature daring use of photographic imagery and cool type.

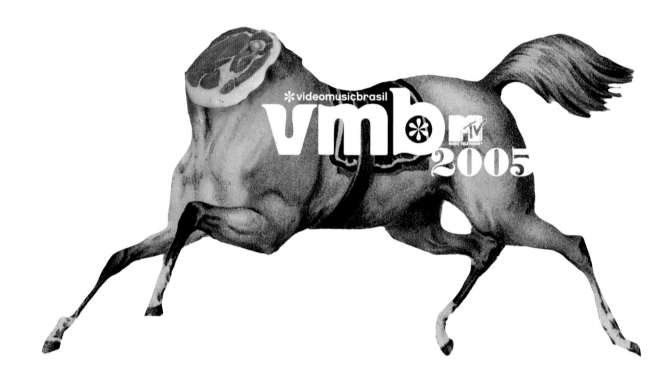

Having worked with MTV Brasil as a senior motion designer, Fernando designed, directed
and animated the annual awards logo and ident in 2005. He created macabre, surreal
imagery by collaging nostalgic ephemera.

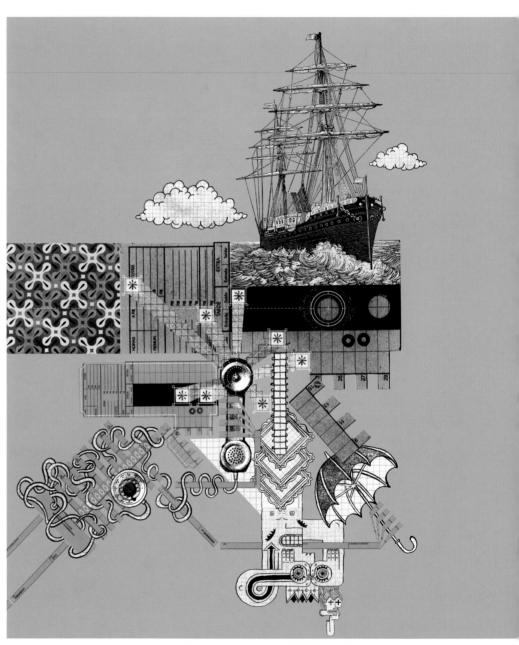

For Brazilian streetwear label VROM Complexo, Fernando created a number of print projects, including a book and this calendar, using his signature digital collage technique. It was printed on card with embossed silver details.

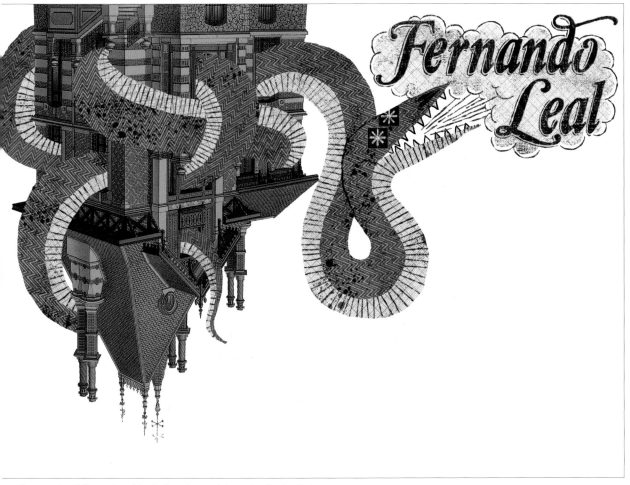

A self-promotional illustration, this displays Fernando's passion for detailed,
fantastical imagery.

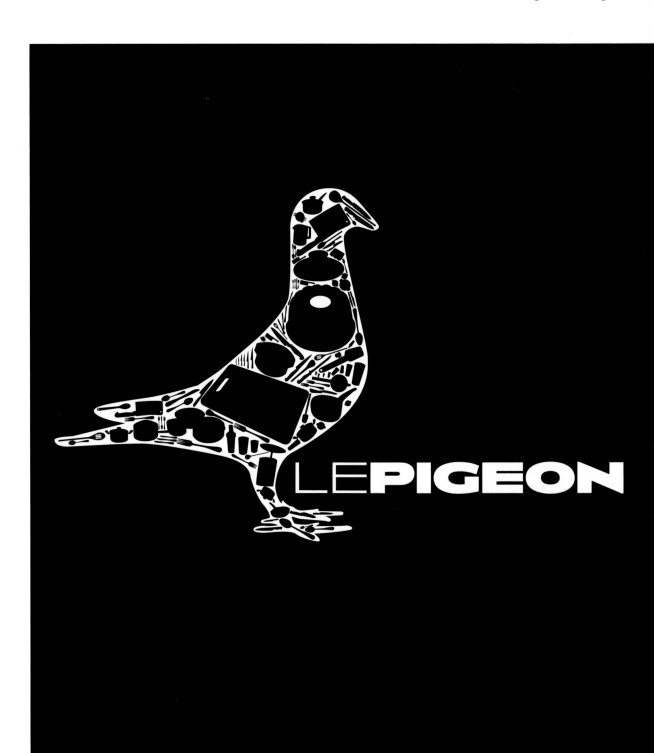

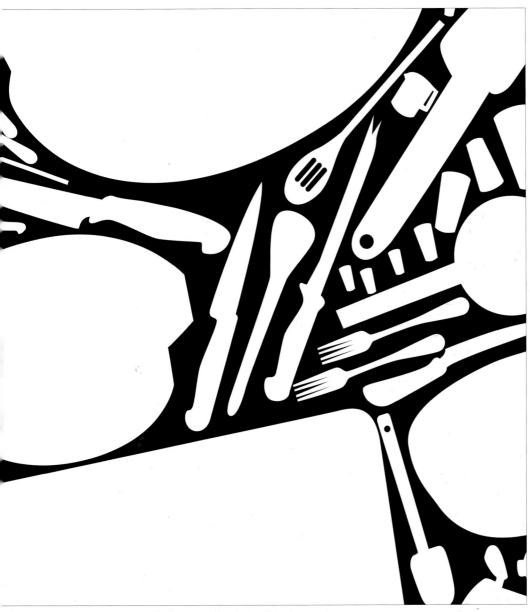

A low-key gourmet restaurant in Portland, Oregon takes the humble pigeon as its mascot.
The striking black-and-white silhouette hides a collection of kitchen utensils that
demonstrates the chefs' culinary expertise.

Ian Lynam demonstrates his technical know-how by building a Web 2.0 site for the urban culture magazine *Rap-Up*, using Ajax, xml and Flash software. Ian brings a broadcast-style sensibility to the visuals.

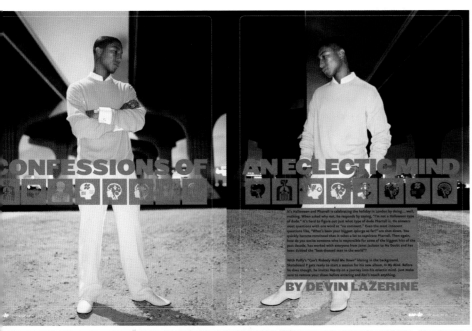

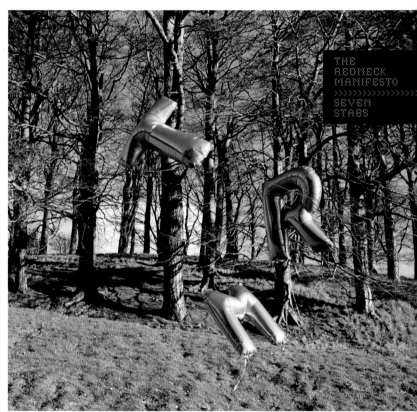

M&E divided up the creative duties on this project, with Matthew Bolger doing the illustration and design, and his partner Emelie Lidström taking the photographs. The Redneck Manifesto is a popular and experimental Irish band. Various visual languages were used on this project to create CD artwork, press photos, posters and limited-edition promotional packing for the album release.

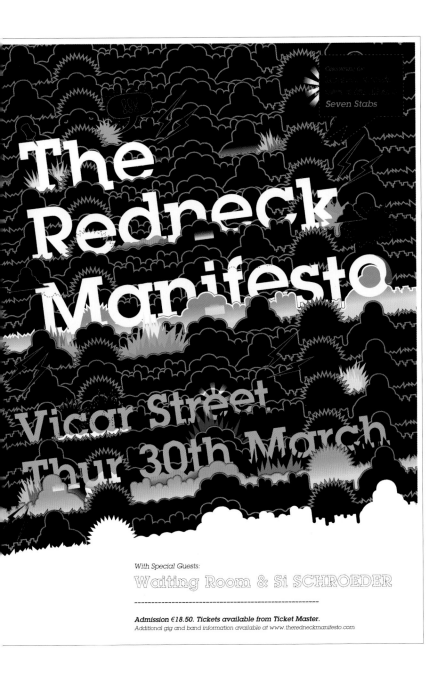

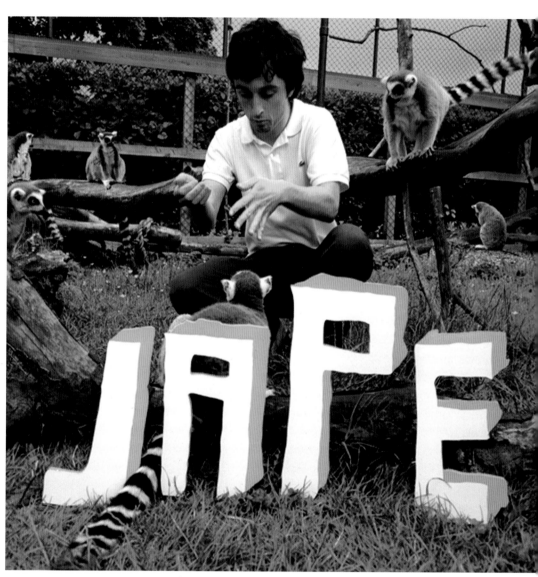

This CD package with eight-page booklet, featuring 'over-written' photography, is for an admitted eccentric – the singer Jape. The album is entitled *The Monkeys in the Zoo Have More Fun than Me.*

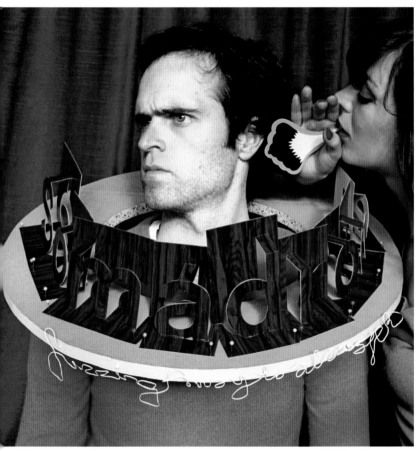

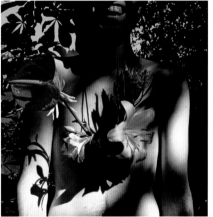

Combining paper sculpture with original photography, M&E montage together
a personalized fantasy world for this release by the electronic artist Somadrone.

01 360º **Abraka**

Gorgeous isn't Good enough – Carine Abraham,
JJ Tachdjian
Client: Feature Contemporary, ITD UK, fondation Pirelli (2005)

Geste 1 – Carine Abraham
Client: Nogoodindustry, France (2005)

Quoting William Burroughs, 'images, millions of
images, that's what I eat', Carine Abraham has been a
flamboyant collagist since 2004, working across media
and genre. She combines graphics with textile design
and interior decoration with video, typography and
illustration, borrowing elements from Art Nouveau
(she grew up in Nancy, a town embellished in that
style), Japanese aesthetics and a personal, highly
whimsical, visual language.

48 rue Léon Gambetta, 59000 Lille, France
carine.abraham@free.fr / abraka.com

02 360º **Accept & Proceed**

Oligarch/Ablute, Aqua Vitae, Altruism – David Johnston
Client: Oligarch (2006)

A&P by… – Concept: David Johnston
Illustration/Photography: Si Scott, Matt Johnstone,
Rory McCartney, Sarah Howell, Stephen Heath, J&D,
A Forest, Ben Wittner
Client: Accept & Proceed (2006)

A graduate of London's Central Saint Martins College
of Art and Design, David Johnston has worked in
London and Amsterdam for Overland (on fashion
footwear brands including Paul Smith and Caterpillar),
Interbrand and Nike (at their European HQ). He
returned to the south-coast seaside town of Brighton
to work with Red Design, purveyors of graphics to
music, fashion and leisure clients. In 2006 David set up
on his own to 'push boundaries, inspire and innovate'.

Studio 1, 66 Clyde Road, Brighton BN1 4NP, UK
info@acceptandproceed.com / acceptandproceed.com

03 360º **Alter**

Modular – Jonathan Wallace, Dan Whitford, Rick Milovano,
Leigh Maclellan
Client: Modular Recordings (2006)

Sparks – Jonathan Wallace, Dan Whitford, Rick Milovano
Client: Ism Objects (2006)

Established in 2000 by Jonathan Wallace and Dan
Whitford, this Melbourne-based studio reflects the
wide-ranging interests of its partners; Dan plays
in a well-known band, Cut Copy, and Jono lectures
in Visual Communication at Monash University.
Working with a roll call of local creative clients, Alter
produce print, websites and advertising campaigns for
architects, product and fashion designers, record labels
and bands. They mix an eclectic cut-up aesthetic with
a left-field sense of humour.

151 Union Street, Windsor 3181, Victoria, Australia
alter@alter.com.au /alter.com.au

04 360º **Matthew Appleton**

Afterlife – Matthew Appleton, Tom Lucas
Client: personal (2006)

Generation – Matthew Appleton, Alexandre Bettler,
James Graham
Client: Royal College of Art (2006)

Canadian-born Matthew trained as an architect at
Glasgow University and University College London,
and worked with Wilkinson Eyre before signing on
in 2003 for a Communication Art and Design MA at
the Royal College of Art. In the same year he set up
multi-disciplinary design practice MVOR; he works
individually and with a wide range of collaborators,
under the banner of m,a+j-studio and the narrative
illustration collective/magazine *LE GUN*.

Space Studios, 19 Warburton Road, London E8 3RT, UK
matt@mvor.com / www.mvor.com

05 360º **A Practice For Everyday Life**

Cineclub – Kirsty Carter, Emma Thomas
Client: Thomas Dane Gallery London (2005)

The Architects' Journal – Kirsty Carter, Emma Thomas
Client: Emap (2005)

Beck's Futures 2006 – Kirsty Carter, Emma Thomas
Client: Institute of Contempoary Arts (2006)

Village Fete 2005 – Kirsty Carter, Emma Thomas
Client: Scarlet Projects and Victoria & Albert Museum,
London (2005)

Kirsty Carter and Emma Thomas set up their
partnership, affectionately known as APFEL, in 2003.
With a practice firmly based in design for print, they
do, however, work across the genres of exhibition
and editorial design, events, publishing and products
on both personal and commercial projects. APFEL
specializes in working with clients from the creative
industries, including Tate Modern, the British Council
and the Institute of Contemporary Art, London.
Offering deceptively straightforward solutions, APFEL
subvert generic formats with a mix of bold typography
and low-key humour.

Unit 12A, 5 Durham Yard, London E2 6QF, UK
m@apracticeforeverydaylife.com /
apracticeforeverydaylife.com

06 360º **Attak**

Attak icons – Attak
Client: personal (2005)

Throwing gasoline – Attak
Client: personal (2006)

Paleiskwartier – Attak
Client: AKV/St Joost (2006)

Established in 2004 by Casper Herselman, Peter
Korsman and Tim van de Kimmenade, Attak are a
self-styled design collective, working to combine
clarity with experimentation. Happy to deal with print,
designing books, ads and brochures, they also work
with time-based media and digital means, on fonts,
websites and animation – often taking their cues
from street art and popular culture.

Oude Vlijmensweg 190C, 5223 GT 's-Hertogenbosch,
The Netherlands
attak@attakweb.com / attakweb.com

07 360° **Danielle Aubert**

58 Days Worth of Drawing Exercises in Microsoft Excel
– Danielle Aubert
Client: personal (2006)

With a degree in English Literature and an MFA from Yale University in Graphic Design, Danielle is a concept and ideas-driven designer. Before setting up her studio in 2005, she had worked in New York and Moscow (at Art.Lebedev Studio). She has lectured at the ATypI Conference in Helsinki, and teaches at the College for Creative Studies in Detroit.

1321 Orleans Street, 1109, Detroit, MI 48207, USA
mail@danielleaubert.com / danielleaubert.com

08 360° **BB/Saunders**

Jason Bruges – BB/Saunders
Client: Jason Bruges (2006)

Fashion Stories – BB/Saunders
Photography: Rankin
Client: Rankin (2006)

Established in 2004 by two previous members of Spin, Warren Beeby and Martin Saunders, BB/Saunders is now a team of six, specializing in design and branding. Working in partnership with film directors, copywriters and interactive and 3D designers allows them to express brands across all media, with no technical barriers to realizing ideas. Their aim is to produce both thoughtful and eye-catching solutions.

2nd Floor, 7 Plough Yard, London EC2A 3LP, UK
mail@bbsaunders.com / bbsaunders.com

09 360° **Beautiful/Decay**

Beautiful/Decay – Amir H. Fallah
Illustration: Skwak, Barry McGee (Deitch Products), Jesse LeDoux, Harmen Liemburg, Dust La Rock, Erik Parker, Made, Aaron Noble
Client: *Beautiful/Decay* magazine (2005-06)

Back in 1996, founder and creative director, Amir H. Fallah, printed the first issue of *Beautiful/Decay* magazine – 300 copies of his black-and-white zine – at Kinkos. Out of sheer exasperation at the compartmentalization of art, music and popular culture, Amir set out to bridge the gap between art and graffiti, hiphop and punk, underground and mainstream, illustration and graphics – all the while showcasing cutting-edge work. With each magazine spread treated as a unique design opportunity for collaboration and innovation, Amir has grown *Beautiful/Decay* into a sought-after and collectable artefact, and a trusted source for new ideas, talent and trends.

PO Box 461419, Los Angeles, CA 90046, USA
bd@beautifuldecay.com / beautifuldecay.com

10 360° **Alexandre Bettler**

Bread and Circus – Alexandre Bettler
Client: personal (2003)

Again! – Alexandre Bettler
Client: Again! (2005)

Hyperwerk – Alexandre Bettler, Karin Wichert
Client: Hyperwerk (2003)

DePLOY – Alexandre Bettler
Client: DePLOY (2005)

After gaining a BA at École Cantonal d'Art de Lausanne (ECAL) in Switzerland, Alexandre freelanced for three years before signing on at London's Royal College of Art for an MA in Communication Art and Design. Since graduating in 2005, he has featured in magazines and exhibitions, and lectured at the Forum Laus Europe in Spain. His work is informed by an intense interest in the minutiae of daily life; he focuses on the mundane in order to magnify overlooked beauty. Alexandre combined his passion for sustainability with a talent for events organizing when he staged an exhibition at the RCA, urging his fellow students to recycle.

The Bunkery, 238 Hoxton Street, London N1 5LX, UK
hello@aalex.info / aalex.info

11 360° **Nirit Binyamini**

House-Home – Nirit Binyamini
Client: Bezalel Academy of Art and Design (2005)

Block Magazine – Nirit Binyamini @ studio Gila Kaplan and Kobi Franco
Photography: Elinor Carucci, Decosterd and Rahm Associés, Ahlam Shibli, Adi Menahami
Client: Block Magazine (2005-06)

Educated at Jerusalem's Bezalel Academy of Art and Design, Nirit also studied in Madrid on a student exchange before returning to work in Tel Aviv. She set up as a freelancer in 2005, and has collaborated with Gila Kaplan and Kobi Franco. She has designed websites, posters, menus and more.

24A Hissin Street, Tel Aviv 64284, Israel
niritbin@gmail.com / niritnirit2000@yahoo.com

12 360° **Chris Bolton**

Lindstrom & Prins Thomas – Chris Bolton
Illustration: Juha Nuuti
Client: Eskimo Recordings (2005-07)

Make-Up – Chris Bolton
Illustration: Laura Laine
Client: Make-Up Club (2006)

Radio Slave/Creature of the Night – Chris Bolton
Illustration: Rami Niemi, Jesse Auersalo
Photography: Nina Merikallio
Client: Eskimo Recordings (2006)

Club Escalator/Part 1 and Part 2 – Chris Bolton
Client: Escalator Records (2005)

Educated in the UK and Canada, Chris Bolton is based in Helsinki, and perfectly placed to work with a range of directional European and Asian clients; from worldwide telecoms giant, Nokia, to avant-garde Japanese fashion house, Comme des Garçons, along with artists, bands and cultural institutions. Chris's aesthetic approach combines photography with surface pattern, strong typography and a bold use of colour.

Iso Roobertinkatu 10 A1. 00120 Helsinki, Finland
chris@chrisbolton.org / chrisbolton.org

13 360° **Bunch**

Sky Broadband – Bunch
Client: Brothers and Sisters, London (2006)

Ekran TV Awards – Bunch
Client: Vecernji List, Croatia

Nude – Bunch
Client: Ministry of Sound (2006)

Promax Awards – Bunch
Client: Promax UK (2006)

More than the sum of its parts, Bunch is a dynamic group of friends working across three offices, located in London, Singapore and Zagreb. Diversity of approach and lifestyle, married with an open-minded attitude to design solutions, is their unique strength. Eschewing any house style, and encouraging collaboration across offices, Bunch offer clients multi-cultural solutions without the worrying inconsistencies that occur when commissioning across territories. Clients are as diverse as the BBC, Diesel, Hewlett Packard and the Ministry of Sound.

Bunch London, 27 Phipp Street, London EC2A 4NP, UK
Bunch Singapore, 72 Monks Hill Terrace, Singapore 228153
Bunch Zagreb, Tomiceva 3/1, 10000 Zagreb, Croatia
info@bunchdesign.com / bunchdesign.com

14 360° **Circuit73**

Yoko Solo/the beeps – Todd Kurnat
Client: Quake Trap Records (2005)

Thumbtack Smoothie/fall back – Todd Kurnat
Client: Quake Trap Records (2005)

Creepy Little Anthems – Todd Kurnat
Client: Soultheft Records (2003)

Having relocated to San Francisco from America's mid-west, self-taught designer Todd Kurnat established Circuit73 in 2000. The design and illustration studio enables Todd to combine his love of music and image-making. As a producer, DJ and events organizer, he also works closely with Bay Area musicians and labels, including Robotspeak, Quake Trap and Beta Lounge.

904 Central Avenue, San Francisco, CA 94117, USA
todd@circuit73.com / circuit73.com

15 360° **Malcom Clarke**

3x3 Work in Progress
Design: Malcom Clarke, David Sudlow, dixonbaxi
Photography: Jason Tozer
Client: London College of Printing (2006)

Pigeon type
Design: Malcom Clarke
Client: personal (2006)

After completing an MA at the Royal College of Art, Malcom took up the role of Research Assistant in 2004, working on projects that explored the potential of both digital print and moving image. Malcom has made audio-visual installations, DVDs, books and catalogues, employing his skills across diverse media, including video, film, photography, screen-printing and letterpress. He also teaches graphic design in London and Southampton.

4 Brecon Close, Surrey KT4 8JW, UK
malcomclarke03@hotmail.com

16 360° **Cobbenhagen & Hendriksen**

Recruitment campaign
Design: Marijke Cobbenhagen, Chantal Hendriksen
Client: Jan van Eyck Academy (2006)

Marijke Cobbenhagen and Chantal Hendriksen met at the Werkplaats Typografie MA course in Arnhem in 2004, and have been collaborating ever since. Now based in Amsterdam, they design for print, with the goal of pushing content into new formal solutions. Working mainly for the creative industries, they have completed several projects for the prestigious Jan van Eyck Academy in Maastricht.

Willem Beukelsstraat 42, 1097 CT Amsterdam, The Netherlands
**chantal@cobbenhagenhendriksen.nl /
marijke@cobbenhagenhendriksen.nl /
cobbenhagenhendriksen.nl**

17 360° **Container**

Container stickers – Luise Vormittag, Nicola Carter
Client: personal (2005)

Project Fox – Luise Vormittag, Nicola Carter
Photography: diephotodesigner.de
Client: Volkswagen AG Germany / Eventlabs (2005)

Nicola Carter and Luise Vormittag met while studying Graphic Design at London's Camberwell College of Art, and established Container in 2003. They have illustrated for books and editorial, created window displays, redesigned a café at Selfridges department store, decorated hotel rooms and developed a prize-winning identity for MTV. The partnership also works on non-commercial projects – they have even built their own haunted house. Their highly decorative layering of illustrative elements adds up to a surreal world view. 'It's all in the detail', they admit.

Unit 96 Westferry Studios, 90-162 Milligan Street,
London E14 8AS, UK
info@container.me.uk / container.me.uk

18 360° **Coolmix**

okaycoolmix.de – Tim Schmitt, Johannes Spitzer
Client: Coolmix (2006)

Unregelmäßiges Muster – Tim Schmitt, Johannes Spitzer
Client: Coolmix (2006)

Tim Schmitt and Johannes Spitzer met at the University of Applied Sciences in Nuremberg, and began working together in 2001, while they were still students. Their first joint commission was to produce life-sized illustrations for the International Toy Fair in Nuremberg. Since then they have continued to explore, play and experiment using digital and traditional media. They established Coolmix in 2005 – even though they live in different cities – and have also worked under the name Formalismus.

Nuremburg, Germany
hi@okaycoolmix.de / okaycoolmix.de

19 360° **Jelle Crama**

Parts & Labor, Secret Puppets, Yuma Nora – Jelle Crama
Client: Berbati's, Portland (2005)

Jour Fixe – Jelle Crama
Client: Factor 44, Antwerp (2006)

Death Petrol Ibiza Acoustica – Jelle Crama
Client: Schelda'pen, Antwerp (2006)

Mouthus & Loosers – Jelle Crama
Client: Rotkot, Antwerp (2005)

Puik – Jelle Crama
Client: personal (2004-06)

A self-taught designer, Jelle Crama has a surreal take
on reality, cramming his designs with mutant creatures
and other-worldly apparitions. A musician and
entrepreneur, he stages events and club-nights and
publishes music through a number of record labels. A
self-confessed party animal, Jelle is a genuine one-off!

Begijnenstraat 52, 2000 Antwerp, Belgium
jellecrama@telenet.be / jellecrama.com

20 360° **Cut-up Design**

Mugshots – Jo Hogan
Client: Urban Outfitters (2002)

Irish-born, London-based designer, Jo Hogan
graduated with an MA in Typographic Studies from
the London College of Printing. Since 2003 she has
worked for a broad range of arts, culture and fashion
clients, including Urban Outfitters, NME and Rough
Trade Publishing. Establishing Cut-up Design in 2006,
she works in all media, producing record sleeves,
magazine layouts, flyers, zines and websites – all of
which are embellished with what she terms 'creative
typographics'.

11 Nettleton Road, London SE14 5UJ, UK
info@cut-up.co.uk / cut-up.co.uk

21 360° **Frédérique Daubal**

Welcome – Frédérique Daubal
Client: Arkitip (2002)

Eclaircie en fin de journée – Frédérique Daubal, Mario Guay
Client: Gas Shop (2003)

Frédérique Daubal trained as a graphic designer in
France and Canada, worked in London and later settled
in Amsterdam. Initially attracted to the Netherlands
because of its strong graphics heritage, she was
also inspired by the wider design culture, citing the
likes of Droog as an influence. She began making
clothes and printing textiles, moving from 2D to 3D,
encouraging her audience to interact with words and
images through wearing. Her garments make verbal
statements and stretch the limits of form, while being
both wearable and humorous. Now back in Paris, she
works across media, producing regular collections (of
T-shirts, dresses, knickers and more), which are sold
in shops around the world.

28 rue des Trois Frères, 75018 Paris, France
frederique@daubal.com / daubal.com

22 360° **deValence**

Robert Malaval – Alexandre Dimos, Gaël Étienne
Client: le Palais de Tokyo, Paris (2005)

Les circonstances ne sont pas atténuantes –
Alexandre Dimos, Gaël Étienne
Client: le Palais de Tokyo, Paris (2003)

Alexandre Dimos and Gaël Étienne studied graphic
design together at Valence's École Régionale des
Beaux Arts and the École Nationale Supérieure des
Arts Décoratifs in Paris. In 2001 they set up deValence,
moving into a refurbished factory, the Mains d'Oeuvres
(French for 'working class'), which is home to artists,
designers, musicians and creative companies.
They are also responsible for the building's graphic
communications. Using a down-to-earth approach,
tempered by visual experimentation and hands-on
making (e.g. hand-drawn type, photography, new book
formats), their design is a mass of contradictions. This
eclectic approach appeals to clients ranging from
avant-garde artists to luxury brands. 'We advise clients
on how they can speak for themselves; we propose
graphic answers.' Keen to raise awareness of the scope
of graphic design, deValence has established a non-
profit organization, F7, to stage lectures and publish
books and magazines on the subject.

Mains d'Oeuvres, 1 rue Charles Garnier, 93400 Saint-Ouen, France
everyone@devalence.net / devalence.net

23 360° **Dextro**

Microthol: microkosmos – Dextro
Client: Trust Records, Vienna (2006)

Animation – Dextro
Client: Cimatics, Belgium (2005)

Idea Magazine – Dextro
Client: Idea Magazine, Tokyo (2002)

Specialists in creating abstraction, and then applying
their experiments to graphic design solutions, Dextro
make 3D architectural imagery, algorithmic movement
for music videos, self-generating imagery, animated
wallpapers and interiors, interactive moving images
and more.

Postfach 59, 2500 Baden, Austria
dextro@dextro.org / dextro.org /turux.org

24 360° **dixonbaxi**

Zero – dixonbaxi
Client: personal (2006)

Sci Fi
Art direction: dixonbaxi
Photography: Mark King, Jason Tozer
Illustration: Steve Johnston, Jeff Wack
Client: Sci Fi Channel (2006)

The design and directing team of Simon Dixon and
Aporva Baxi work as creative directors for a number of
international clients, including MTV, VH1, Sony, NBC,
Universal and more. They are as happy designing a
logo and print material as they are directing a live-
action advertising campaign for television.

4D Printing House Yard, Hackney Road, London E2 7PR, UK
info@dixonbaxi.com / dixonbaxi.com

25 360º **Dress Code**

Register to Rock – Andre Andreev, G. Dan Covert
Client: Joe Jahnigen (2004)

VMA 05 – Andre Andreev, G. Dan Covert, Jeffrey Keyton,
Jim deBarros, Romy Mann
Client: MTV Off-Air Creative (2005)

Andre Andreev from Bulgaria and G. Dan Covert from
Ohio met on the BFA course in Graphic Design at
the California College of the Arts in San Francisco.
They set up Dress Code in 2004 after working at
X-Large, karlssonwilker inc., Odopod and MTV. As
well as teaching at New York's Pratt Institute, they
produce print and motion graphics for clients such
as Adobe, Nike, Fila and a host of independent record
and fashion labels. Their work has appeared in
many magazines, and among their many awards are
those from the AIGA, the Art Directors Club and the
magazines *Print* and *I.D.*

68 Richardson 504, Brooklyn, NY 11211, USA
casual@dresscodeny.com / dresscodeny.com

26 360º **forcefeed:swede**

etherfox – forcefeed:swede
Client: etherfox (2003)

Team Swede – forcefeed:swede
Client: Redmagic, Love Original (2006)

forcefeed:swede are a team of British designers
based in Australia working on projects as diverse
as snowboard graphics, vinyl toys, websites and
animation. Established by Oz Dean in 2003, work
by the studio has appeared in books and magazines
worldwide, and Oz regularly writes a column and
illustrates for *Computer Arts* magazine in the UK.
Design for Chunks is a side-project, an online gallery
of in-flight sick bags – this collaboration with Virgin
Atlantic in 2004 made Oz the first person to curate
an exhibition showing on a fleet of 26 planes for
six months.

4/24 Moore Street, Bondi, New South Wales 2026, Australia
studio@forcefeedswede.com / forcefeedswede.com

27 360º **Farhad Fozouni**

Le Joug et le Papillon – Farhad Fozouni
Client: Virguleidea.com (2005)

Trans Modern Music – Farhad Fozouni
Client: Tehran Experimental Orchestra (2005)

Based in Tehran since graduating from the city's Azad
University, Farhad Fozouni has worked across a variety
of media, producing posters, magazines, motion
graphics, studio sets and identities for television
shows, cultural festivals and magazines. Farhad's
design work has appeared in exhibitions
in China, Poland and the Czech Republic.

PO Box 19575-194, Tehran, Iran
fozouni@yahoo.com / farhadfozouni.com

28 360º **Hugh Frost**

Dada Manifest – Hugh Frost
Client: University of Brighton (2005)

The Hypochondriac – Hugh Frost
Client: personal (2005)

Sportsday Megaphone – Hugh Frost
Client: Industry (2006)

The Decadence Inherent – Hugh Frost
Client: University of Brighton (2005)

Hugh Frost graduated from the University of Brighton
in 2006 with a degree in graphic design and a series
of entrepreneurial endeavours already in the bag.
Co-publisher of *Math* magazine, an occasional,
catch-all, image-maker's showcase, and co-founder of
posikids!, a support network for young designers, he
has staged exhibitions, shot music videos for friends
The Maccabees and taken to the stage himself with a
laptop and keyboard. After a stint working at American
Apparel in Los Angeles, Hugh returned to London,
where he continues to produce posters, zines, T-shirts,
websites and more, with his distinctive mix of in-your-
face manifestos and exuberant entertainment. Clients
include *Dazed and Confused* and Nike.

Flat 5, 34-40 Sumerford Grove, London N16 7TX, UK
mathmagazine@hotmail.com / posikids.org

29 360º **Gaffa**

Popper type specimen – Paulus M. Dreibholz
Client: personal (2004)

Sketchbook – Paulus M. Dreibholz
Client: personal (2004)

Paulus M. Dreibholz came from Austria to London to
study graphic design, and eventually graduated from
Central Saint Martins College of Art and Design with an
MA in Communication Design. Previous to that he had
studied Law and Spanish in Graz. Established in 2004,
Gaffa enables Paulus to combine his teaching duties,
at Central Saint Martins, with designing publications
(a book for Coop Himmelblau, the magazine *.Cent*),
with websites, typefaces and exhibitions. Paulus
uses the practice of design to create a dialogue
between himself, the client and the end-user, in
an effort to evolve and progress ways and means
of communicating.

East Studio, 2 Pontypool Place, London SE1 8QF, UK
paulus@dreibholz.com / dreibholz.com

30 360º **George&Vera**

T-Bar – James Groves
Illustration: Matthew Green
Client: T-Bar London (2005-06)

Budgie With Ear – James Groves
Photography: Larry Dunstan
Client: Rude (2003)

Promise Promo – James Groves
Client: Promise Promo (2005-06)

In 2003 James Groves set up George&Vera, a studio
offering design and art direction predominately to the
fashion world. James creates retail design solutions,
advertising, branding and identity design for a range
of clients, from major brands such as Levi's,
Timberland Boot Company and Diesel to cutting-
edge labels, including Oliver Spencer, Lascivious and
Rude. Directional photography and an attention to
detail (focusing on paper stock, imaginative print
formats and refined typography) are George&Vera's
trademark. In late 2006, James was approached by
Third Eye Design, and transformed George&Vera into
the London arm of this successful fashion-led agency,
with the ability to offer transatlantic coverage, via
offices in New York, Glasgow and London.

4th Floor, 79-81 Paul Street, London EC2A 4UT, UK
james@georgeandvera.com / thirdeyedesign.co.uk

31 360° **Amirali Ghasemi**

Walking on the Clouds with Closed Eyes – Amirali Ghasemi
Client: Virgule performing arts company (2006)

photographic virtual exhibits – Amirali Ghasemi
Client: Parkingallery (2006)

A designer, photographer, curator and blogger of renown, Amirali Ghasemi was well established on Tehran's cultural scene, and internationally, even before graduating from Azad University with a degree in graphic design in 2004. However, he had already set up in 1998 the unique gallery/web presence, Parkingallery, for the promotion of a new generation of contemporary Iranian artists. Amirali has produced music videos, shot documentaries, taught web design classes (in the gallery), curated shows, been featured in a number of books and won awards – including Canada's Top Ten Blogs, for 'Live From the Iris', and in Taiwan for his poster designs. He also represented Iran in The Guardian Online's international art project 'Imagine.Art.After'.

11 Milad Chahar Street, Farahzadi Boulevard,
Shahrak-e-Gharb, Tehran 14686, Iran
amirialonly@gmail.com / **amirialonly.com**

32 360° **Giampietro+Smith**

Art Directors Annual – Rob Giampietro, Kevin Smith
Client: Art Directors Club (2006)

aiga.org – Rob Giampietro, Kevin Smith
Client: AIGA (2004)

Established in 2004 by Rob Giampietro and Kevin Smith, this design consultancy is happy working across industries and genres. Working for cultural, non-profit and corporate clients, ranging from the AIGA and Gagosian Gallery to the Global Fund to Fight AIDS to General Electric and New York University, the partnership also regularly collaborate on editorial projects with the *New York Times*, *Print* magazine and others, and with artists Damien Hirst, Lauren Greenfield and Marcel Dzama.

195 Chrystie Street, No. 402F, New York, NY 10002, USA
info@studio-gs.com / **studio-gs.com**

33 360° **Grandpeople**

Trollofon – Grandpeople
Client: Trollofon (2006)

Alog/Catch That Totem – Grandpeople
Client: Melektronikk (2005)

A partnership of Magnus Voll Mathiassen, Magnus Helgesen and Christian Strand Bergheim, Grandpeople offer a range of skills to clients at home in Norway, and abroad. Declaring, 'Design. Art Direction. Shapes and Colours since 2001', Grandpeople play with pop culture references, while mixing their typographic and illustration skills to produce lyrical, painterly and hand-made solutions for projects in the music, entertainment and creative industries.

Møllendalsveien 17, N-5009 Bergen, Norway
magnus@grandpeople.org / **grandpeople.org**

34 360° **Hans Gremmen**

MLB third series – Hans Gremmen
Client: MuziekLab Brabant (2004)

Karl Martens: counterprint – Hans Gremmen
Client: Lecturis BV, Eindhoven (2004)

Working solo since 2002, Hans Gremmen is a graduate of both graphic design and typography courses. His work gravitates towards the arts. He has designed catalogues for the Stedelijk Museum, collaborated with artists Roger Willems and René Onsia and is a member of photography collective Fw, for which he edits and designs a regular publication. An educator and lecturer, he contributes to OBKComp, a discussion group reviewing the use of computers in art schools. In 2006 he participated in *inside out*, an exhibition of young, Dutch graphic designers, curated by Armand Mevis.

Amstel 242 sous, 1017 AK Amsterdam, The Netherlands
post@hansgremmen.nl / **hansgremmen.nl**

35 360° **Hansje van Halem**

PrintROOM – Hansje van Halem
Client: Room, Rotterdam (2004)

Drops in the Ocean – Hansje van Halem
Client: Room, Rotterdam (2004)

GreyTones 2 – Hansje van Halem
Client: Design week, Eindhoven (2005)

A graduate of the Gerrit Rietveld Academie in Amsterdam, Hansje van Halem has regularly featured in exhibitions and awards contests since 2003. Highlighting his predilection for editorial design, Hansje's work has been lauded in the prestigious Most Beautiful Books competition, as well as in exhibitions at the Witte de With Centre for Contemporary Art and Nederlands Architectuurinstitut (NAI) in Rotterdam.

Berberisstraat 16, 1032 EL Amsterdam, The Netherlands
hansje@hansje.net / **hansje.net**

36 360° **Happypets**

Theatre – Happypets
Client: Moulin-Neuf Theatre (2004-06)

Res – Happypets
Client: Res (2004)

Le Masque – Happypets
Client: Le Masque (2004)

Vibrant colours, witty illustrations, hand-printed, hand-drawn, cute and cuddly, Happypets really do live up to their name! Whether they are making limited-edition T-shirts, rubber-jacketed books, large-scale posters, entertaining exhibition installations, flyers or stickers, their bold, colour-separated, layered aesthetic mixes found imagery with hand-rendered lettering and the most personal of doodles. Happypets have carved a unique niche for themselves working on a friendly, small scale; meanwhile, thanks to their contributions to books and conferences, they have gathered a worldwide audience of fans.

3 Avenue du Tribunal-Fédéral, 1005 Lausanne, Switzerland
info@happypets.ch / **happypets.com**

37 360° **Pierre Hourquet**

Grrr – Pierre Hourquet
Client: Hey Ho Let's Go (2005)

Office – Pierre Hourquet
Client: Buy-Sellf Art Club, Marseille (2006)

Pierre Hourquet gained a Master of Design degree
from Bordeaux's École des Beaux Arts, and now lives in
Paris working as a freelance designer. His typographic
wall pieces and witty/macabre soft sculpture have been
exhibited at galleries in Paris and Marseille – including
the Lazy Dog – and feed into his commercial work,
which includes '3D graphics' for magazine photo
shoots, stage set design, short-run T-shirts, limited
edition silkscreen prints and hand-made books. His
work bristles with the in-your-face attitude of punk
and the energy of street culture.

10 rue Vauvenargues, 75018 Paris, France
pierrehourquet@free.fr / pierrehourquet.free.fr

38 360° **Hudson-Powell**

Responsive Type – Hudson-Powell
Client: Shift Magazine, Tokyo (2005)

Kitty's wizard mirror – Hudson-Powell
Client: All Rights Reserved, Hong Kong (2006)

Carat – Hudson-Powell
Client: North (2006)

Established by brothers Jody and Luke Hudson-
Powell in 2005, the studio later expanded into Tokyo,
after exhibiting their Responsive Type project
around Japan. The brothers both studied graphic
design at London's Central Saint Martins College of
Art and Design, with Jody going on to an M.Sc. in
Virtual Environments at the city's Bartlett School
of Architecture. After working at a number of large
companies, and directing a promo for PJ Harvey, they
decided to incorporate more of their 'outside' interests
into their studio practice and set up Hudson-Powell.
With an eye to new technology and working across a
range of platforms, they have completed projects as
diverse as branding, motion graphics, model making,
programme development and interactive installations.
Clients include Timberland, Diesel, Beams T, Island
Records and Nickelodeon.

4-5-12-103 Aobadai, Meguro-Ku, Tokyo 153-0042, Japan
4 Sunbury Workshops, 25 Swanfield Street, London E2 7LF, UK
studio@hudson-powell.com / hudson-powell.com

39 360° **Apirat Infahsaeng**

Ventricle
Chin Up
Synthetic Automatic
Like, Like, Like
Amenities:Creature
Amenities:Gamer
Storytelling
Illustrations: Apirat Infahsaeng
Client: personal (2006)

After studying art at university in rural Connecticut,
Apirat Infahsaeng began practising as a graphic
designer in 2004. With a wide interest in technology
– old and new, music, science fiction and gaming – he
has used his eclectic tastes to create a unique graphic
language, marrying organic and electronic elements
and visuals. He creates self-initiated projects, works
for clients across the USA and participates in Ogilvy
& Mather's Brand Integration Group in New York City.

181 Nassau Avenue, No.1, Brooklyn, NY 11222, USA
ai@apirat.net / syntheticautomatic.com

40 360° **Inksurge**

Pabhaus – Rex Edward Advincula, Joyce Tai
Table design: Doy Lagos
Client: Pablo Gallery (2006)

Sandwich/Five on the Floor – Rex Edward Advincula,
Joyce Tai
Client: EMI Philippines (2006)

After working for various companies, Joyce and Rex,
self-confessed coffee junkies who like to get up late,
set up Inksurge in 2002. With the aim of collaborating
with other creatives, they also established Schema,
'an experimental pad', and have consistently won
awards for best creative outlets and websites in their
hometown of Manila. Their output includes collections
of T-shirts and badges along with animations,
websites, illustrations and identities in their
distinctive, highly decorative style.

171 Cordillera Street, Sta Mesa Heights, Quezon City 1114,
Philippines
broadcast@inksurge.com / inksurge.com

41 360° **It is blank**

Next Festival 3 – Paul Paper, Jurgis Griskevicius
Client: Next festival (2004-06)

Having worked together since 2003, photographer
Paul Paper and designer Jurgis Griskevicius decided
in 2006 to form the multi-disciplinary studio, It is
blank. Their first major project, a website and graphic
identity for the musician Michael Fakesch, one half
of Funkstörung, led to a sudden influx of projects,
including work for the fashion magazine *Melynas*
and the Next Festival of short film and video.

Savanoriu pr. 36-74, 03120 Vilnius, Lithuania
talk@itisblank.com / itisblank.com

42 360° **IWANT**

Buzzin' Fly – John Gilsenan, Bruce Allaway
Client: Buzzin' Fly (2006)

Cheikh Lô/Lamp Fall – John Gilsenan, Bruce Allaway
Client: World Circuit (2005)

Chiltern Street Studio – John Gilsenan, Bruce Allaway
Client: Chiltern Street Studio (2006)

Sound Transmitter – John Gilsenan, Bruce Allaway
Client: Arts Council, England (2006)

John Gilsenan and Bruce Allaway met while working
at Cog Design, and became friends before John left
to travel and freelance in Prague. By 2003 he was
back; Bruce left Cog and the pair set up IWANT.
From the start the partners aimed to stick to projects
that inspired, so as to 'create beautiful things'. Their
enviable client list is split between music, fashion, arts
and charities, boasting Virgin, Paul Smith, the Arts
Council and Oxfam as satisfied customers.

172 Stoke Newington Church Street, London N16 0JL, UK
info@iwantdesign.co.uk / iwantdesign.co.uk

43 360° **J6 Studios**

M – Tim Jester
Client: personal (2005)

N – Tim Jester
Client: personal (2002)

Tim Jester – or just JESTER – is a native of New Jersey, now settled in Houston, Texas. After a childhood dominated by graffiti, skateboarding and punk rock, and nine years in the American military, Jester enrolled at college, started a family and set up J6 Studios. A keen observer of popular culture and the urban environment, Jester loves seventies fusion, Led Zeppelin, Spaghetti Westerns and the seminal cop show, *Columbo*. Along with drumming, knife throwing and skateboarding, Jester supports local graffiti artists and has created self-initiated projects that investigate memory and place.

1001 Omar, Houston, TX 77009, USA
info@j6studios.com / j6studios.com

44 360° **Miss Karen Jane**

Not Bad For a Girl – Karen Jane
Client: Not Bad For a Girl (2006)

i love sausage – Karen Jane
Client: personal (2005)

With her tongue-in-cheek humour and a love of typography mixed with a deep knowledge of popular culture, Karen Jane has won some big name clients, such as Coca-Cola, Nike and Sony Playstation, since setting up on her own in 2005. A graduate of Brighton University and London's Royal College of Art, Karen has developed an extensive network of contacts and collaborators, and a keen entrepreneurial sense, which converts personal projects into products – i.e. a range of T-shirts and badges.

33c Pepys Road, London SE14 5SA, UK
kj@karenjane.com / karenjane.com / notbadforagirl.com

45 360° **June**

intramuros – June
Client: intramuros magazine (2005)

Established in 2006, June's mission is to explore the convergence between 2D and 3D design – product and spacial design alongside new forms of graphics and web-based technologies. With previous experience working across a range of media, the studio aims to combine information and ergonomics, using an intuitive approach to technology to create simplified, user-friendly interfaces for a range of products and services.

1 Bis av. de la Folie, 95169 Montmorency, France
june@designjune.com / designjune.com

46 360° **Kallegraphics**

Marius Martinussen – Karl Martin Sætren
Client: Marius Martinussen (2006)

Tara/Plain as Coal – Karl Martin Sætren
Photography: Kristine Jakobsen
Client: Berland Production (2006)

NUD/Struggle in Stereo – Karl Martin Sætren
Photography: Ragne Sigmond
Client: Production Speciales (2006)

Karl Martin Sætren describes himself as 'an unknown multi-talented artist' who is happiest when he is making images. In fact Karl has two design personas; during the day he works at Mission Design, but in the evenings and weekends he becomes Kallegraphics. Because of time constraints, Karl only takes on projects that are challenging, exciting and provide an opportunity for him to develop his design approach and visual aesthetic. Based in Oslo, he works mainly for Norwegian clients, designing for independent music companies and artists, making websites, posters, packaging, catalogues, flyers and illustrations. He is a keen collaborator, tapping into the local talent pool of web developers and photographers.

Motzfeldtsgate 28, 0561 Oslo, Norway
email@kallegraphics.com / kallegraphics.com

47 360° **karlssonwilker inc.**

Buildings of Disaster – Hjalti Karlsson, Jan Wilker
Client: Boym Partners, Inc (2001)

The Vines – Hjalti Karlsson, Jan Wilker
Client: Capitol Records (2002)

Hattler – Hjalti Karlsson, Jan Wilker
Client: Baseball Records (2003-06)

Jan Wilker, from Ulm, Germany, and Hjalti Karlsson, from Iceland, talked about setting up karlssonwilker in the heart of Manhattan while Jan was still a student. By the summer of 2001, Jan was in New York full time and with the help of a trusty intern, karlssonwilker have become a stalwart of the New York design scene, amassing an eclectic client list, including such New York cultural institutions as the Museum of Modern Art (MOMA) and the Guggenheim, as well as MTV, the *New York Times Magazine* and Puma. They are well known on the lecture circuit, regularly teach and occasionally stage rooftop parties. In 2003, Princeton Architectural Press published a book of their first two years' projects, entitled *Tellmewhy*.

536 6th Avenue, 2nd and 3rd Floor, New York , NY 10011, USA
tellmewhy@karlssonwilker.com / karlssonwilker.com

48 360° **Kinetic**

Books – Kinetic
Client: Alex Goh

In 2001 Roy Poh and Pann Lim set up Kinetic, a design and advertising agency based in Singapore. With a mission statement of aiding communication and pushing the creative and conceptual limits of design, Kinetic are passionate about combining arresting images with cross-platform delivery, utilizing both innovative and traditional advertising and marketing tools. Fostering creativity at the top of their agenda, the partners have built an agency that is both 'diverse and close-knit'. They act as advocates for independent local design, and have flagged-up their achievements by winning awards, including the New York One Show, D&AD, Clio, Art Directors Club, YoungGuns Australia and Singapore Creative Circle.

2 Leng Kee Road , Thye Hong Centre, 03-02 Singapore 159086
kinetic.org.sg

49 360° **Kiosk**

Gatecrasher Forever – Kiosk
Client: Ministry of Sound (2006)

every egg a bird – Kiosk
Illustration: David Bailey
Client: Stolen music collective (2006)

Sound Tribe Sector Nine/Live As Time Changes – Kiosk
Client: STS9/Endit! productions (USA) (2005)

Addicted – Kiosk
Photography: Shaun Bloodworth
Client: Platipus Records (2006)

In 2005 David Bailey split from Sheffield's legendary graphics' outfit The Designers Republic, after eight years on the team. Setting up Kiosk, also in Sheffield, David makes full use of 'a new independent attitude in design and thinking, it is more accessible, creative and entrepreneurial' – thanks to changes in technology. Collaborating with clients and suppliers around the world, David designs and art directs for music, fashion, advertising and the arts, as well as directing music videos, title sequences and advertising spots.

Sheffield, UK
david@letskiosk.com / letskiosk.com

50 360° **Daniel Kluge**

Bambiland – Daniel Kluge
Client: Intermedium Records (2005)

My Band – Daniel Kluge
Client: Royal College of Art (2002)

Jackie – Daniel Kluge
Client: Intermedium Records (2004)

Intermedium@utopiastation/moving city – Daniel Kluge
Client: Intermedium Records (2005)

After studying in Germany and Italy, Daniel Kluge earned an MA at London's Royal College of Art. Before completing his education, though, Daniel had set up and run two companies, Pilotfisch (with Kornelia Bunkhofer), designing websites, and then Pictoplasma (with Peter Thaler), creating virtual characters. But it was after co-founding Elektrofilme (with Christian Ganzer and Bernd Ulbrich) – a live music and film performance group, that Daniel discovered what he describes as 'a completely different way of approaching visual language, inspired by music, space...rhythms, notes, silence'. He has since mastered playing video 'like a musical instrument'.

Baldestrasse 9, 80469 Munich, Germany
mail@danielkluge.com / danielkluge.com

51 360° **KURZ:HAUG**

Le Book – KURZ:HAUG
Client: Schierke Photographers (2006)

Dummy Frauen – KURZ:HAUG
Client: Dummy Magazine (2006)

Pooling their experience of working for publishers and art institutions in both Germany and the UK, partners Ingrid Haug and Carolin Kurz established KURZ:HAUG in 2002. Combining a cool, informational approach with dramatic use of photographic imagery and a keen interest in contemporary culture, KURZ:HAUG have designed corporate identities, books and catalogues for clients including Palais de Tokyo in Paris, Hatje Cantz Verlag in Stuttgart, and Booth-Clibborn Editions in London, for whom they also edited and designed a book charting Berlin's 'post-wall' creative groundswell.

Lettestrasse 01, 10437 Berlin, Germany
kontakt@kurzhaug.com / kurzhaug.com

52 360° **Fernando Leal**

MTV Video Music Brasil Awards – Fernando Leal
Client: MTV Brasil (2005)

VROM Complexo 12 Calendar – Fernando Leal
Client: VROM (2005)

Untitled – Fernando Leal
Client: personal (2006)

In 2006 Fernando Leal went independent after five years working across the creative industries, producing motion graphics, websites, animations and idents (for MTV Brasil). Commissions have come from *Playboy*, Terra, VROM and Sesc TV, while self-instigated projects include stickers, characters and book spreads (featured by German publishers DGV). A frequent contributor to exhibitions and awards, Fernando has temporarily left Brazil to pursue personal projects at London's Royal College of Art.

Rua Antonio Carlos, 259 No.92, São Paulo, 1309-011, Brazil
fernando@fleal.com / fleal.com

53 360° **Ian Lynam Design**

Le Pigeon – Ian Lynam
Client: Le Pigeon, Portland

Rap-Up – Ian Lynam
Client: Rap-Up Magazine, Los Angeles

Having studied in Portland, Oregon, and worked for local creative agency Plazm Advertising, Ian moved south, obtaining his MFA in graphic design in 2004 at the California Institute of the Arts in Valencia. After stints at 86 The Onions and Ignited Minds, working for clients ranging from Adidas, Virgin Records and the Surfrider Foundation, to NEC, Boeing and Miller Beer, Ian relocated to Japan. Having always worked freelance for a number of clients, setting up Ian Lynam Design was a natural career extension. With clients such as Nike, MTV, Grey Advertising and Pony, and projects including film logos, apparel design and magazine art direction, Ian's also happy to work in the widest range of media, including mobile phone content and sound and spacial design.

Utsukushigaoka 4-8-1, 303 Aoba-Ku, Yokohama-Shi 225-0002, Japan
ian@ianlynam.com / ianlynam.com

54 360° **M&E**

The Redneck Manifesto/Seven Stabs – Matthew Bolger, Emelie Lidström
Client: Greyslate Records (2006)

Jape/The Monkeys in the Zoo Have More Fun than Me
Art direction: Emelie Lidström, Matthew Bolger, Richard Egan Design, photography and woodwork: Emelie Lidström, Matthew Bolger
Client: Just Me I'm A Thief Records (2004)

Somadrone/Fuzzing Away to a Whisper + Let's Depart – Matthew Bolger, Emelie Lidström
Client: Just Me I'm A Thief Records (2005)

Collaborators since 2002, Matthew Bolger (from Ireland) and Emelie Lidström (from Sweden) set up M&E in 2006, after studying graphic design and photography/fine art, respectively. With creative freedom at the top of their career agendas, M&E have concentrated on designing for the music industry, and aim to expand from print-based projects into animation and video.

14 Richmond View, South Richmond Street, Dublin 2, Ireland
medesign.matthew@gmail.com / me-me-me.se

55 360° **MAKI**

Studenten Band Festival – MAKI
Client: Stichting Daidalos (2005)

Like Life – MAKI
Client: Semi Permanent (2006)

Zwols Studenten Cabaret Festival – MAKI
Client: Stichting Daidalos (2006)

Established in 2005 by Kim and Matthijs, MAKI is a design and illustration studio based in Groningen. The partners met at the Minerva Art Academy in Groningen and share an approach to design that mixes edgy, urban influences with a dash of humour and a serious streak. MAKI have applied their approach and the resultant wild and funky visuals to walls, shoes, posters, flyers and magazine spreads, even drawing directly onto human skin.

Aquamarijnstraat 205, 9743 PE Groningen, The Netherlands
info@makimaki.nl / makimaki.nl

56 360° **Russell Mann**

New – Russell Mann
Client: personal (2005)

RUS – Russell Mann
Client: personal (2005)

Abstractions in Sound – Russell Mann
Client: personal (2006)

Russell Mann graduated from the Western Australia School of Art and Design in Perth in 1998. Working as an independent designer, he divides his time between London and his hometown Perth, working for clients on both sides of the world. Primarily a print-based designer, Russell combines a bold colour palette with a pared-down, minimalist approach to create sophisticated, dynamic solutions, made more unique by the inclusion of custom-designed typography.

32 Parsons Avenue, Manning , Perth, 6152 Australia
hello@russellmann.com / russellmann.com

57 360° **MARC&ANNA**

AOP – Marc Atkinson, Anna Ekelund
Client: Association of Photographers (2006)

The Connectors – Marc Atkinson, Anna Ekelund
Client: Sonic Arts Network (2005)

Marc Atkinson and Anna Ekelund met at London's Central Saint Martins College of Art and Design while studying graphics. After graduating they worked at a number of leading agencies before setting up MARC&ANNA in 2005 with the aim of realizing big ideas via beautiful solutions. Playing on the duality of their partnership, they celebrate the contradictions, mixing tongue-in-cheek wit with a refined attention to detail. Their list of loves includes rubber stamps, ampersands, stickers, heavy books, being challenged and happy clients.

Studio 71, Regent Studios, 8 Andrews Road, London E8 4QN, UK
hello@marcandanna.co.uk / marcandanna.co.uk

58 360° **MASA**

Project Fox, Copenhagen – MASA
Assistant: Jakob Printzlau
Client: Volkswagen AG/Event Labs GmbH (2005)

Football Personalities T-shirts – MASA, Stuart McArthur at Nike
Client: Nike Football Europe (2006-07)

MASA, aka Miguel Vásquez, graduated from Caracas's PRO Diseño Escuela de Comunicación Visual y Diseño in 1999 with a BA in graphic design. An accomplished multi-media practitioner, MASA art directs, illustrates and makes motion graphics using his distinctive combination of bold black line, organic shapes and vibrant colours. He is an accomplished muralist, happy to paint walls, cars and a twelve-metre ship container. Using the raw materials of Latin American folklore and urban street art, MASA seamlessly blends traditions and cultures to produce an instantly recognizable, unique visual language. Since editing and designing *Latino* in 2002, the first book to showcase contemporary South American graphics and illustration, MASA has been in demand around the world, appearing in books, magazines and exhibitions, hand-painting bespoke hotel rooms in Copenhagen and custom-made shoes in Paris. Happy to mix personal work with commercial projects, MASA does his stuff for clients including Nike, Volkswagen, Mini Cooper, Toyota and Miramax Films.

4ta. Av. con 3ra Transv, Edif. ELITE, Piso3, AP.304, Los Palos Grandes, Caracas, Venezuela 1070
info@masa.com.ve / masa.com.ve

59 360° **Kieran McCann**

Digital Divide – Kieran McCann
Copy: Arundhati Roy
Client: personal (2005)

What's It Called? – Kieran McCann
Photography: Kieran McCann
Client: personal (2004)

With a degree from Glasgow School of Art and an MA in Communication Art and Design from London's Royal College of Art, Kieran McCann works independently and is based in London. Stints creating motion graphics at The ISO Organization in Glasgow, at Fabio Ongarato Design in Melbourne, PMcD in New York and Meta Design in Berlin, brought Kieran in contact with a wide range of clients. He has worked with London's Westminster City Council and UK broadcasters the BBC and Channel 4, as well as the Discovery Channel. Kieran considers his graphic work as 'visual journalism', employing a process of research, collating, editing, structuring and storytelling, tackling subjects of social concern and creating narratives to aid communication.

Flat 4, 19 Gleneldon Road, London SW16 2AX, UK
kieran@kieranmccann.co.uk / kieranmccann.co.uk

60 360° **Clare McNally**

GRAy Magazine 2 – Clare McNally, Lane Gry, Risto Kalmre
Client: The Gerrit Rietveld Academie, Amsterdam (2006)

With a degree in English and Journalism from Rhodes University in Grahamstown, South Africa, and a post-graduate design degree in advertising that landed her copywriting jobs in Cape Town, Johannesburg and Amsterdam, Clare McNally's interests in text and image were well defined before she even turned to design. In 2006 she graduated from Amsterdam's Gerrit Rietveld Academie as a graphic designer, with a commission from the school to produce a publication on craftsmanship. Recognizing that content and text are often mistreated by designers, Clare aims to mingle the visual and the linguistic into a beautiful and readable whole. She is also intrigued by the form and meaning of type and letters, and aims to combine her design and writing skills on editorial and publishing projects.

Korte Amstelstraat 12b (3), 1018 XS Amsterdam, The Netherlands
planetclare@planet.nl

61 360° **The Mighty**

Family Portrait – Aleksandar Maćašev
Client: BELEF 2006 Festival (2006)

Joseph Goebbels ™ – Aleksandar Maćašev
Client: BELEF 2005 Festival (2006)

Mirko Ilic – Aleksandar Maćašev
Client: Mirko Ilic comics (2006)

Personal cards – Aleksandar Maćašev
Client: personal (2006)

Aleksandar Maćašev is The Mighty! An independent designer since 2004, Aleksandar is a prominent member of the design scene in Serbia and Montenegro. Graduating from the Faculty of Architecture in Belgrade, in 1998 Aleksandar worked as an urban planner and then for a number of advertising agencies, including BBDO and Saatchi&Saatchi. As a teacher of interactive design and the history of design at BK (Braća Karić) Art Academy in Belgrade, Aleksandar was voted 'most popular tutor' by the students. He is a prolific writer (currently working on a project with Steve Heller) and reviews for a number of magazines. Aleksandar's work is by turns provocative and humorous, whether produced to a brief for clients as diverse as Swatch and *Playboy*, or for exhibition.

Djure Djakovica 5, 11000 Belgrade, Serbia and Montenegro
mighty@the-mighty.com / **the-mighty.com**

62 360° **Mode**

Font Book – Phil Costin, Ian Styles, Richie Clark
Client: Dalton Maag (2006)

Dalton Maag – Phil Costin, Ian Styles, Richie Clark
Exhibition architects: 6a
Client: Dalton Maag (2006)

Mode identity – Phil Costin, Ian Styles, Richie Clark
Client: Mode (2005)

Mode was established in 2001 by Phil Costin and Ian Styles, after a decade working for leading design companies. The aim of Mode is to be both creative and pioneering, while working with clients that are both commercial and cultural. Mode collaborates with key contemporary architects, photographers, writers and digital designers, and is able to offer a comprehensive level of integration on major projects. With experience designing identities, publications, exhibitions, signage and digital interfaces, Mode is redefining the role of the contemporary design consultancy.

26 Middle Row, London W10 5AT, UK
info@mode-mail.co.uk / **mode-online.co.uk**

63 360° **Tom Munckton**

The Fall/Fall Heads Roll – Tom Munckton
Client: Sanctuary Records (2005)

Theme Tunes – Tom Munckton, Alexander Turner
Client: personal (2006)

Ode to Cage – Tom Munckton
Client: personal (2006)

Er'voy gnieb deloof – Tom Munckton
Client: personal (2005)

Tom Munckton's work is concerned with perception and interaction. Aesthetically it is deceptively simple, leaving space for thoughtful questions and possible solutions to both inform and entertain the reader/viewer/listener. Designing graphics for music packaging led to a course at London's Central Saint Martins College of Art and Design and a day job. But Tom's self-initiated projects, often in collaboration with Alexander Turner, continue to investigate sounds, words, images and their formal arrangement.

Flat 3, 93-95 Sclater Street, London E1 6HR, UK
anything@tommunckton.co.uk / **tommunckton.co.uk**

64 360° **No Days Off**

Full Moon Empty Sports Bag – Patrick Duffy
Client: Full Moon Empty Sports Bag (2006)

The Rifles/No Love Lost – Patrick Duffy
Client: Red Ink (2006)

Established in 2006 by Patrick Duffy, No Days Off is an umbrella for Patrick's many self-initiated projects, including his own literary/art magazine, *Full Moon Empty Sports Bag*, and his commercial work. Until 2003 Patrick was art director of the edgy, style magazine *Sleazenation*, guiding the publication's punchy, no-holes-barred layouts for over three years. Editorial jobs often lend designers an added sensitivity to the work of other creatives; Patrick designs for musicians (The Rifles) and photographers (including Wolfgang Tillmans) creating books, posters, packaging and promotional packs.

223b Canalot Studios, 222 Kensal Road, London W10 5BN, UK
info@nodaysoff.com / **nodaysoff.com**

65 360° **Node**

Happy Days Sound Festival – Node
Photography: Andreas Meichsner
Client: Ny Musikk (2005)

Heitere Weitere Polterei, Tere Recarens – Node
Client: Galeria Toni Tàpies, Barcelona (2002)

Having met at and graduated from Amsterdam's Gerrit Rietveld Academie, Anders Hofgaard, from Norway, and Serge Rompza, from Germany, set up Node in 2003 – a design studio that operates out of both Oslo and Berlin. Working on both commercial briefs and personal projects, Node collaborate with designers and photographers, tapping into a wide network of creatives from both cities. Clients range from *mono.kultur* – a thematic magazine from Berlin – to the Happy Days Sound Festival to the Norwegian Ministry of Education and Research. Along the way, there is still time for fun and provocative self-initiated work, such as their Demonstration about Nothing, where empty banners and placards were produced simply to confuse the media!

Schwedterstr. 36a, 10435 Berlin, Germany
mail@nodeberlin.com / **nodeberlin.com**

66 360° **One Day Nation**

Pixels of Reality – One Day Nation
Client: Public Space With a Roof (2006)

Thinktank 0.3 – One Day Nation
Client: Think Tank (2005–07)

Established in 2006 by graduating students from Amsterdam's Gerrit Rietveld Academie – Selina Bütler from Switzerland, Paul Gangloff from France and Matthias Kreuzer from Germany – One Day Nation works with practitioners and cultural institutions within Amsterdam's lively art scene. With three equal partners, dialogue is at the core of their practice, and they consider design to be 'the act of making relationships'. One Day Nation's signature approach is to take a brief, look at it from different angles and offer not just the required solution, but something more – a redefinition.

Apollolaan 117, 1077 AP Amsterdam, The Netherlands
selina@onedaynation.com / **onedaynation.com**

67 360° **One Fine Day**

it's bigger than – James Joyce
Client: it's bigger than (2005-06)

Primate / Face slide – James Joyce
Client: Creative Review (2006)

We Can Stop Climate Chaos – James Joyce
Client: Penguin (2006)

REVL9N – James Joyce
Animation: David Oscroft
Client: REVL9N (2006)

A studio and an online gallery, One Fine Day is the brainchild of designer and illustrator James Joyce. Established in 2006 with the aim of selling limited-edition prints online and attracting commercial clients, One Fine Day has produced posters, animation, music packaging and textile prints for products, working for Penguin Books, Kiehls, Carhartt and Levi's. James's aesthetic, combining confident line drawing and areas of bright, flat colour, is informed by his use of silkscreen printing.

4 Beauchamp Building, Brookes Market, London EC1N 7SX, UK
james@one-fine-day.co.uk / one-fine-day.co.uk

68 360° **Pandarosa**

Perspacial – Pandarosa
Animation: Organic
Sound: Frank G. at AKA Ltd
Client: personal (2005)

Shadows in a Diamond Cave – Pandarosa
Photography: Martina Copleya
Client: Gallery 101, Melbourne (2005)

Coming together in 2001 as Pandarosa, Ariel Aguilera and Andrea Benyi are based in Melbourne, but have a very international outlook, having travelled the world, stopping off to work on various projects along the way. With an aesthetic that combines the most delicate drawing with a comprehensive knowledge of computer techniques, they set out to prove that their personal, art-based approach could also feed into commercial projects. Working for clients ranging from Platform – an Australian artists' group – to Adidas and Volkswagen, Pandarosa's work has been exhibited at film festivals in Asia, Europe and America, and featured in publications from New York, London and Tokyo.

Studio 10, 6-14 Tanner Street, Richmond, Victoria 3121, Australia
info@pandarosa.net / pandarosa.net

69 360° **Peter and Paul**

Tapehead – Peter and Paul
Client: Dirt Records

Plug – Peter and Paul
Photography: Nigel Barker
Client: Plug (2004)

Originally from neighbouring villages outside Sheffield, Peter Donohoe and Paul Reardon met when they skipped school to watch striking miners at Orgreave Pit. They attended the same college, but it wasn't until Peter, while working at a small studio, hired Paul, that they got to know each other and work together. Taking on freelance projects as a team, they set up Peter and Paul in 2005, and it's still evolving, 'almost on a daily basis'. Working with a number of PR and strategic agencies, they provide creative solutions for big name clients with generous budgets, and without having to deal direct. They also work with a number of arts and culture clients, including indie record labels and local clubs.

Unit R9a, Riverside Block, Sheaf Bank Business Park, Prospect Road, Sheffield S2 3EN, UK
info@peterandpaul.co.uk / peterandpaul.co.uk

70 360° **Petpunk**

MTV Exit – Gediminas Šiaulys, Andrius Kirvela
Illustration: Gediminas Šiaulys
Client: MTV Networks (2006)

Welcome – Gediminas Šiaulys, Andrius Kirvela
3D Graphics: Romanas Zdanavicius
Client: InCulto (2006)

Declaring themselves to be 'less professionals more enthusiasts', PetPunk are Gediminas Šiaulys and Andrius Kirvela. Coming from a family of artists, Gediminas took to pencil and marker pen from an early age. After working in Vilnius and Moscow, he studied design and illustration in Denmark. From an early age Andrius was interested in computers and programming. Working in an advertising agency ignited his creative spark. He went on to design and animate at a large web agency, before setting up with Gediminas. View the duo via webcam on their site in a small but perfectly formed studio. They illustrate, photograph, animate and art direct for music videos, television ads, channel idents, CD packaging and more.

Vivulskio 15-20, Vilnius, Lithuania
hello@petpunk.com / petpunk.com

71 360° **Pixel Nouveau**

Warter – Diego Vargas
Client: personal

A&P – Diego Vargas
Client: Accept and Proceed (2006)

Conjunto – Diego Vargas
Client: personal

Tres Argumentos – Diego Vargas
Client: personal

Diego Vargas Sales, born in Costa Rica, studied architecture and urbanism in San Jose, and with the artist Joaquin Rodrigues del Paso, who taught him drawing and to work in a variety of media. A self-taught computer artist, Diego has produced advertising, illustration, video and animation, also taking to the stage as a live VJ. He has worked for clients in fashion and music, in collaboration with Marco Kelso, Rocket and members of Taller Rosa (the Pink Workshop), and at Grey Costa Rica and JWT. Diego now lives in Barcelona where he collaborates with cultural powerhouse, Maxalot, turning his intricate and surreal landscapes into high-quality, limited-edition wallpapers that have been exhibited at the Today's Art Festival and the International Art Fair in Moscow.

Carrer Stiges 5, 1/1, 08001 Barcelona, Spain
esteviernes@gmail.com / www.pixelnouveau.com

72 360° **Plusminus ±**

hopefulvoyeur.com – Peter Crnokrak
Client: hopefulvoyeur.com (2006)

1960s posters – Peter Crnokrak
Client: Cinéma du Parc (2006)

Mobile Digital Commons Network (MDCN) Symposium Poster + Hotspots Map – Peter Crnokrak, Michael Longford
Illustration: Antoine Morris
Client: Mobile Digital Commons Network (2005)

Established in Montreal in 2004 by Peter Crnokrak, ± has been on the move, setting up studios in both Toronto and New York. 'A statistical symbol that indicated the variation about the norm', Peter chose the symbol because 'it can be represented in any typeface...so there is no formal brand identity'. Loving clean snow, miniature trees and dirty pink, Peter likes love and isn't always too serious. With clients ranging from Grafuck to Salon Rouge and Mobile Digital Commons Network, Peter has also developed a series of intriguing product designs and a number of DJ compilation CDs, all of which is definitely beyond 'the norm'.

350 West 47th Street, 3C, New York, NY 10036, USA
info@plusminus.ca / plusminus.ca

73 360° **Qube Konstrukt**

Riot – Qube Konstrukt
Client: Arc Media (2006)

Escape to Suburbia – Qube Konstrukt
Client: K-Swiss (2004)

Established in 2002 by creative director Adam Gardiner and partner Janine Wurfel, Qube Konstrukt has grown into a leading multi-disciplinary design studio, servicing clients not just from the Melbourne area, but from as far afield as Canada and the USA. Working with clients as diverse as youth-oriented shoe companies K-Swiss and Royal Elastics, cutting-edge magazine Riot and Toyota's Yaris, Qube Konstrukt have produced identities, branding, advertising and broadcast campaigns, mixing dynamic, hand-rendered elements with found imagery and sophisticated photography.

5 Kipling Street, Richmond, Victoria 3121, Australia
qube@qubekonstrukt.com / qubekonstrukt.com

74 360° **Carsten Raffel**

Machine From Hell – Carsten Raffel
Illustration (devil): Jens Uwe Meyer
Client: superReal Digital Media GmbH (2006)

True Style (Never Dies) – Carsten Raffel, Jens Uwe Meyer, Lawrence Tureaud
Client: United States of the Art (2006)

After working for Mutabor Design for six years, Carsten Raffel set up as an independent graphic designer and illustrator in 2005. Carsten's world of manga-style characters and in-your-face logos has attracted clients as diverse as Greenpeace, superReal and 5special. Plus, his online network promoting '(ir-)regular output of optical works…in a daily struggle for graphical perfection and office communication' is crammed with all sorts of creative nuggets – a source of true inspiration – some of which are available as T-shirts.

Limp'lweg 6, 22767 Hamburg, Germany
mail@unitedstatesoftheart.com /
unitedstatesoftheart.com

75 360° **The Remingtons**

Das Schiff – The Remingtons
Client: Das Schiff (2005)

Typo poster – The Remingtons
Client: various (2002-03)

Established in 2002 by Ludovic Balland and Jonas Voegeli, The Remingtons briefly expanded in 2005 to include Nina Hug, before Jonas left to set up his own studio. Offering 'nice graphic solutions', their daily worksheet, recorded on their website, gives a good impression of the versatility of this studio, with projects ranging from an ad campaign for furniture company Vitra, to a series of novels for Das Magazin Tages-Anzeiger, and shifting scale, to a building hoarding for the Schweizerisches Landesmuseum in Zürich.

Bärenfelserstrasse 19 CH-4057 Basel, Switzerland
contact@theremingtons.ch / theremingtons.ch

76 360° **Adam Rix**

Adam – Adam Rix at Love Creative
Creative director: Phil Skegg
Copy: Simon Griffin
Client: Adam (2006)

twelve – Adam Rix at Brahm Design
Creative director: Lee Bradley
Client: St George's Crypt (2005)

Just three years out of college and Adam Rix has already been showcased at London's Design Museum in an exhibition of contemporary European design. He has taken the brave step, in terms of profile, of basing himself north of London – after graduating from Leeds Metropolitan University he stayed in the city, working for Brahm Design, and then across the Pennines in Manchester for Love Creative. Adam's work has been featured in the D&AD Annual and a host of magazines. He won the Design Week Award for Best Annual Report in 2005.

29 Kent Road, Cheadle Heath, Stockport SK3 0JD, UK
mail@adamrix.com /adamrix.com

77 360° **Richard Sarson**

Sound Seminar – Richard Sarson
Client: Royal College of Art (2005-06)

With a degree from University College Falmouth and an MA in Communication Art and Design from the Royal College of Art, in 2006 Richard Sarson established himself as an independent graphic designer based in east London. Keeping it simple is his mantra, as he aims to convey complex ideas through basic techniques and materials, with composition and the combining of 2D forms and geometries at the forefront of his methodology. A keen collaborator on projects ranging from magazine and book design to moving image and web design, Richard also exhibits and sells drawings and silkscreen prints.

12a Sylvester Path, London E8 1EN, UK
info@richardsarson.com / richardsarson.com

78 360° **Satian:Studio**

Sorry / Thanks – Satian Pengsathapon
Client: Satian:Studio (2005)

Columbia Composers – Satian Pengsathapon
Client: Columbia University (2005)

Originally from Bangkok, Thailand, Satian Pengsathapon moved to New York in 1997, and graduated from the city's Pratt Institute with a BFA in graphic design. Working at McDevitt Group as art director, designer and strategist he oversaw the brand development of ITO EN, Japan's leading purveyor of green tea, culminating in their first flagship store opening on Madison Avenue. Joining Ogilvy & Mather's Brand Integration Group in 2003, Satian worked with Coca-Cola, Dove and Kodak, and designed an award-winning identity for the Tribeca Film Festival. Moving to San Francisco to Goody Silverstein and Partners, Satian worked with Virgin Atlantic and Adobe Macromedia. His entrepreneurial streak lead to collaboration with fashion designer Hussein Chalayan, developing his original concept of downloadable clothing. Satian also designs for Columbia Composers – staff and graduate students at Columbia University's music department, and for friends' bands.

35 Eastern Parkway, 3L, Brooklyn, NY 11238, USA
naitas@gmail.com

79 360° Jens Schildt

N-D-S-M – Jens Schildt, Matthias Kreutzer
Photography: Charlott Markus, Oran Hoffman, Shinji Otani
Copy: Johan Vogels
Client: NDSM, Amsterdam (2006)

Jens Schildt lives and works in Amsterdam and Stockholm, having graduated from Amsterdam's Gerrit Rietveld Academie in 2006. An occasional collaborator with fellow graduate Matthias Kreutzer (under the name Matthias-Jens & Jens), their aim is to focus on clients in the fields of music, art, fashion, design and culture. Designing for print, Jens mixes informational type with poignant photographs and illustrations – sometimes drawn by himself. The results are powerful and informative.

Amsterdam, The Netherlands
jens@ourpolitesociety.org / ourpolitesociety.org

80 360° Séripop

MSTRKRFT/The Looks – Séripop
Client: Last Gang Records (2006)

Levinas and Law Centennial Conference – Séripop
Client: McGill University Faculty of Law (2005)

Sightings – Séripop
Client: Mandatory Moustache Booking (2005)

The product of a friendship between Yannick Desranleau and Chloe Lum, Séripop was founded in 2002. Making prints, artworks, designs and illustrations, 'for lack of any other saleable skills', the pair admit to becoming addicted to, 'having ink-soiled hands and clothing'. Describing themselves as 'maximalists', they celebrate messy aesthetics over dry rhetoric – especially in the art world – and admire the retro styling and comic humour of Ford Econolines and Archie. And, as members of 'slime rock' bands AIDS Wolf and Hamborghini, Séripop have a regular outlet for their poster screen-printing skills.

PO Box 1911, Montreal, Quebec H3B 3L4, Canada
info@seripop.com / seripop.com

81 360° Natasha Shah

My Local Newsagent & Grocer – Natasha Shah
Client: News@The Grove (2006)

Heart – Natasha Shah
Client: Natasha Shah (2006)

After graduating from the London College of Printing in 2003, Natasha Shah set out to work for a range of agencies, including Design Machine in New York and Exposure in London. Sampling different working environments, the mix of travel to a new city, and then working within a PR company, and with clients of the calibre of Coca-Cola, Sony PSP, Sharp and Levi's, offered invaluable experience. But Natasha was determined to set up independently. Since doing so in 2005, she has produced distinctive signage for a local retailer, installations for a chain of bars and branding and packaging for a couture knitwear label – she enjoys the challenge of working with a wide variety of clients.

19 Lonsdale House, Westbourne Grove, London W11 2DG, UK
nat@natashashah.co.uk / natashashah.co.uk

82 360° The Small Stakes

Stellastarr* – Jason Munn
Client: Stellastarr* (2005)

Rogue Wave – Jason Munn
Client: Rogue Wave (2005)

Jeff Tweedy – Jason Munn
Client: Jeff Tweedy (2005)

The Books – Jason Munn
Client: The Books (2006)

Litquake – Jason Munn
Client: Litquake Literary Project (2006)

Jason Munn is The Small Stakes, having set up the independent design studio upon relocating from Wisconsin to his adopted city of Oakland. A passionate fan of music and design, Jason has brought the two together in his work for a number of independent labels and bands, producing CD packaging, silkscreen-printed gig posters, T-shirts and book jackets. His distinctive aesthetic delivers graphic ideas with an exceptional visual clarity. Jason leaves room for his mark-making to breathe.

1847 5th Avenue, Oakland, CA 94606, USA
jason@thesmallstakes.com / thesmallstakes.com

83 360° Astrid Stavro

The Devil's Dictionary – Astrid Stavro
Client: Royal College of Art, London (2004)

Forum Laus Europe 2006 – Astrid Stavro
Design: Rosanna Vitiello, Cynthia Furrer, Joana Sarmento
Client: ADG-FAD (2006)

Born in Trieste, Italy, and now based in Barcelona, Astrid Stavro gained her design education at London's Central Saint Martins College of Art and Design and Royal College of Art, graduating in 2005. In a hiatus between degrees, she co-founded and designed *Lab* magazine, an alternative showcase for young, creative individuals, and informed by a worldwide network of contributors. Specializing in editorial design, Astrid has produced book jackets for world-famous authors, winning awards from D&AD, ADCE, *Creative Review* and *Grafik* magazine. Her work has appeared in exhibitions at London's Victoria and Albert Museum, FAD Barcelona and the Brno Design Biennale, as well as in a host of publications. Astrid's entrepreneurial skills have also led her to publish books and produce furniture and stationery designs, with her Grid-it! notepads gaining wide recognition.

Arc de Saint Agusti, 7, 08001 Barcelona, Spain
astrid@astridstavro.com / astridstavro.com

84 360° Frauke Stegmann

Series One – Frauke Stegmann
Client: John Coxon, Ashley Wales (2004)

Series Two – Frauke Stegmann
Client: John Coxon, Ashley Wales (2006)

Born in Namibia, educated at Hochschule für Gestaltung Mainz, in Germany, and at London's Royal College of Art (gaining an MA in graphic design in 2000), Frauke Stegmann set up his independent design studio in 2001, and is now based in Cape Town. With a penchant for birds, foil blocking, ceramic casting, wildlife illustration and folding large sheets of paper, Frauke creates evocative and intriguing works, ranging from CD covers for experimental music to Christmas cards you'll want to keep all year to a new range of ceramic vessels. Clients include London's Design Museum, Jarvis Cocker, Treader and *Wallpaper** magazine.

Birds Studios, 127 Bree Street, Cape Town 8001, South Africa
frauke@ineedtimetothinkaboutwildlife.org / ineedtimetothinkaboutwildlife.org

85 360° **Stiletto nyc**

Shopculture – Stefanie Barth, Julie Hirschfeld
Client: Lucky Magazine, New York (2006)

Co-founded in 2000 by Stefanie Barth and Julie Hirschfeld, Stiletto nyc is a design studio based in both New York and Milan. As art directors and designers, producing print, web and moving image solutions informed by a uniquely-sophisticated graphic language, Stiletto nyc has tackled a wide range of projects for clients from the culture, media and fashion industries. Designing CD packaging, broadcast spots and even bespoke carpets for shop interiors, their client list includes Condé Nast, Nickelodeon, HBO, Sundance Channel, *Res* magazine and the cutting-edge fashion collective ASFOUR. Working on both sides of the Atlantic, Stiletto nyc offer global coverage to international organizations, as well as being available to work with smaller, local businesses.

86 Forsyth Street, 3rd Floor, New York, NY 10002, USA
info@stilettonyc.com / stilettonyc.com

86 360° **Studio8**

RAN (Rainforest Action Network) – Studio8
Photography: Giles Revell
Client: RAN (Rainforest Action Network) (2006)

brands in literary modernism – Studio8
Client: Victoria and Albert Museum (2006)

Established in 2006 by Matt Willey and Zoë Bather, both of whom were formerly creative directors at Frost Design London, Studio8 aims to build on that substantial shared experience and a design aesthetic that showcases both strong photography and refined typography. Covering editorial and exhibition design, brand identity and website development, Studio8 has tackled a wide range of projects for clients including independent record company Wall of Sound, photographer Martin Parr and London's Victoria and Albert Museum and the Serpentine Gallery.

1 Sans Walk, London EC1R 0LT, UK
info@studio8design.co.uk / studio8design.co.uk

87 360° **Studio Tonne**

Lilium – Studio Tonne
Client: Container Publishing (2003-04)

Noked – Studio Tonne
Client: Calima Records (2006)

SoundToy – Studio Tonne
Client: BipHop (2003)

Klitekture/Epitome Vol 2 – Studio Tonne
Client: Klitekture Records (2004)

Studio Tonne is home to Paul Farrington, graphic designer, typographer, interface innovator and maker of electronic music. A graduate of the Royal College of Art, it was his 2002 album and software, *SoundToy*, that probed the possibilities of screen-based, custom-built sound toys – gaining him both acclaim and recognition, and leading to two of his most important commissions to date. Working for Moby and Depeche Mode, Paul has developed new ways to market music and news, through the web, to fans and customers. A second album, Lilium, reinforced his musical credibility. Meanwhile, Paul's design practice has expanded as he creates unique interfaces and user experiences for clients such as Mute, 4AD, Beggars Banquet, EMI, Channel 4, Katharine Hamnett, Prada and Ars Electronica.

Studio 1.1, 11 Jew Street, Brighton BN1 1UT, UK
studio@studiotonne.com / studiotonne.com

88 360° **Syrup Helsinki**

Koneisto – Teemu Suviala, Antti Hinkula
Client: Koneisto (2004)

Young Designers of the Year – Teemu Suviala, Antti Hinkula
Client: Design Forum Finland (2005)

Escalator – Teemu Suviala, Antti Hinkula
Client: Escalator Records (2003-06)

Established in 2001 by Teemu Suviala and Antti Hinkula, Syrup Helsinki's design aesthetic features strong colours, busy collage, paintbrushes, retro type, found images and more. There is no house style but a sense of energetic innovation. Solutions ooze tongue-in-cheek humour and display a deep engagement with the subject matter. Clients include Converse, the Finnish National Theatre, Amnesty International, Yoko Deveraux, Sony and Le Shop Stockholm. Teemu and Antti were named Young Designers of the Year in 2005 by Design Forum Finland.

Pursimiehenkatu 26H, 00150 Helsinki, Finland
office@syruphelsinki.com / syruphelsinki.com

89 360° **ten ten ten**

Crazy stripes ten ki style – ten ten ten
Client: Le Cube, Paris (2006)

Rolling Stones ten ki style – ten ten ten
Client: Rolling Stones, Plug Inc. (2006)

Tar ten sex businessman – ten ten ten
Client: Brutus (2006)

World's minimum dog ten ki style – ten ten ten
Client: Uniqlo NY (2006)

ten_do_ten is the Japanese artist who creates all his designs from one raw material, pixels. Whether he's creating print designs, textiles, websites or photos, his approach is to work at the scale of the pixel, and expand that to fit. He describes his work as 'mini & max', 'stoic & sexy', 'domestic & universal' and 'classic & contemporary'.

Tokyo, Japan
ten@tententen.net / tententen.net

90 360° **Frédéric Teschner**

Étapes – Frédéric Teschner
Client: Étapes (2006)

Mac Val – Frédéric Teschner
Client: Musée d'art contemporain
du Val-de-Marne (2006)

La Valette-du-Var – Frédéric Teschner
Client: Heritage Days (2006)

After graduating from Paris's École Nationale Supérieure des Arts Décoratifs in 1997, Frédéric Teschner worked with Pierre Di Sciullo, and then Pierre Bernard, at Atelier de Création Graphique. Setting up an independent studio in 2002, Frédéric frequently collaborates with architects, product designers and choreographers, including AAS, Martin Szekely and Compagnie Pascal Montrouge. Recently he designed quirky iconographic signage for the town of La Valette-du-Var, a special issue of *Étapes* magazine, and a website for the promotion of French graphic design, www.cnap.fr/graphisme.

17 rue de la Revolution, F-93100 Montreuil, France
f.teschner@wanadoo.fr

91 360° **Clarissa Tossin**

Instructions On The Back – Clarissa Tossin
Client: Vermelho Gallery (2004)

Gossamer – Clarissa Tossin
Client: Rocket Racer (2004)

Sky_Boxes – Clarissa Tossin
Client: personal (2004)

While still a student at FAAP in São Paulo, Clarissa Tossin worked for the renowned publishing house Editoria Abril. She moved on to Trama Records and won a gold award at the Biennial ADG for interactive design before opening her own independent studio in 2002. With exhibitions featuring her work from Paris to Toronto, Vienna to New York, and extensive coverage in magazines and books, Clarissa's client list has grown to include *Vogue*, MTV, Nike, Dupont, Custo Barcelona, Duran Duran and São Paulo Fashion Week. Moving to California, Clarissa took a job at motion graphics studio Brand New School, and enrolled on the MFA programme of the California Institute of the Arts in Valencia. She continues to work for Brazilian and international clients, offering a distinctive combination of sublime image-making and technical innovation.

725 N Western Avenue, Suite 209, Los Angeles, CA 90029, USA
ola@a-linha.org / a-linha.org

92 360° **Nicole Udry**

Viceversa – Nicole Udry
Client: Viceversa (2003-06)

Forde – Nicole Udry
Client: Forde (2006)

Having studied graphics at the University of Art and Design Lausanne (ECAL), Nicole Udry completed an MA at London's Royal College of Art. She stayed on in London, working for two years with the renowned consultancy North, before returning to Lausanne in 2003 to establish her own studio, teach and contribute to a number of research programmes. Offering a cool, analytical approach with an emphasis on functionality, Nicole collaborates with cultural, social and commercial clients, providing thoughtful solutions for editorial, exhibition and identity projects.

Lausanne, Switzerland
one@pull-down-menu.co.uk

93 360° **Vanillusaft**

Wolf – Siggi Eggertsson
Client: personal (2006)

Quilt – Siggi Eggertsson
Quilting: Johanna Viborg
Client: personal (2006)

Colourful – Siggi Eggertsson
Client: personal (2006)

Berlin – Siggi Eggertsson
Client: personal (2006)

Vanillusaft is Siggi Eggertsson, a print and web designer who 'loves to make beautiful things', and has recently branched out from paper into textiles. Born in Iceland's second city, Akureyri (population 15,000), Siggi's early computer skills landed him at age seventeen the job of designing graphics for the city's annual arts festival. After a design degree at the Iceland Academy of the Arts in Reykjavik, he left for New York and an internship with karlssonwilker inc., along with a stint in Berlin. Siggi ultimately returned to Iceland, to make more beautiful things. His wholly distinctive style, fusing pastel colours and geometric shapes into illustrations and typography (a new font is based on quilting), has led to commissions in the UK, Hong Kong and New York.

Eiriksgata 31, 105, Reykjavik, Iceland
s@vanillusaft.com / vanillusaft.com

94 360° **Vault49**

Fall Movies – Vault49
Client: Entertainment Weekly (2005)

Flaunt – Vault49
Client: Flaunt (2003)

The Greatest Show on Earth – Vault49, Si Scott, Daryl Waller
Client: The greatest show on earth (2006)

Jonathan Kenyon and John Glasgow of Vault49 relocated to New York in 2004 after two years working in London, a decision that was as much a lifestyle choice as economic. 'We travelled for pleasure and the work followed', says Jonathan. With their own successful T-shirt brand on sale worldwide, Vault49 were quickly sought out by clients from the creative industries – commissions coming from MTV, Microsoft and Virgin, as well as smaller-scale clients in music and leisure. Their distinctive, fashion-forward style, with its fluid mix of flamboyant illustration and glamorous photography, is being applied to print, web and moving-image solutions.

10 East 23rd Street, Suite 300, New York, NY 10010, USA
info@vault49.com / vault49.com

95 360° **Viagrafik**

Get Alive – Robert Schwartz, Leo Volland, André Nossek
Client: MTV Germany (2005)

Logos – Leo Volland, André Nossek
Client: various (2005-06)

Project Fox – Leo Volland, André Nossek
Client: Volkswagen AG (2005)

Established in 2003, Viagrafik is an art and design studio. Current members, Leo Volland, André Nossek, Robert Schwartz, Tim Bollinger, Till Heim and Lars Herzig all have a background in graffiti and street art. With a tagline that offers 'from wall to screen to everything', Viagrafik celebrate their virtuosity as mark-makers, working at any scale, across various media. Whether building giant, sculptural TV sets, designing their own range of T-shirts, or producing fonts, websites, books and logos, their hands-on approach is fed by a love of popular culture, and an aesthetic of immediacy – much appreciated by such youth-oriented clients as MTV, Nike and Trust Punk Hardcore magazine.

Unter den Eichen 5/D, 65195 Wiesbaden, Germany
mnwrks@viagrafik.com / vgrfk.com

96 360° **Vivian Cipolla**

.Cent – Vivian Cipolla
Client: .Cent Magazine (2005)

Arrivederci – Vivian Cipolla
Client: The Italian Cultural Institute (2004)

Established in 2002 by Madelyn Postman and Luca de Salvia, Vivian Cipolla is a boutique design agency, personified by a fictional namesake, evoking an enigmatic presence and a sense of mystery and fun. Previously, Madelyn and Luca worked in-house for the Gucci Group, with responsibility for the visual identities of some of the world's most luxurious brands – including Bottega Veneta, Sergio Rossi, Stella McCartney and Alexander McQueen. Recognizing that there was a lack of independent designers with experience of the fashion industry, the duo set about building a new business from their unique starting point. Current clients include Burberry, Nokia, Montblanc, Gucci Parfums and *.Cent* magazine. Vivian Cipolla is currently on sabbatical, travelling in Bhutan.

1 Hippodrome Place, London W11 4NG, UK
design@viviancipolla.com / viviancipolla.com

97 360° **Voegeli jtv**

VideoEx – Jonas Voegeli
Client: Video and Experimental film festival, Zürich (2006)

Thunder and Bolt – Jonas Voegeli
Client: Donnerstag and Fusion Lounge (2005)

After studying at the Hochschule für Gestaltung und
Kunst in Zürich, Jonas Voegeli worked in London,
Manchester and Basel before returning to set up
on his own. After stints at the magazine *Graphics
International*, the consultancy Axis Design and as a
founding member of The Remingtons, Jonas worked
with Daniel Stähli on the redesign of the newspaper
Schweizer Tages-Anzeiger. Jonas's approach of
foregrounding and arranging information works
for a wide range of clients, and across cultural
and commercial divides – from record labels and
nightclubs, to film festivals and arts institutions.

Räffelstrasse 25, CH-8045 Zürich, Switzerland
info@voegeli.info

98 360° **Wallzo**

Spy 51/Play for your life – Darren Wall
Client: Corporate Risk Recordings

Love Music Hate Racism – Darren Wall
Client: United against racism

Hot Chip/The Warning – Darren Wall
Client: EMI records

Darren Wall set up Wallzo in 2006, as an independent,
one-person operation dedicated to entertaining
and surprising his audience. After college and while
working in a publishing company, Darren began taking
on personal projects, focusing on the music, fashion
and advertising industries, with the proviso that he
had 'plenty of creative freedom to experiment and
enjoy myself'. He was so eager to experiment that he
even worked for free. Now it is a paying concern, and
Darren is able to indulge his self-confessed 'obsessive
behaviour' for clients including electro band Hot Chip,
Carhartt and MTV.

22 South Island Place, London SW9 0DX, UK
darren@wallzo.com / wallzo.com

99 360° **Bianca Wendt**

Personal Geographies – Bianca Wendt
Client: personal (2005)

1000 Volt – Bianca Wendt
Client: 1000 Volt (2005)

Biz – Bianca Wendt
Art director: Andrew Foxall, 20ML
Client: Biz Magazine (2005-06)

After obtaining a degree in architecture from Sydney
University, Bianca Wendt moved to London and, in
2005, completed an MA in Communication Design at
Central Saint Martins College of Art and Design. On the
move again, she settled in Istanbul and established her
own studio, mixing personal projects with commercial
jobs, and teaching a graphic design course in the local
university. Fascinated by her adopted city, Bianca has
set about documenting it – producing a book about
taxi drivers and a photography project, 8760 hours,
which required her to take a photo every waking hour
for a year. Bianca is art director of *2'debir*, a publication
showcasing art, design, music and literature.

Batarya Sok 16 D4, Cihangir 34334, Istanbul, Turkey
hello@biancawendt.com / biancawendt.com

100 360° **Zak Group**

T3 – Zak Kyes
Client: Architectural Association (2006)

Specialten – Zak Kyes
Photography: Tim Brotherton
Client: Specialten Magazine (2006)

nOulipo – Zak Kyes
Client: Roy Edna Disney / CalArts Theater (REDCAT) (2005)

After a BFA in fine art/graphic design from the
California Institute of the Arts in Valencia, and time
studying with Wolfgang Weingart in Basel, Zak Kyes
settled in London. In 2006, he opened Zak Group and
became art director of the Architectural Association.
Core to Zak's design is a love of writing and colla-
boration, which feeds his teaching and his work with
art collective etoy. His 2005 solo show *All That Is Solid
Melts Into Air* at London's Kemistry Gallery displayed
a twelve-metre-long installation of recent work, much
of which was for clients in architecture and fashion. On
the awards front, Zak won the Creative Futures prize in
2005 and was named a Young Gun by New York's Art
Directors Club in 2006.

Sunbury Workshops, 25 Swanfield Street, London E2 7LF, UK
studio@zakgroup.co.uk / zak.to

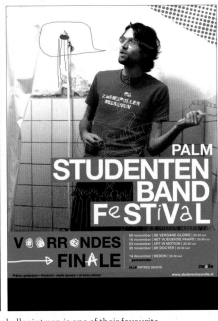

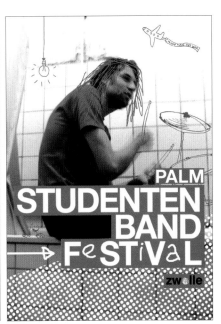

Kim and Matthijs at MAKI love to draw, and the ballpoint pen is one of their favourite devices. Creating illustrations, scanning them, using Adobe Photoshop and then perhaps drawing over the printed result is one way of working. For a series of posters announcing the Studenten Band Festival, they added witty doodles to photos of wannabe popsters.

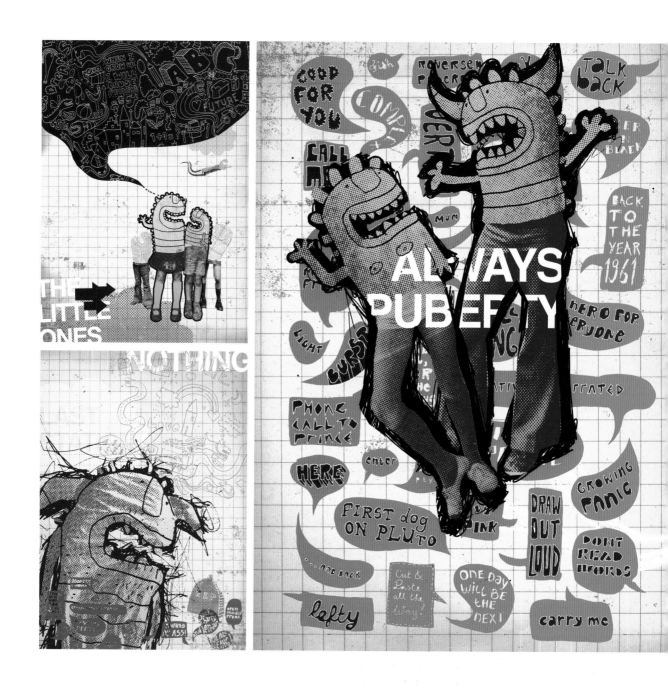

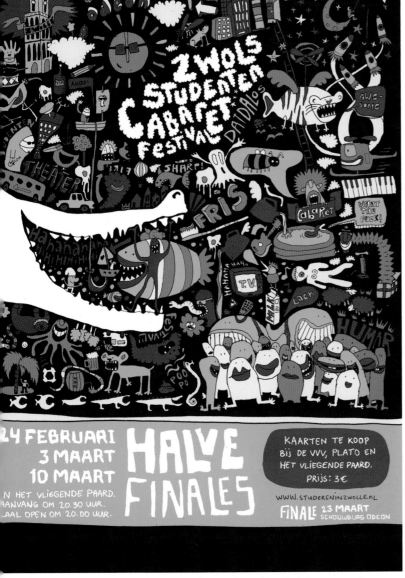

Strange creatures and fantastical objects are a feature of MAKI's work as demonstrated by the Like Life project and the flyers and posters they created for the Zwols Studenten Cabaret Festival. The use of a restricted colour palette in both instances creates harmony in their surreal, imagined universe.

Russell Mann is able to create major impact in print with the most minimal of means.
New is an identity for a start-up clothing store that announces its presence via custom-
designed type in a traffic-stopping colour combination, guaranteeing that their high-
impact carrier bags gain maximum visibility in a crowded retail arena.

A personal project, RUS aims to reflect Russell Mann's minimalist approach to design, using geometric letterforms merged into an iconic logo.

Abstractions in Sound does exactly what it implies, replicating minimalist electronic sounds in geometric, abstracted letterforms.

The Association of Photographers (AOP) annual awards book showcases finalists in a number of categories. MARC&ANNA took 'light' as their starting point, printing the cover in silver with a white-out pattern of radiating lines, repeated in reverse for subject divider pages. Categories were colour-coded, so that the page tabs created a variegated spectrum along the paper edge.

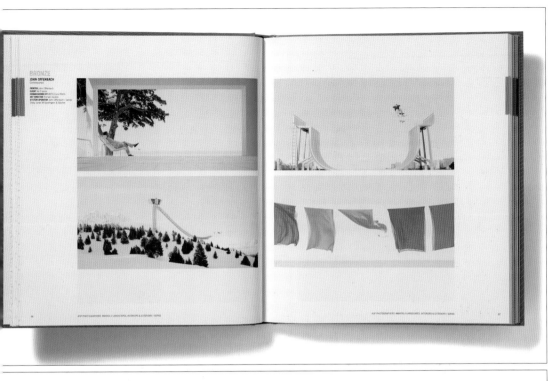

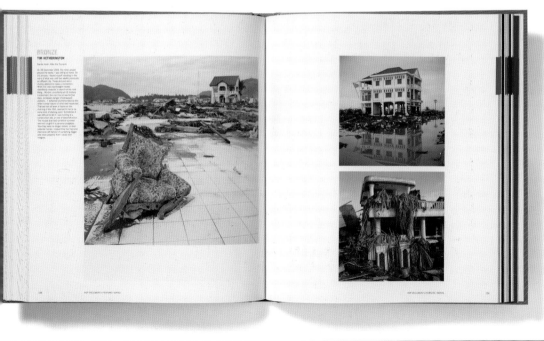

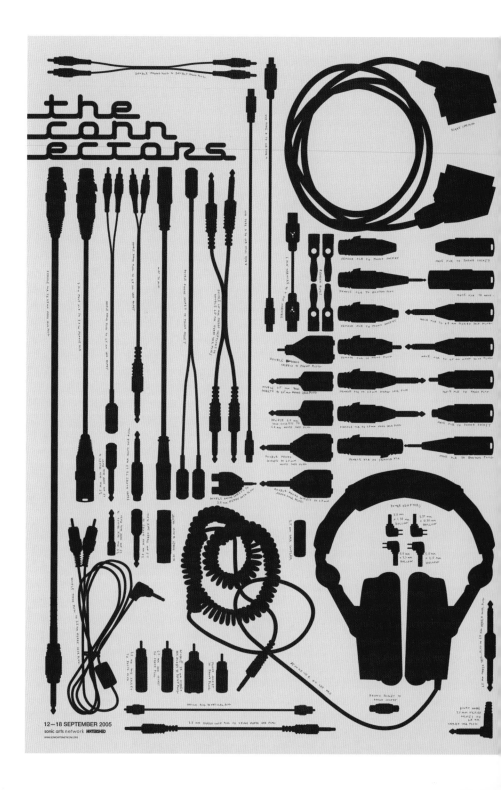

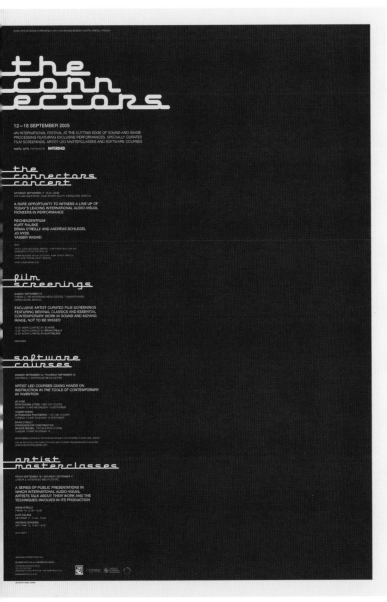

The non-profit organization Sonic Arts Network asked MARC&ANNA to design an invitation for a national audio-visual event, The Connectors. The client left decisions about size and format to the designers. Their solution, a large-scale (B2-size) poster, with event listings on the reverse, presents a 'homage to all things plug-like'.

Working with a roll call of innovative artists and designers, on the Volkwagen-sponsored Project Fox, MASA personalized a number of hotel rooms, creating bespoke carpets, wallpapers and textiles, painting directly onto walls, and dressing the rooms with props and furniture. He also turned the Fox, the car being launched, into a one-off art-car and transformed a transportation container with murals.

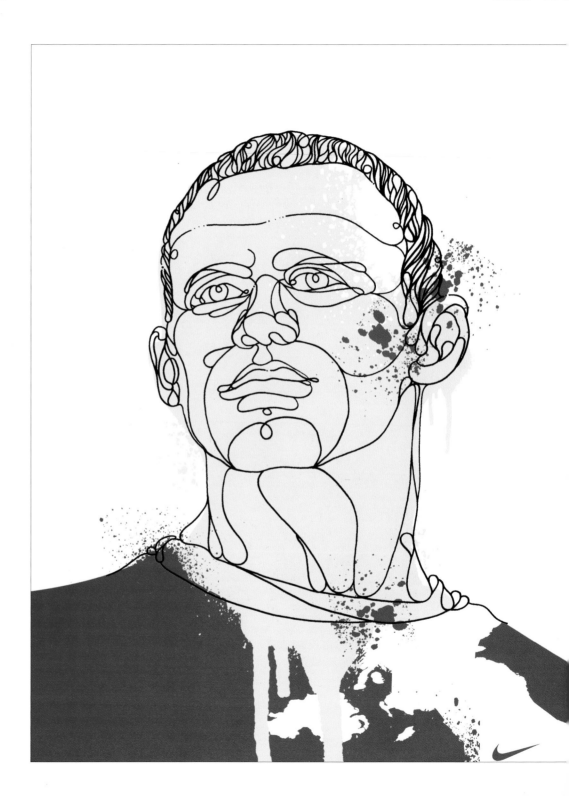

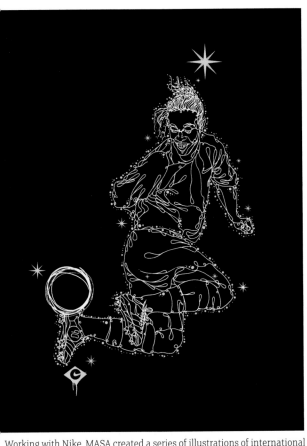

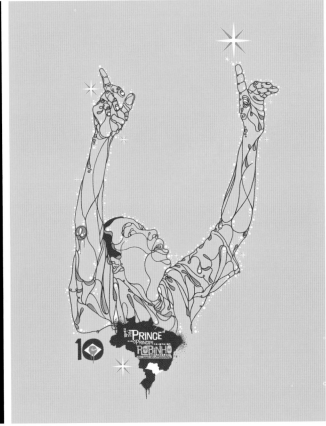

Working with Nike, MASA created a series of illustrations of international soccer heroes, including Rooney, Robinho and Ronaldinho, to be used on a limited-edition series of T-shirts.

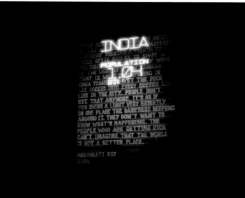

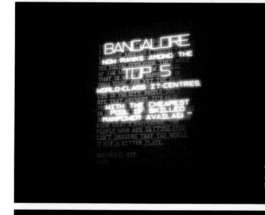

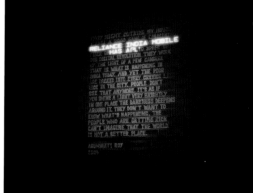

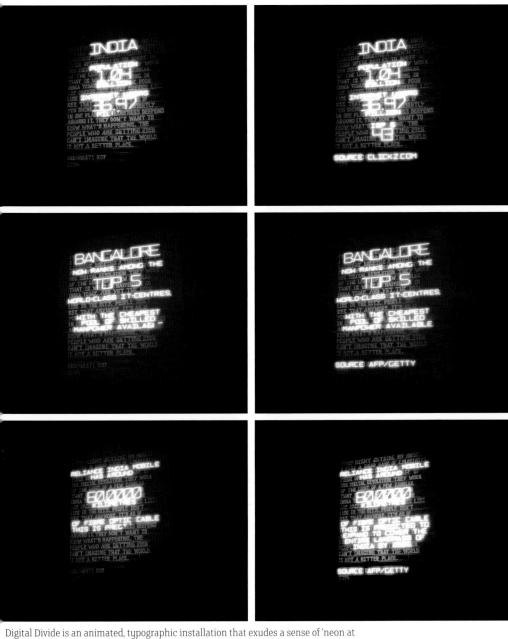

Digital Divide is an animated, typographic installation that exudes a sense of 'neon at night'. It literally brings to life the debate around India's digital revolution, using relevant statistics and quotes from writer Arundhati Roy.

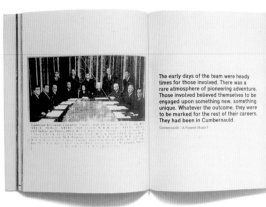

The early days of the team were heady times for those involved. There was a rare atmosphere of pioneering adventure. Those involved believed themselves to be engaged upon something new, something unique. Whatever the outcome, they were to be marked for the rest of their careers. They had been in Cumbernauld.

Cumbernauld – A Flawed Utopia?

Cumbernauld was designated in 1956 when the Macmillan government was telling us we had never had it so good, and the country as a whole looked forward to an era of increasing material-istic abundance.

Jim and Krystyna Johnson,
Cumbernauld Revisited,
Architects Journal October 1977

Cumbernauld is a highly conceptual town in the sense that it is planned, one could say overplanned. It is logically consistent and a theoretically interesting structure but in parts, overdone through its very logicality.

Ferdynand Zweig,
The Cumbernauld Study, 1970

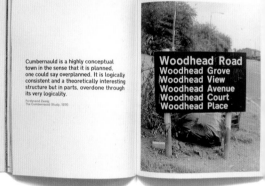

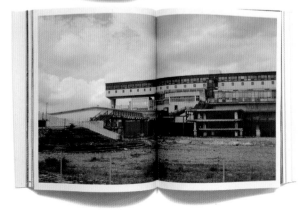

Using his collection of photographs, along with researched archival material, Kieran created *What's It Called?*, a book visually documenting the rise and fall of Scottish new town Cumbernauld, hailed in its day as a triumph of Modernism.

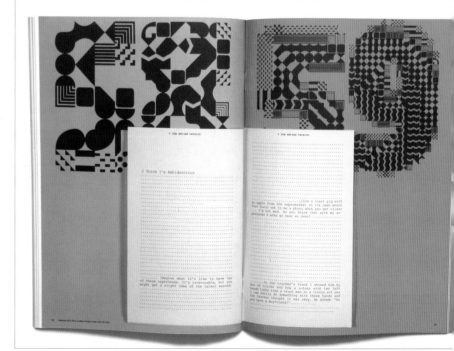

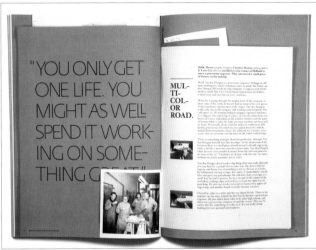

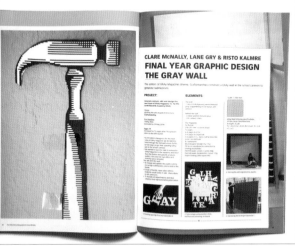

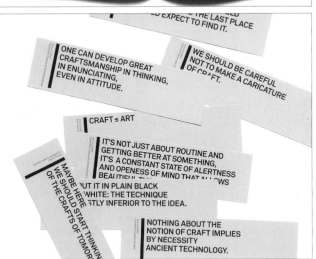

GRAy was a publication commission from the Gerrit Rietveld Academie. This second issue of the magazine deals with 'craftsmanship'. Various stock and page-sizes and a use of documentary-style photography lend the magazine the air of a work-in-progress, or a creative's sketchbook, complete with lists and inspirational quotes.

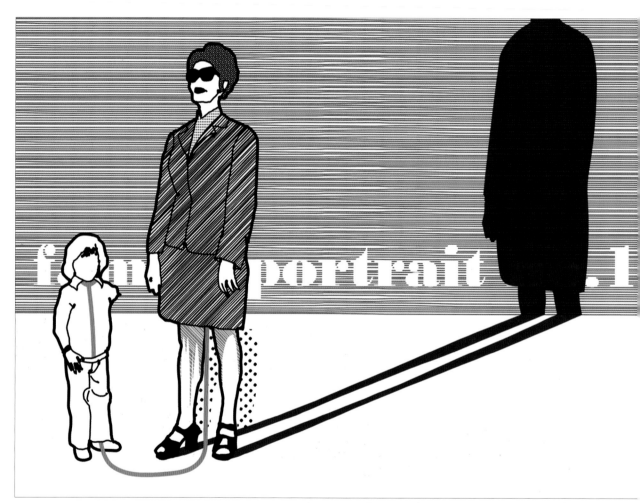

Family Portrait is a large-scale, outdoor poster that is part of an on-going project, and was displayed at the BELEF Festival (Belgrade Summer Festival) in 2006. The theme of activism, both personal and social, was addressed by seven designers from Europe and the USA. Aleksandar Maćašev constructed an ambiguous image of the poignant relationship between mother and child.

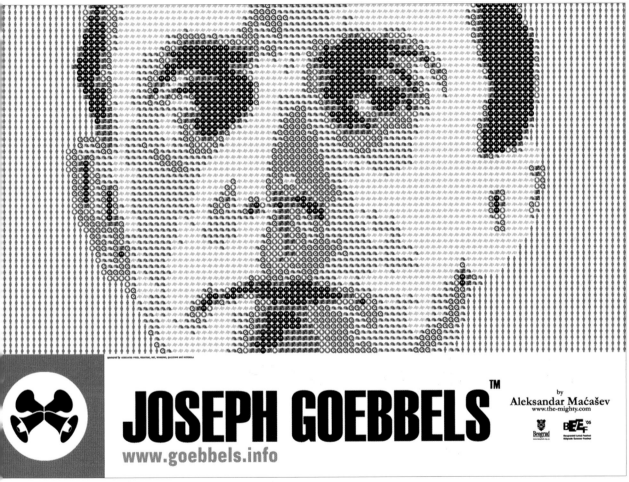

A graphic portrait of Joseph Goebbels, the infamous Nazi minister of propaganda, is constructed from hundreds of logos representing the contemporary media. Three versions of the poster, plus a billboard and postcards, are constructed from different sets of logos.

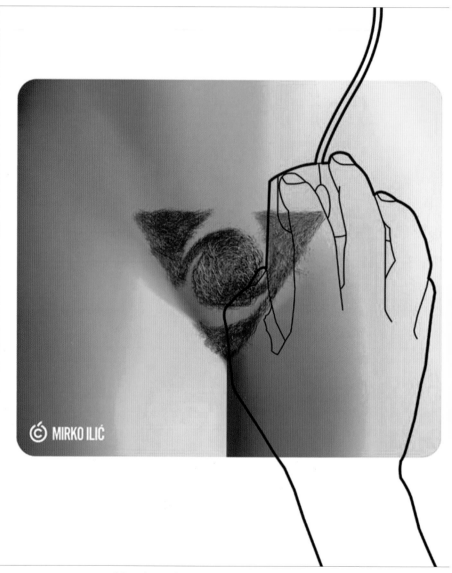

Aleksandar produced an award-winning promotional campaign for a retrospective exhibition of work by New York-based illustrator Mirko Ilic. The aim was to use Mirko's illustrations as a powerful, socio-political commentary on contemporary issues in Serbia to do with the war, sexual politics, tolerance and software piracy. This promotional mouse mat was intended to stimulate a tactile sensation in relation to a provocative image.

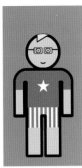
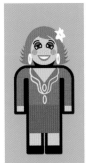

Maja Marinković
art director
Prague

Tatjana Ristić
lawyer
Belgrade

Jelena Stojković
linguist
London

Marko Jobst
writer
London

Stephen Gee
writer
Washington DC

Megan Gallardo
friend
Washington DC

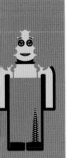
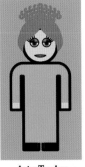

Karen Zareski
californian

Anica Tucakov
art historian
Belgrade

Stefan Arsenijević
film director
Belgrade

Mirko Ilić
designer
New York

Dragoljub Žarković
editor of the 'VREME' magazine
Belgrade

Carlos Gallardo
friend
Washington DC

Using a 'gingerbread man' icon, Aleksandar creates portraits of friends and family by adding specific, personal details onto the generic image.

Working with Dalton Maag, who design bespoke type and logo solutions in partnership with design agencies and corporate brands, Mode produced a book referencing the traditional font specimen book. With an exposed grid and tear-off strips of settings and sizes to place over their layouts, the aim is to raise awareness of Dalton Maag's retail font library.

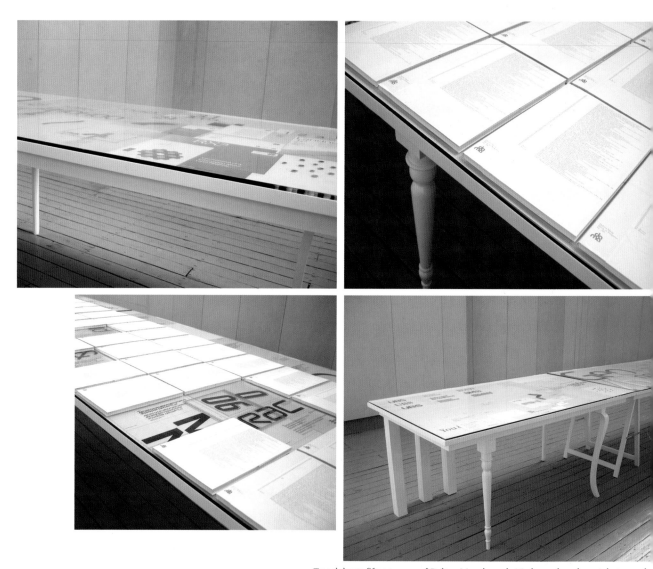

To celebrate fifteen years of Dalton Maag's work, Mode produced a catalogue and exhibition, working in collaboration with architects 6a. A series of bespoke tables, encapsulating original sketches, on-screen developments and final applications of Dalton Maag typefaces, offers a flexible solution for a touring exhibition. Paying homage to Swiss roots, the exhibition kicked off at the Hochschule für Gestaltung und Kunst in Zürich, travelled Europe, visited Brazil and ended up in London.

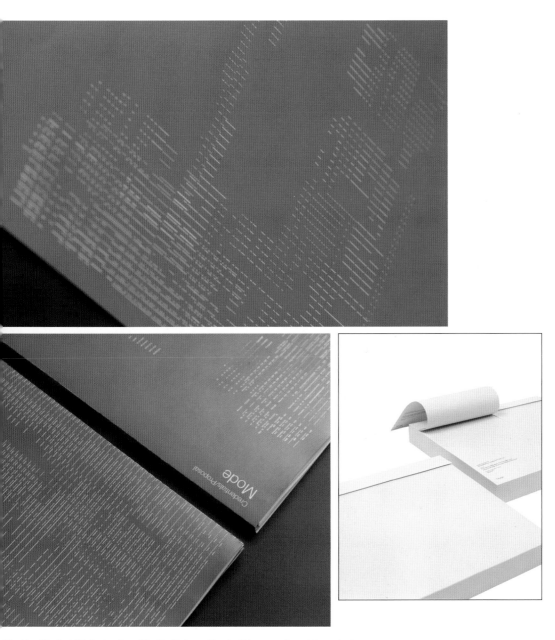

The identity that Mode developed for itself shows the studio's commitment to exploring the frontiers of type.

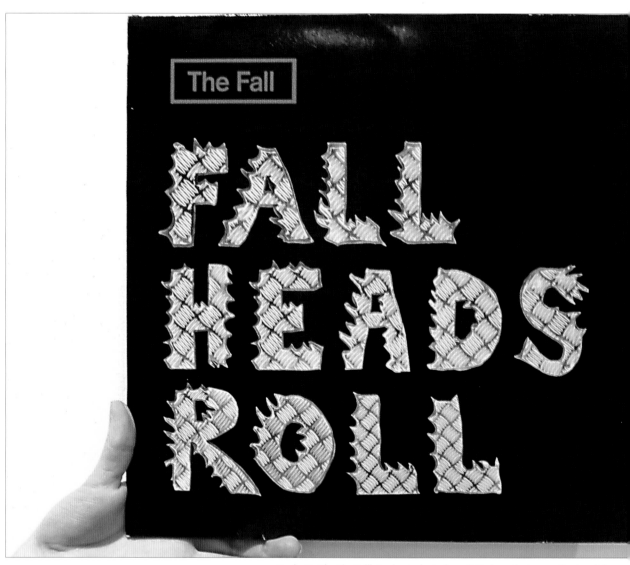

Packaging for The Fall's twelve-inch single and CD sleeve features spiky, hand-drawn type, which perfectly matches the band's quirky music.

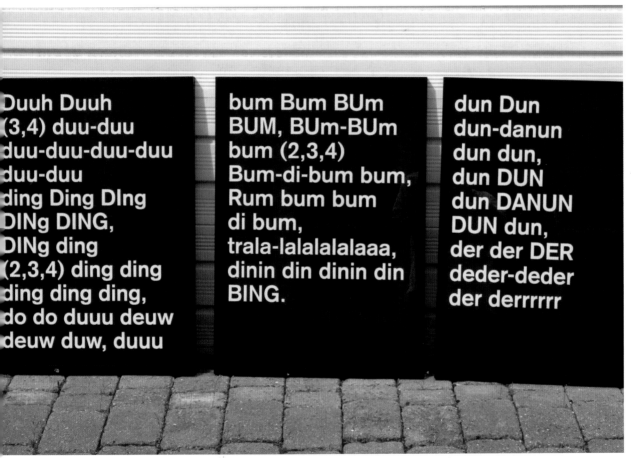

Duuh Duuh (3,4) duu-duu duu-duu-duu-duu duu-duu ding Ding DIng DINg DING, DINg ding (2,3,4) ding ding ding ding ding, do do duuu deuw deuw duw, duuu

bum Bum BUm BUM, BUm-BUm bum (2,3,4) Bum-di-bum bum, Rum bum bum di bum, trala-lalalalalaaa, dinin din dinin din BING.

dun Dun dun-danun dun dun, dun DUN dun DANUN DUN dun, der der DER deder-deder der derrrrrr

This self-initiated project by Tom Munckton (in collaboration with Alexander Turner) consists of three A1-sized posters that aim to amuse and intrigue. Can you guess these wordless theme tunes by humming along?

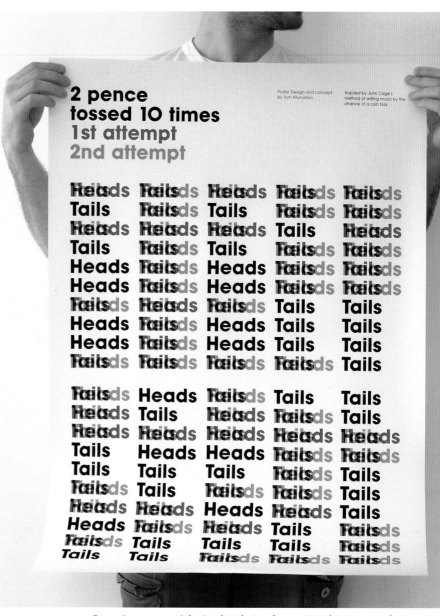

Borrowing composer John Cage's technique for creating arbitrary musical composition by tossing a coin to dictate decisions, Tom incorporates chance into the creative process. In Ode to Cage, he uses the same technique to decide the print order for each element of this silkscreened, A1-sized poster.

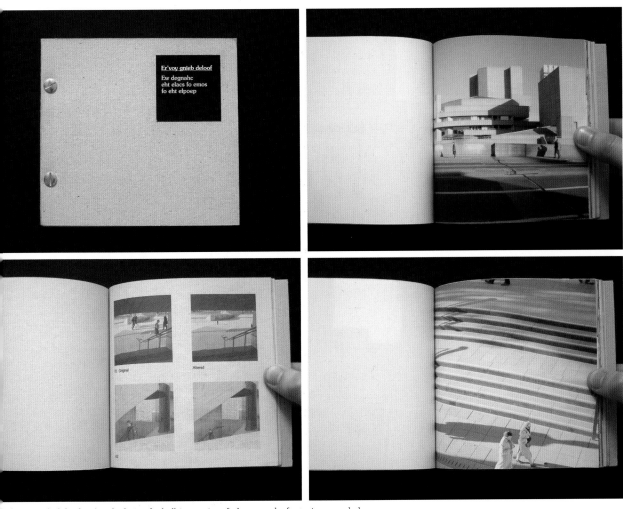

Er'voy gnieb deloof, or 'you're being fooled', is a series of photographs featuring rescaled human figures. The aim is to detect how small or large you can make a figure before the photograph becomes unbelievable. The printed photos are massed together via a very simple 'nut and bolt' binding.

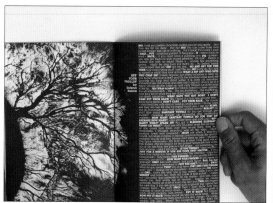

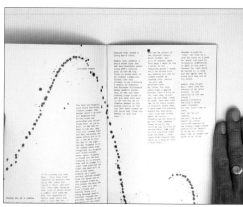

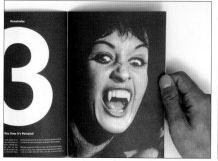

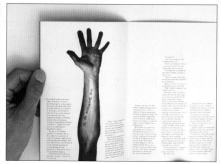

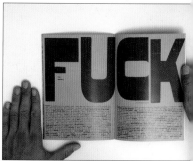

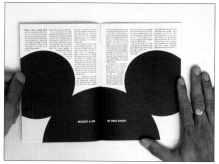

Patrick Duffy of No Days Off started *Full Moon Empty Sports Bag* with a group of fri⟨...⟩
who were inspired to create a magazine free from all the usual commercial constra⟨...⟩
Each issue reinvents itself, combining poetry, fiction, real-life accounts, photogra⟨...⟩
and design, to give voice to the unrepresented and break all the conventions and ⟨...⟩
of publication design. Whether they're binding two A5-sized sections together to cr⟨...⟩
– literally – multiple readings, doing 'violence' to the page by cutting and burnin⟨...⟩
eradicating all typographic devices, this magazine has to be seen to be belie⟨...⟩

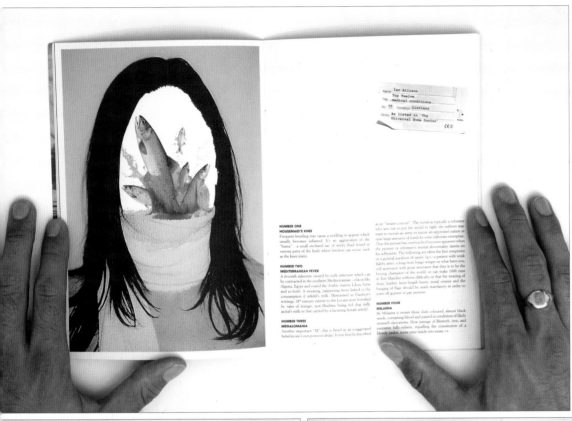

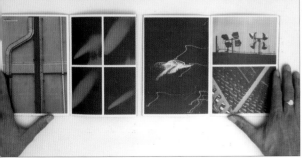

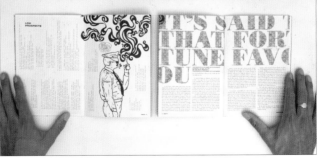

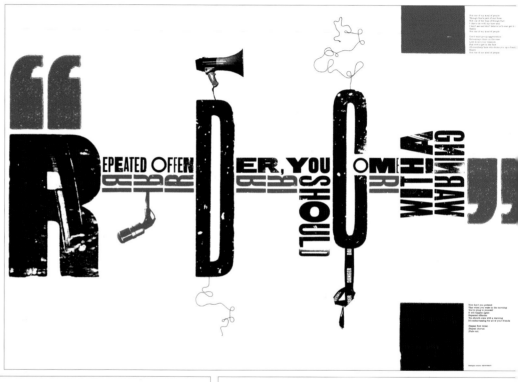

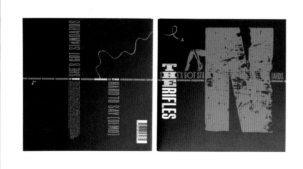

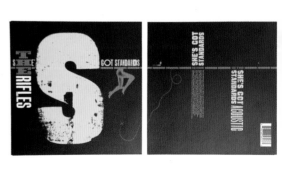

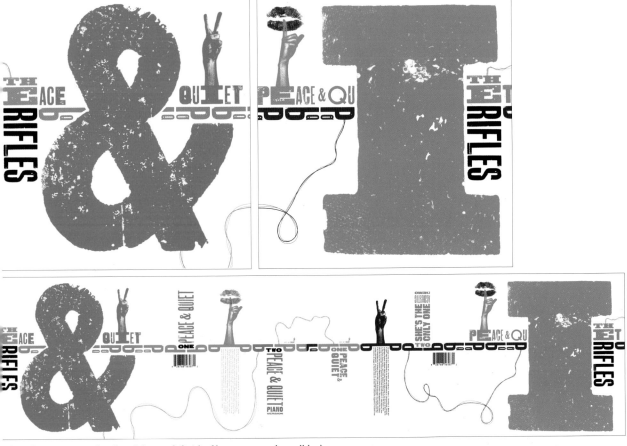

The Rifles are a guitar band, and the rough finish of letterpress and woodblock
type appealed to Patrick as a perfect match for their no-nonsense rock and roll.

The relationship between image and sound was the starting point for creating an identity and print for the Happy Days Sound Festival in Norway in 2005. Working with photographer Andreas Meichsner, Node created images of people making sounds. The series is also in homage to Kurt Schwitters and a photo that documents him performing sound poetry in Oslo.

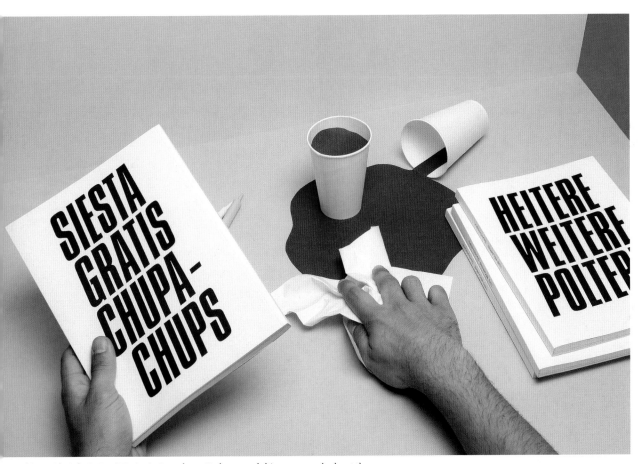

Working with Galeria Toni Tàpies in Barcelona, Node created this monograph about the Catalan artist Tere Recarens, using their signature mix of strong typographic treatment and witty photographic treatments.

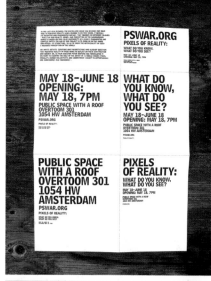

AHRON SHABTAI
BANU CENNETOGLU
CARLOS LLAVATA
CHRIS VECCHIO
CHRISTIAAN BASTIAANS
FABIAN MARCACCIO
HARUN FAROCKI
IVAN GRUBANOV
JON KESSLER
KRZYSZTOF WEGIEL
NICOLE COUSINO
PRANEET SOI
RAINER GANAHL
RINAT KOTLER
SAGI GRONER
WAEL SHAWKY

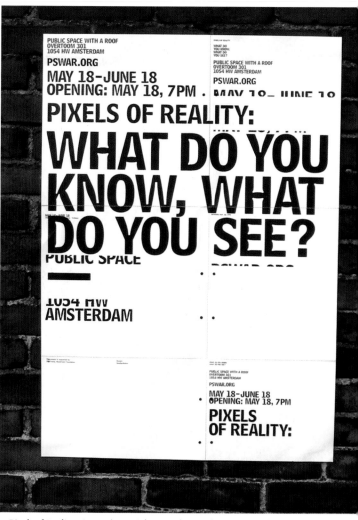

Pixels of Reality aims to 'zoom in' on our digitized perception of the world, revealing its true, fragmented nature. Working with Adi Hollander, Tamuna Chabashvili and Vesna Madzoski at Public Space With a Roof, the One Day Nation team set out to re-examine notions of 'political' and 'art', and the role the media has in turning aesthetics into 'anaesthetics'. The project's graphic identity showcases a typeface designed by Matthew Carter (for use in telephone books and on billboards), which reveals its unique qualities when shrunk-down or blown-up.

Changing the nature of content provision, debate and journal publication, Thinktank is a 'groupware' research and development project initiated by Inga Zimprich. A number of conversations with remote participants were instigated online for an entire month. The resulting publications set out to visualize the dynamic between up to eleven participants, with the format dictated by the number of speakers. Using the services of Print On Demand, any number of copies could be produced. One Day Nation has designed Thinktank within the challenges and restrictions of this revolutionary publishing service.

James Joyce's One Fine Day persona creates beautifully naïve, deceptively uncomplicated imagery for a range of clients. A monthly party located in central London, 'it's bigger than' asked One Fine Day to create new flyers and poster artwork for each event. James designed the pieces so they could accumulate into an evolving, projected showreel.

Alongside commercial projects, James produces limited editions of silkscreen-printed posters.

SOMETIMES I Wonder if the WORLD if BEING RUN by SMART PEOPLE Who Are PUTTING US ON, OR BY imbeciles that REALLY MEAN it

We Can Stop Climate Chaos is a series of images for environmental charity Stop Climate Chaos, supported by Penguin Books. All proceeds from the awareness-raising posters go to charity.

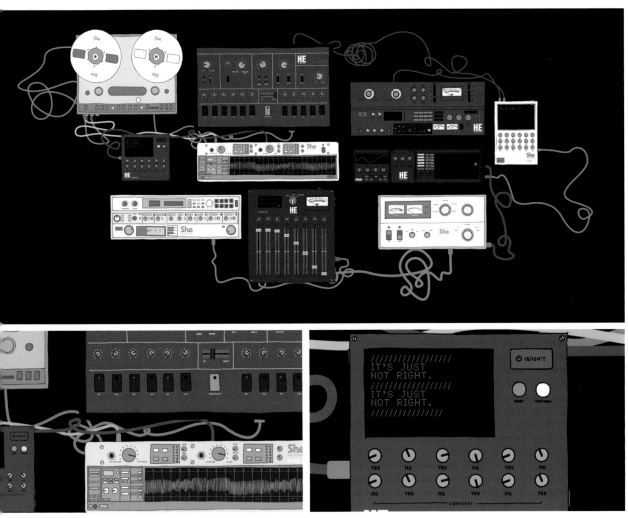

Someone Like You, an animated promo for Swedish electro outfit REVL9N, charts
a burgeoning relationship – between male and female recording equipment.

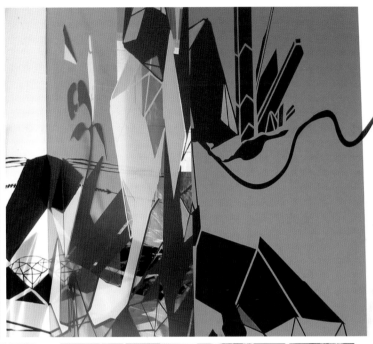
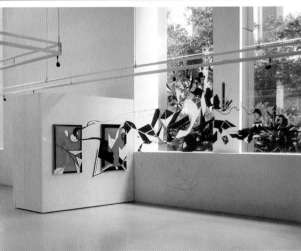
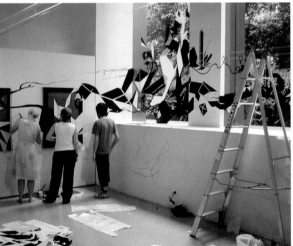

Pandarosa used the simple, but effective device of a spider-like web in their animated projection Perspacial. With Shadows in a Diamond Cave, Pandarosa took graphics literally off the page as part of the *Translation* group show held at Gallery 101, in their hometown of Melbourne.

With a day from idea to artwork, the Tapehead identity gave Paul the opportunity to wrap Peter's head in tape and photograph the results. 'We only do music packaging for friends or musicians we really like, because it's always such a pain....but using C90 tape to create an image to go on a twelve-inch record seemed too ironic to pass up. Dead formats R US!' The rough and ready approach was emphasized by printing the sleeve on uncoated bond paper.

PLUG//FRIDAYS//
OCT//07/NOV/04//
JEFF/MILLS//
X-ECUTIONERS/
PETE/TONG//
RAHZEL///
BENJI/B//
GROOVERIDER//
DANNY/KRIVIT///
SQUAREPUSHER//
GOLDIE/LOOKIN/CHAIN//
GILES/PETERSON//
20:20/SOUNDSYSTEM///

Converting an old club and the vacant supermarket next door into one giant venue –
with three separate offers all under one roof: live venue, edgy/underground night club
and slick, commercial club – gave Peter and Paul their biggest challenge to date. Asked
to design the interior, identity, print and website, they used the three colour-coded wires
of a plug – with its live, neutral and earth elements – to differentiate between spaces,
themes and visuals.

Petpunk entered an invited competition to design the identity for MTV Exit, which aimed to raise awareness about human trafficking in Eastern Europe. Setting out to warn potential victims, including those travelling abroad on holiday, the campaign combined 'fluffy' imagery with hidden, 'spiky' detail – the message being 'stay vigilant'.

Welcome is a promo video for a Eurovision song representing Lithuania. Mixing fairytales
with contemporary culture, Petpunk set out to entertain with a witty animation that
plays with national identity and is full of hidden meanings.

Diego Vargas Sales is Pixel Nouveau. His intense images are simultaneously shocking and bizarre. Diego collages with photographic imagery that he treats with digital effects to create surreal landscapes inhabited by strange creatures. Diego constantly re-appropriates and re-configures these images, turning a visual into a print, wallpaper, an animation or a live projection. Warter, Conjunto and Tres Argumentos are all personal projects, while Diego has also participated in Accept and Proceed's A&P logo project, with a pair of monogrammed birds.

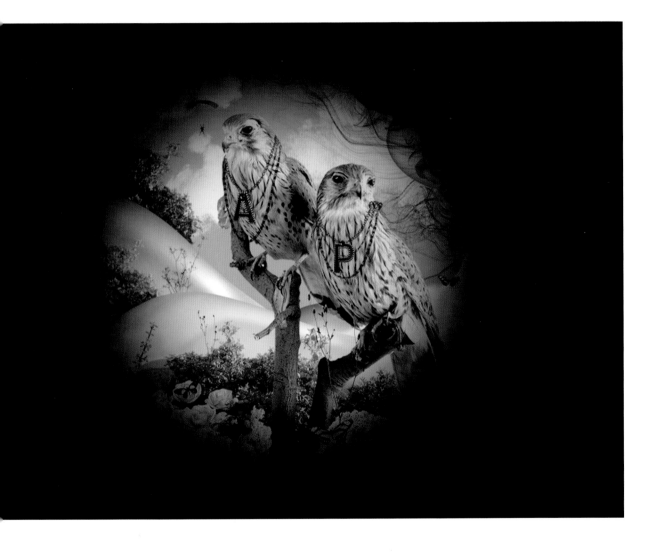

A series of posters for this 'adult' content website were printed in dark ink on a black ground. During the day only the type is visible, while at night the back-lit installation produces enough contrast to reveal the erotic content.

VE BURN
THEM TO
ASHES,
AND THEN
URN
THE
SHES·F451

TRAVIS : DEATH TO THE OPPRESSOR,

JOHNNY: THE

RESISTANCE,

WALLACE : LIBERTY,

TRAVIS: ONE MAN

CAN CHANGE THE

WORLD

WITH A BULLET

IN THE

RIGHT PLACE

...REAL BULLETS.

IF....

, PROBABLY A
VIRGIN , BUT
GOOD
MILITANT MATE-
RIAL.
MASCULIN/
FÉMININ

CINÉMA du PARC | THU & FRI | JULY 3 to 23
4 281 1900 | 3575 ave du PARC | 7:00 and 8:00

THÉÂTRE Cinéma PARC | DATE Mon.-Fri. | DATE may 1 to 7
TL. 514 281 1900 | 3575 du Parc | 5:30 and 8:30

THÉÂTRE CINÉMA du PARC | MON & WED | DATE JUNE 5 to 21
TL. 514 281 1900 | 3575 ave du PARC | 6:30 and 8:30

Creating posters for the screening of a series of sixties films, Peter Crnokrak of Plusminus adopted a language of black-and-white text and image that affords maximum flexibility. For Lindsay Anderson's *If...* Peter adopted the peace dove as a symbol of sixties rebellion. Some of the type was added by hand with a black marker pen.

A poster and brochure for the Mobile Digital Commons Network (MDCN) symposium in Montreal includes a 3D map of the city showing wireless hotspots and the 'freedom' bird logo.

RIOT

issue.04 POP.CULTUR
Australia $7.95 www.riotmag.n

9 771832 959002

RIPE FOR THE PICKING

JEFF BUCKLEY
SUSUMU YOKOTA
BELGRADE
KINGS OF LEON
GEEK GRAFFITI
NIRVANA
FASHION WARS
& ELLEN JONG
PISSES ON
NEW YORK

Asked to design a template, masthead and layout of a new progressive and adventurous magazine, Qube Konstrukt created a strong visual identity while retaining the freedom to radically change the look with each issue to reflect the ever-changing nature of pop culture. Using two typographic approaches – classic, in reference to art journals, alongside contemporary, handcrafted and illustrative elements – they underlined both the intellectual and experimental attitude of featured artists and designers.

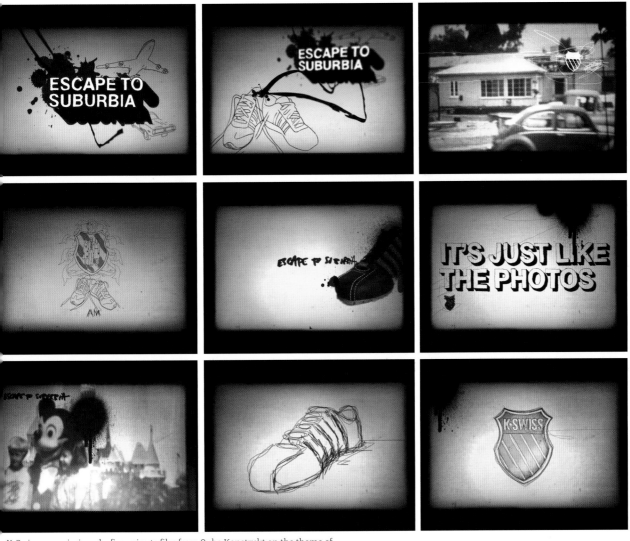

K-Swiss commissioned a five-minute film from Qube Konstrukt on the theme of 'suburbia'. Featuring found images and footage of Australian suburban life – rescued from charity shops and digitally treated – the team recreated their childhood memories via a dreamy, nostalgic home-movie about a child's first trip overseas.

MACHINE FROM HELL

7MACHINE FROM HELL

machine from he

Working with superReal Digital Media, Carsten designed a number of logo ideas for a
high-performance pro-gaming computer. The skull version is used on the website, while
the others have been applied to various merchandise.

Carsten designs lots of T-shirt graphics. This one was for a competition, and was to be printed in four colours on a blue ground.

N°18

DAS SCHIFF

SA 18. JUNI 05
TÜR 23:00

CLIENT

MUTE RECORDS, LONDON

DIRTY PRETTY
THINGS

FEAT. CARL BARÂT & GARY POWELL
(THE LIBERTINES)
VERTIGO RECORDS, LONDON

DAS SCHIFF : WESTQUAI · HAFEN BASEL · ANLEGEPLATZ WIESEMÜNDUNG
WWW.DASSCHIFF.CH

N°49

FR 30. SEPT.
TÜR 23:00

DAS SCHIFF DJ

COSMIC
ROCKER

ORGANIC GROOVES
CODEK RECORDS, NY

VISUALS:
ALEX GLOOR

DAS SCHIFF : WESTQUAI · HAFEN BASEL · ANLEGEPLATZ WIESEMÜNDUNG
WWW.DASSCHIFF.CH

Two series of posters by The Remingtons, for venues and bands, use found formats and typography as their starting point. For Das Schiff, the posters adopt the language of by-gone travel, by bus or tram, with the date highlighted and the overprinted type approximating the low-tech print technology of a ticket machine. The Typo poster series look like 'font alphabets' or letter puzzles. They inform and intrigue.

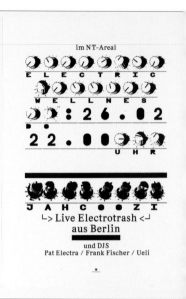

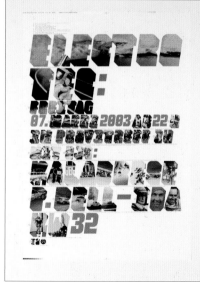

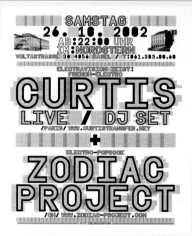

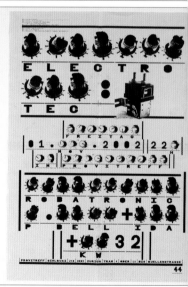

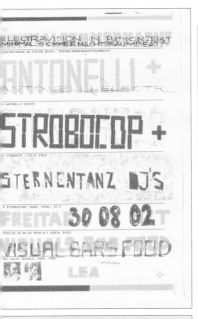

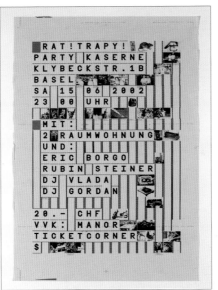

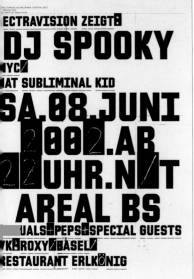

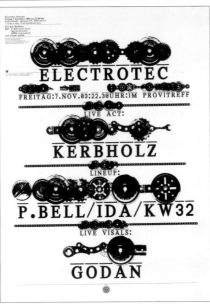

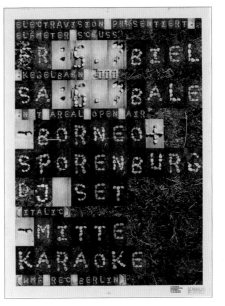

Adam is an identity for a recruitment consultancy that thinks of people as individuals, not numbers. Asked to name the company, produce a logo, typeface, stationery, promotional items and adverts, Adam Rix also came up with the idea of mailing this ceiling tile to company directors, asking them to insert it in the staff canteen ceiling.

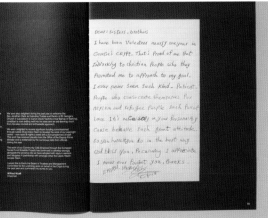

twelve is an award-winning annual report for St George's Crypt, a homeless shelter. Asking the homeless audience to contribute text and images to the charity created a human connection with a usually marginalized audience, and produced an engaging and thought-provoking piece of literature.

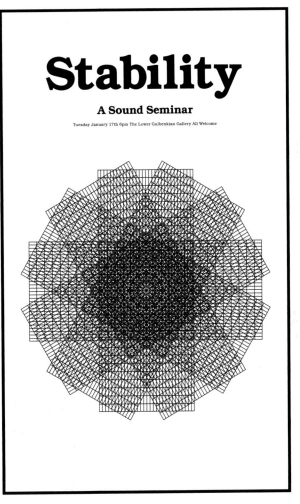

Exploring his fascination with geometry, Richard Sarson produced a number of posters introducing the Sound Seminar series. Using the simplest of means, strong typography, line illustration, black ink and white paper, Richard aims to express ideas via shapes generated with a grid devised from the golden section.

Satian Pengsathapon designed a series of self-promotional greetings cards, offering a message for all occasions via speech bubbles and flowers.

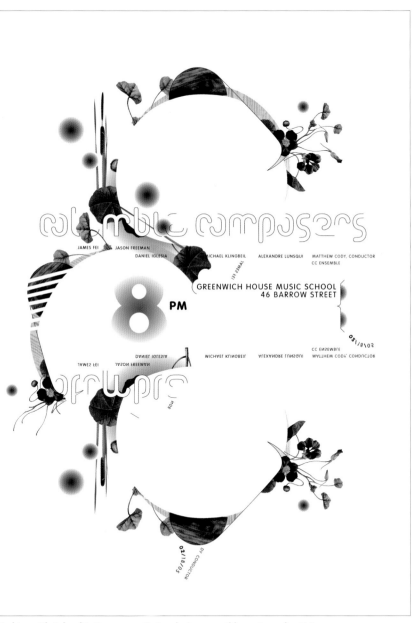

Working with Columbia Composers, Satian designs monthly posters advertising
the group's recitals and concerts, using delicate illustration and decorative type.

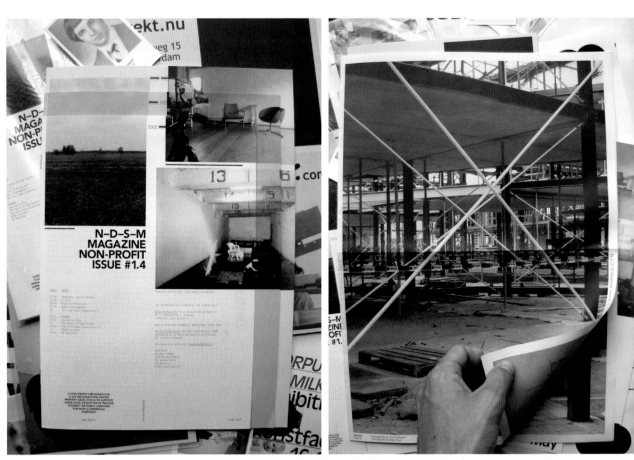

Working with Matthias Kreutzer, under the name Matthias-Jens & Jens, the duo made *N-D-S-M*, a magazine of three issues dedicated to the topic of 'non-profit'. The sponsoring organization NDSMwerf works with artists and craftspeople, aiding cooperation and creativity.

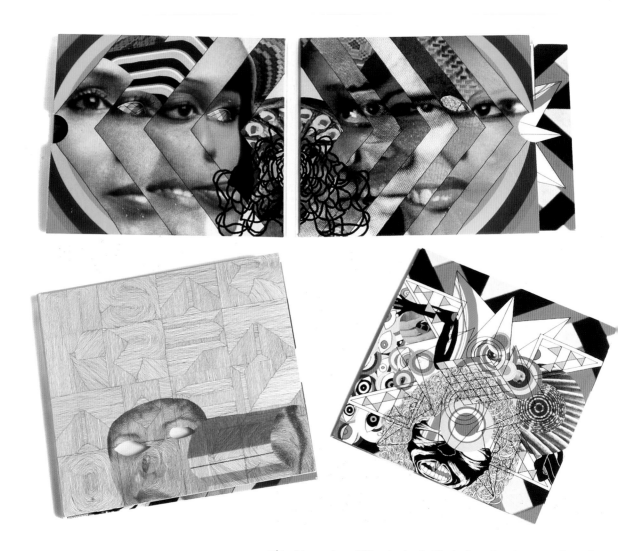

This virtuoso piece of CD packaging, for The Looks on Last Gang Records, combines die-cuts and found imagery to create a claustrophobic sense of surveillance. Images are layered and overlapped, using line, colour and various graphic languages to disorientate.

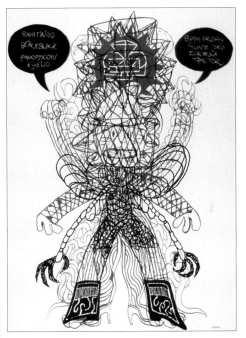

Séripop reckon they've made 'about a billion posters since 2002' for bands and friends, and friends with bands. Their preferred medium of silkscreen printing allows for the layering of images and their signature use of colours.

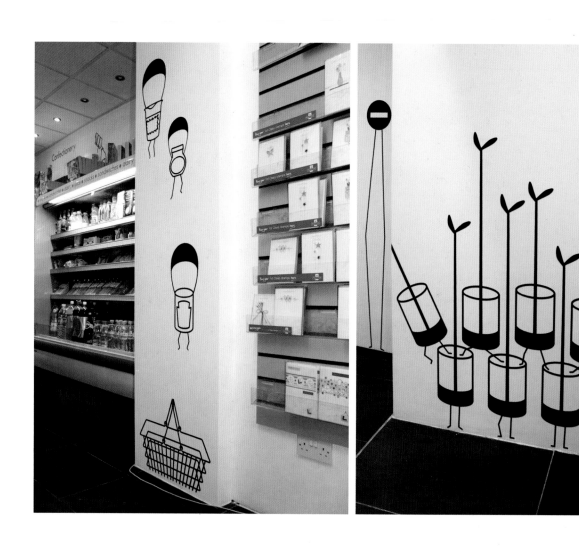

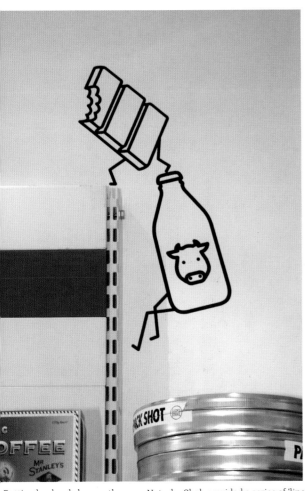

Putting her local shop on the map, Natasha Shah provided a series of 'line-drawn' vinyl decal icons for News @ The Grove – signposting services (such as the ATM machine) and directing customers to popular products on various aisles (e.g. where to find the chocolate!). With local customers who don't necessarily speak English, Natasha's icons had to be elegant, identifiable and culturally non-specific.

From a business card to a building hoarding, Natasha's Heart project needed to work across scale and media. Adapting Milton Glaser's famous I ❤ New York campaign, Natasha set out to promote her corner of London by featuring stuff she loves about the city – most especially a Full English Breakfast, hence the baked beans can!

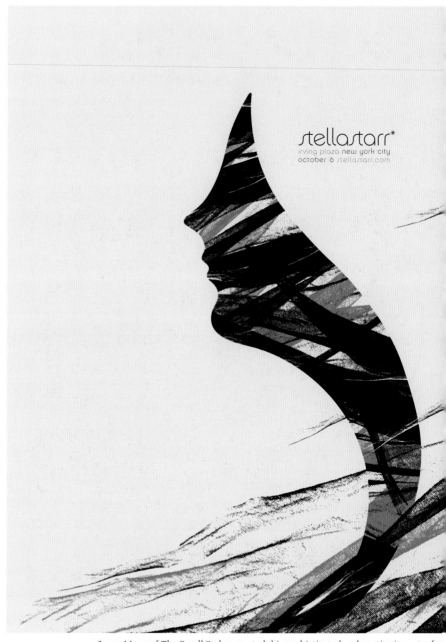

Jason Munn of The Small Stakes created this sophisticated and poetic gig poster for Stellastarr*, using his favoured medium of silkscreen printing. A masked-off silhouette is delineated via vigorous 'brushstrokes', which also suggest long, windswept hair.

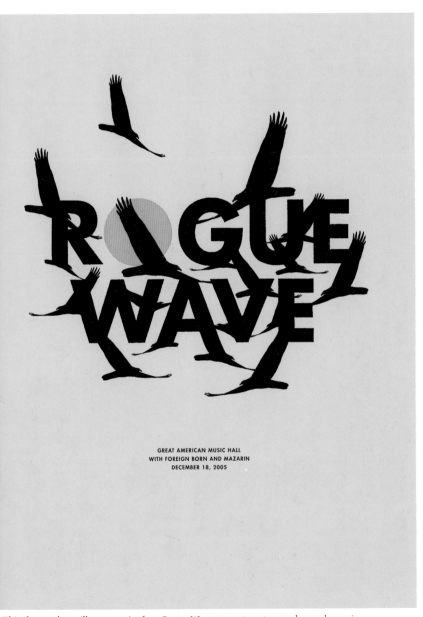

This three-colour silkscreen print for a Rogue Wave concert poster employs a dynamic type-image with majestic, swooping birds, merging and emerging from the logo.

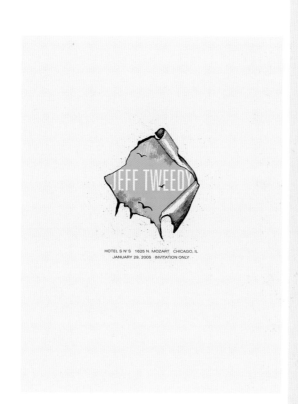

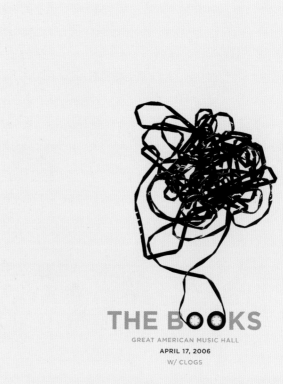

The central image of this poster is a *trompe l'oeil* device approximating torn paper. It quietly and surreptitiously announces Jeff Tweedy's gig. For the band The Books, Jason produced a bespoke type-image from unravelled cassette tape, hinting at a lo-fi, retro aesthetic. A visual joke is created using the band's name as a stand-in for the cassette-tape housing.

A SAN FRANCISCO LITERARY FESTIVAL • NINE DAYS • 250 AUTHORS

OCT. 7 – 15, 2005
LITQUAKE
LITQUAKE.ORG

Litquake is sponsored in part by San Francisco Chronicle • HarperSanFrancisco • MacAdam/Cage • craigslist • Avalon Publishing Group • Chronicle Books • Alibris • Grants for the Arts/San Francisco Hotel Tax Fund • Zellerbach Family Foundation • William and Flora Hewlett Foundation

Jason created this poster for the San Francisco literary festival Litquake by constructing
an iconic exclamation mark from an overlapping, cut-up collage of columns of type.
The technique of silkscreen printing is a perfect method for realizing this image.

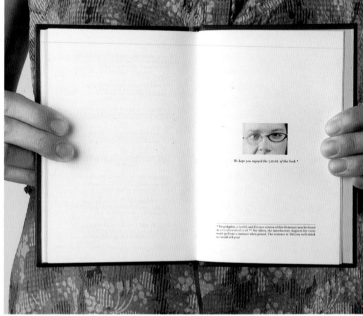

In an attempt to go beyond the grid while working with Alan Kitching in the letterpress department of London's Royal College of Art, Astrid chose to typographically re-interpret Ambrose Bierce's The Devil's Dictionary. Creating new definitions, additional text, indices and bindings, Astrid's book subtly subverts while aiding understanding.

DAVID CASACUBERTA *E-Philosophus*

David Casacuberta enseña filosofía de la ciencia en la Universitat Autònoma de Barcelona (UAB) y es un experto en las implicaciones sociales y culturales de las nuevas tecnologías. Ha escrito diversos libros y artículos sobre el tema y trabaja con www.transit.es en proyectos internacionales que tienen que ver con la e-inclusión, como e-Learning for E-Inclusion y Face Value. Como docente ha colaborado en varios masters y postgrados. Y como artista forma parte, junto a Marco Bellonzi, del grupo dentd–c.

David Casacuberta teaches science philosophy at Universitat Autònoma de Barcelona (UAB) and is an expert in the social and cultural consequences of new technology. He has written several books and articles on the subject and works with www.transit.es in international projects related to e-inclusion, such as E-Learning for E-Inclusion and Face Value. As a teacher, he has taken part in several masters and graduate programmes. And as an artist, he is part of dentdvdc group together with Marco Bellonzi.

CONFERENCIA / CONFERENCE

Introducción al concepto de Web 2.0, mostrar como esta nueva Internet no se basa tanto en las nuevas tecnologías sino en la construcción y el diseño colectivo de contenidos entre todos los usuarios, consiguiendo así enormes bases de datos de información y conocimiento que con el esfuerzo de un solo equipo de personas sería imposible. En paralelo, mostrar como el diseño cargado, móvil, barroco del tiempo de la 'burbuja' ha sido sustituido por un diseño muy simple, basado en conceptos de accesibilidad, eficacia y funcionalidad.

An introduction to the concept of Web 2.0, showing how this new Internet is not based only on new technologies, but rather on the building and design of groups of contents among all users. Thus, we all have to our disposal huge information and knowledge databases that would be unachievable with just the work of a single team. At the same time, we will show in this new Web 2.0 model how the oversaturated and mobile design of the 'bubble' times has been replaced by a very simple design, based on concepts such as accessibility, efficiency, and functionality.

□ Conferencia / Conference: 05/07/06, 18h

FORUM LAUS EUROPE 2006

Frontiers

Freedom calls

05 – 08 July / Barcelona
www.forumlauseurope.net

Designers that are thinkers. Intellectuals that are art directors. Illustrators that shoot photographs, typographers that make films. European studios with New York City clients. Parisians in London, Berliners in Barcelona. Global thinking guides our most creative minds towards new and undiscovered areas, migrating with ease across frontiers.

At Forum Laus Europe 06, ADG-FAD and ACD*E unite those who cross their own boundaries to explore other fields. Voices as eclectic as Spin, A2/SW/HK, Oliviero Toscani, å.b.å.k.e., Red Spider, Tony Herst, David Casacuberta, Francesc Muñoz, Alexandre Bettler and Francesc Ruiz amongst many others.

They'll recount tales of travels across disciplines and share their experiences and ideas. We want to know how they redraw the limits of their own territories, what their creative options are, and how far they've got to go to achieve creative freedom.

□ A1/SW/HK (Henryk Kubel)

□ A2/SW/HK (Scott Williams)

□ David Casacuberta

□ Oliviero Toscani

□ Alexandre Bettler

Forum Laus Europe 2006 was a conference held in Barcelona, bringing together speakers and audience from across creative disciplines, and celebrating the migration of thinkers and doers between countries and methodologies. Astrid designed a website, print material and signage, using the sounds and images of migrating songbirds to represent the tagline 'Freedom Calls'.

Exploring the relationship between surface and ink, Frauke Stegmann layers the richest print technique – gold embossing – onto low-grade paper to create a series of CD covers for the experimental jazz label Treader. A keen wildlife watcher, he reprises the technique for a second series, this time featuring exotic birds.

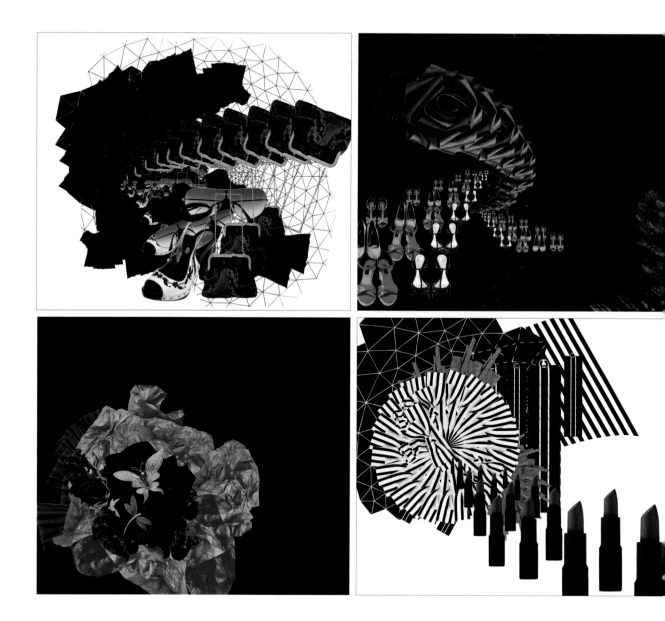

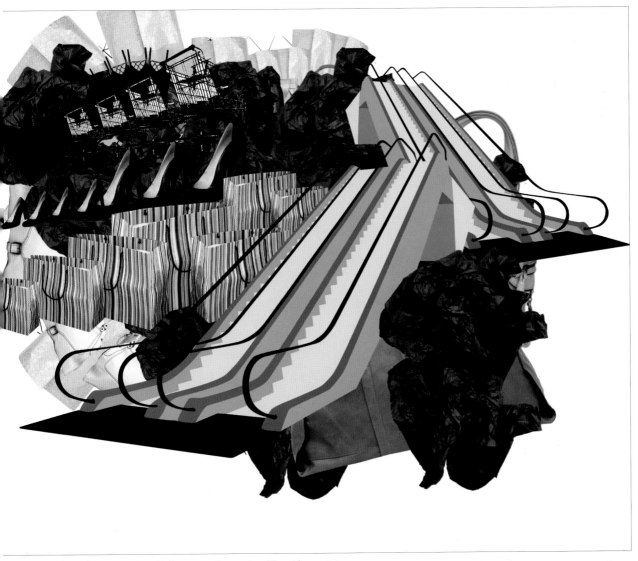

The magazine *Lucky* commissioned Stiletto to make a series of five video spots to be aired on television. Giving the studio an open brief to use abstraction to interpret the consumer culture, the aim was to demonstrate how fashion knowledge and taste travels virally – as in 'where'd you get that bag' – after certain items were featured in the magazine.

2060?

Working for the American-based charity RAN (Rainforest Action Network), Studio8 developed a concertina and gatefold booklet and a B1-sized poster; both were intended to raise awareness about the destruction of the Amazonian rainforest. Mixing crisp, precise type – in stark black and white – with intricate images of diseased foliage, the countdown to destruction is presented in high contrast.

Benjamin Markovits and Adam Thirlwell
on brands in literary modernism
28th April 2006, 8pm, National Art Library in the V&A
A Lanternlit lecture

Think of what our Nation stands for,
Books from Boots and country lanes

What is home without
Plumtree's Potted Meat?
Incomplete.
With it an abode of bliss

Benjamin Markovits and Adam Thirlwell
on brands in literary modernism
28th April 2006, 8pm, National Art Library in the V&A
A Lanternlit lecture

Commissioned by London's Victoria and Albert Museum to publicize a Lanternlit lecture at the National Art Library, these two limited-edition posters adopt a simple, geometric arrow device with a nod to Constructivism. Pull-quotes from various Modernist works of fiction test the literary knowledge of the viewer/reader.

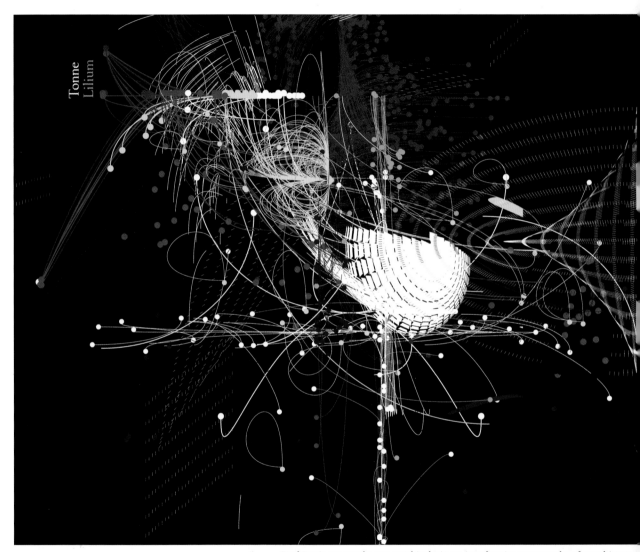

Paul Farrington works as a graphic designer, interface innovator and performs his own music under the name of Tonne. He develops label identities and designs covers not only for his own releases (Lilium is his second album), but also for other electronic artists.

SoundToy is simultaneously a software CD providing a programme for sound and image interaction and an audio release by the BipHop label of new work using that software by four of today's most innovative electronic artists. Originally developed while Paul was still studying at London's Royal College of Art, SoundToy allows you to drag music samples into a sequencer to create both colourful patterns as well as interesting sonic contrasts and combinations.

Klitekture is a music label based in Barcelona specializing in experimental computer music. Paul designed a cover for the release of the second volume of this compilation album using his SoundToy software.

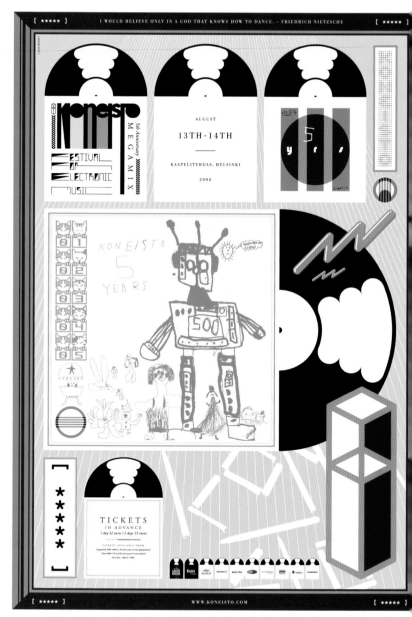

Koneisto is an electronic music festival, and to develop the brand across print, web and broadcast applications Syrup adopted a funky-retro approach, harking back to the early days of electronica.

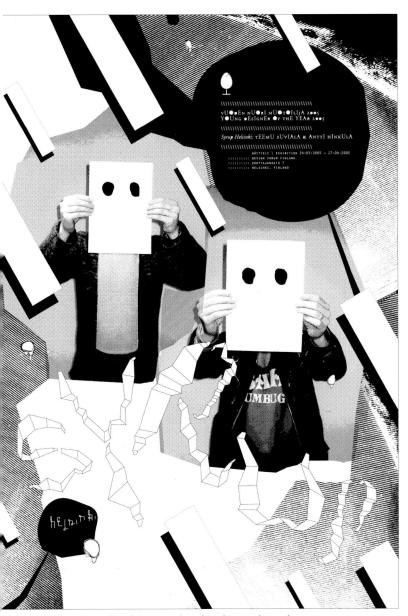

A witty, staged photo is collaged into a rough-and-ready, anarchic Dada-esque poster design promoting the Young Designers of the Year exhibition at Design Forum Finland.

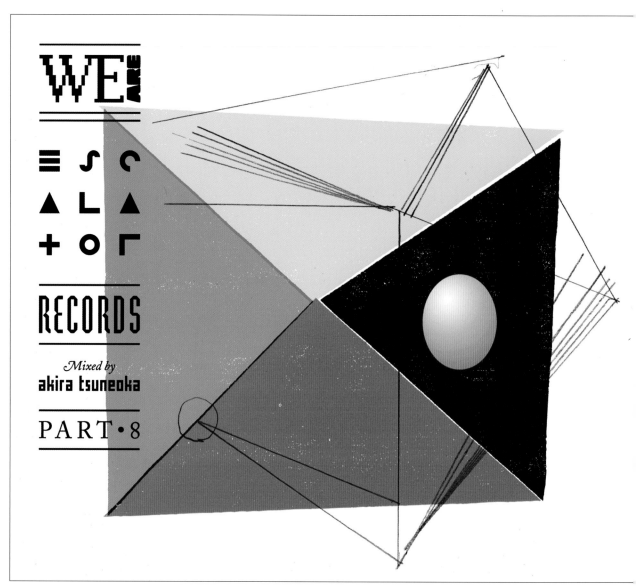

WE ARE ESCALATOR RECORDS
Mixed by akira tsuneoka
PART • 8

An ongoing collaboration with Escalator Records in Tokyo produced a graphic identity, music packaging, promo videos and clothing designs. Syrup mixed paper and textiles in 'new wave'-inspired collages, adopted and adapted across various media.

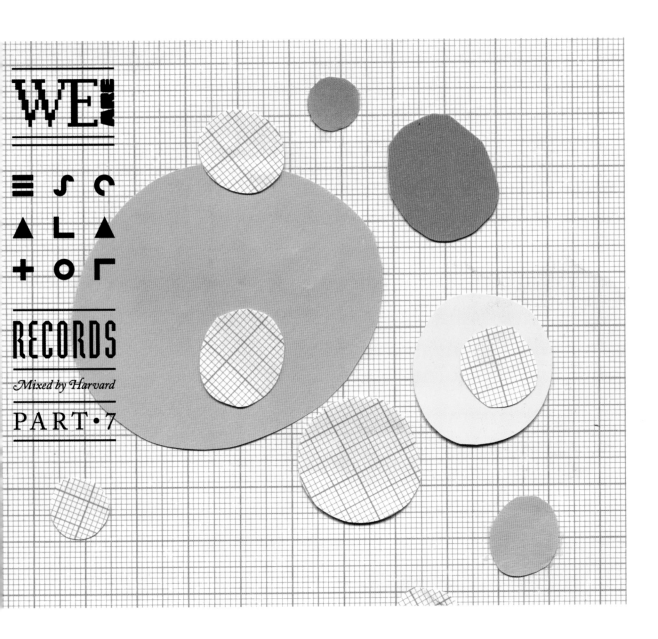

Japanese artist ten_do_ten works exclusively with pixels! However, his expe
at manipulating the most minimal element of digital design allows him to
commissions as diverse as: a striped pattern for Le Cube, a reinterpretation of the Ro
Stones' iconic big mouth logo, a styled, photo-self-portrait for *Brutus* magazine a
textile design for Japanese clothing store Uniqlo, featuring the 'world's minimum

Asked to art direct a special issue of the graphic design magazine *Étapes* on the theme of books, Frédéric Teschner creates a typeface referencing folded paper, and displays 'books within books' as facsimile spreads laid out on various surfaces.

Frédéric's treatment for the catalogue of the Musée d'art contemporain du Val-de-Marne
overlays type and icons onto photographic spreads, highlighting the physicality of the
institution through its architecture and spaces.

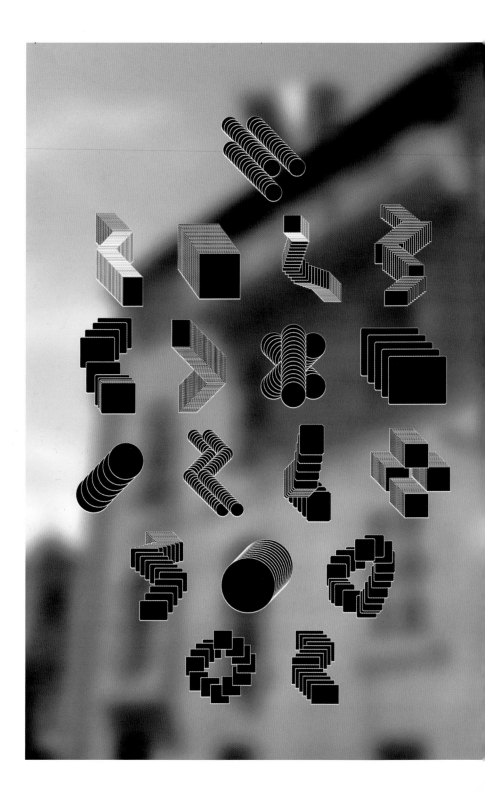

For the town of La Valette-du-Var, Frédéric created a new language of icons to act as signage and wayfinding markers for a 'graphic' walk. These were applied to a variety of surfaces, not always the most obvious.

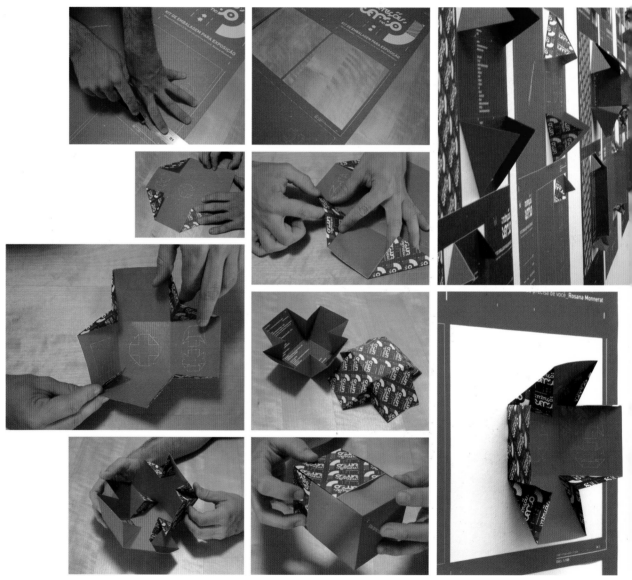

A long-term relationship is developing between Clarissa Tossin and the Vermelho Gallery, their mutual aim being to introduce design both as a communications device and an exhibit in each show. Instructions On The Back is a way of packaging the gallery – a double-sided poster relates information about adjacent exhibitions, folding into an *origami* form that literally 'boxes' the artists.

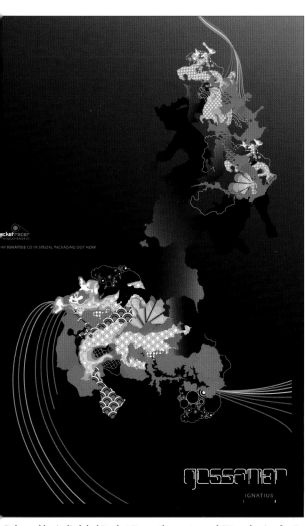

Released by indie label Rocket Racer, the poster and CD packaging for Gossamer uses illustrations inspired by thermographic charts to interpret this minimal, electronic music.

Sky_Boxes is a series of digital-collage illustrations investigating the way mirrored glass buildings are affected by the sky – disappearing, transforming and reflecting.

⟩ VICEVERSA — bijoux contemporains
Sophie Bouduban
vernissage : jeudi 26 octobre, 18h⁰⁰ à 20h⁰⁰
exposition : 27 octobre au 25 novembre 2006

⟩ Galerie viceversa, Place Sᵗ-François 2
2ᵉ étage, au-dessus du Café Romand
CH – 1002 Lausanne

mardi au vendredi : 12h³⁰ à 18h³⁰, samedi : 10h³⁰ à 16h³⁰
www.viceversa.ch, ⁺41 21 323 96 34

Ⓢ viceⱱƨɿɘⱱ

viceversa — bijoux contemporains
Swedish Jewellery

Sonja Ekman, Karin Johansson, Tore Svensson, Tobias
Andersson, Ida Forss, Agnieszka Knap, Aud Charlotte Ho
Sook Sinding, Castello Hansen, Mona Wallström, Mirjam
Norinder, Ulrika Swärd, Miro Sazdic Löwstedt, Anna
Unsgaard, Charlotte Skalegard, *Sissi Cecilia Westerberg*

vernissage le 13 septembre 2006 de 18h00 à 20h00
exposition du 14 septembre au 14 octobre 2006

Ⓢ viceⱱƨɿɘⱱ

galerie viceversa www.viceversa.ch
place Sᵗ-François 2, 2ᵉ étage t. ⁺41 21 323 96 34
au-dessus du Café Romand ma – ve : 12h30 – 18h30
CH – 1002 Lausanne sa : 10h30 – 16h30

Anne Baezner
Christian Balmer
Carola Bauer
Philippe Bergeon
Sophie Bouduban
Brune Boyer
Petra Dömling
Valentine Dubois
Diane Dudek
Beate Eismann
Félix Flury
Peter Frank
Karl Fritsch
Simone Gugger
Andi Gut
Masako Hamaguchi

Sophie Hanagarth
Mari Ishikawa
Rian de Jong
Susanna Kuschek
Christina Langes
Florence Lehmann
Katrin Lucas
Natalie Luder
Edgar Maag
Nadia Morgenthaler
Mah Rana
Fabrice Schaefer
ilona Schwippel

viceversa
bijoux contemporains

galerie éponyme
place St-François 2
2ème étage
au-dessus Café Romand
CH – 1002 Lausanne

viceversa@bluewin.ch
t. 021/323.96.34 /f. 32
ma – ve 12h30 – 18h30
sa 10h30 – 16h30

porte-bonheur

exposition collective
de la Saint-Valentin
à la Saint-Rodrigue
soit du 14 février 2004
au 13 mars 2004

vernissage
vendredi 13 février 2004
18h00 – 20h00

viceversa
bijoux contemporains

vernissage
6 novembre 2003
18h00 – 20h00
finissage musical
6 décembre 2003
17h00 – 19h00

galerie éponyme
place St-François 2
CH – 1002 Lausanne
tél 021 / 323.96.34
ma – ve 12h30 – 18h30
sa 10h30 – 16h30

Andi Gut

exposition personnelle
du 7 novembre 2003
au 6 décembre 2003

place St-François 2
1002 Lausanne

vitrine d'exposition
rue Mercerie 9
CH – 1002 Lausanne
viceversa@bluewin.ch
tél 021/312.91.19

Contemporary jewellery gallery Viceversa produces and sells cutting-edge designs.
Working as exhibition curator and art director, Nicole Udry has developed a visual
identity based on photographic content complemented by a combination of colour
elements and typographic devices that is both flexible and versatile.

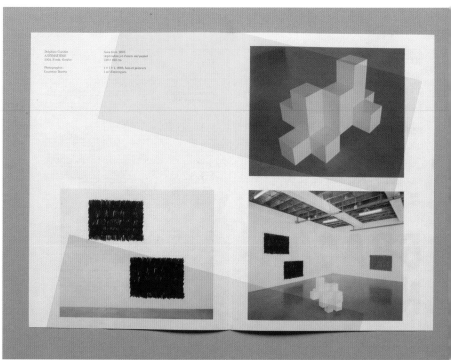

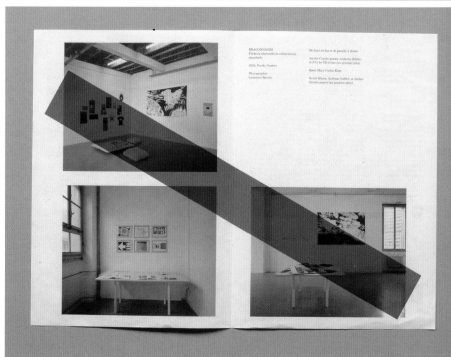

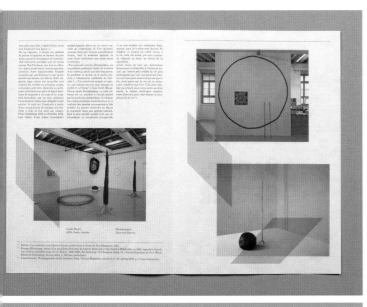

Forde is a contemporary art space in Geneva staging regular exhibitions, accompanied by a series of newsletters featuring texts from and interviews with artists, curators and critics. Working with a co-designer, Angelo Benedetto, Nicole developed a communication system based on a 'news bulletin'. These newsletters were then compiled into a book.

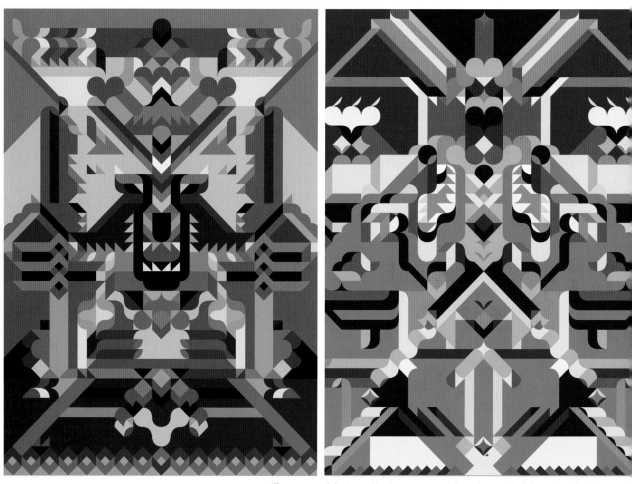

Illustrator and designer Siggi Eggertsson explores the possibilities of creating imagery using colour and geometry. He began at an early age with the help of graph-paper guidelines. Here he explores a selection of subject matter: traditional Nordic folklore icon – the wolf, a basketball hero rendered as a unique hand-made quilt, abstract patterns and an urban-scape of Berlin.

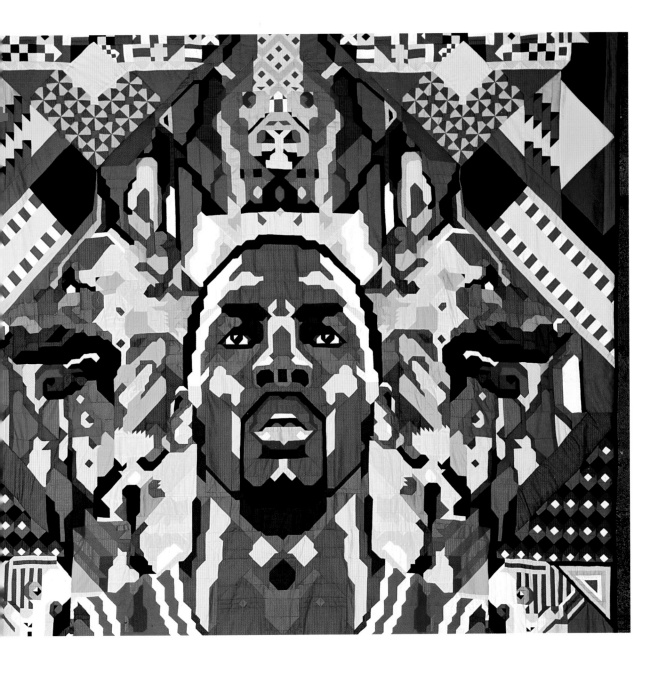

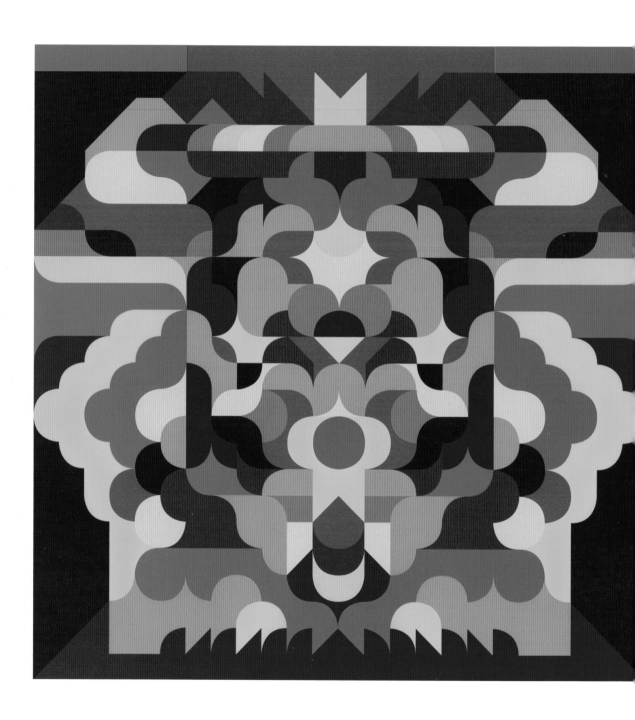

Vault49 combine autumnal colours and dramatic silhouettes – spotlighting the magic of cinema – in a series of editorial illustrations for the *New York Times*.

This ground-breaking cover design for esoteric style magazine *Flaunt* combines visual
elements from fashion and nature, and hints at the sophistication of the editorial content.

For their fans back in London, Vault49 staged an exhibition at the renowned illustration hotspot, the Coningsby Gallery. Held in collaboration with Daryl Waller and Si Scott, and using photography by Michael Creagh and Rinze van Brug (from New York) and Stephan Langmanis (from London), they combined glamorous shots with Victoriana type and sinuous black-and-white line drawing with splashes of colour. Vault49 create a sumptuous fantasy world — the very best type of eye-candy.

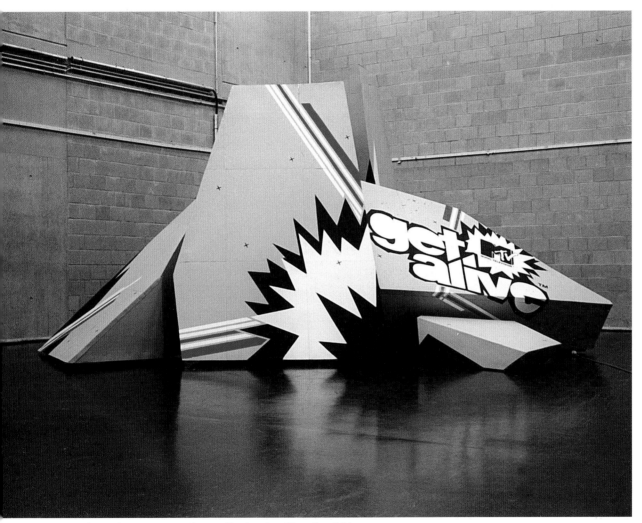

For MTV Germany's *Get Alive* programme, vibrant collective Viagrafik produced this large-scale logo that doubles as a stage set and prop. After planning the project on computer, André Nossek, Robert Schwartz and Leo Volland built the maxi-logo from wood and cardboard, and painted it with acrylics.

VIA GRAFIK latest logodestillate® VIA GRAFIK LOGOS
CONSTRUCTING DEPARTMENT

2291
U.S.A. ORDER NO. 10 -29-CN

LIVE & DE STROY™

C/O POP™

DESTRUCT®

KINKY™

SABBAGE™
will set us free...

graphic™ punks

obnoxious™

LICK MY FUCKIN' BRUSH™

SUNPON

POPPY™

KAUZ®

SURREAL™

DUROGAT®

neodada®

KOOL KILLERS™
KOOLKILLERS ★ VGRFK VS. 55DSL

backspin™
HIP HOP MAGAZINE

slow™

slick™

anti-

2291
PRINTED IN GERMANY U.S.A. ORDER NO. 10 -29-CN

André Nossek and Leo Volland created this page of logos using pencils and computers, combining pop and punk aesthetics with clip-art elements and futuristic typefaces – all drawn from scratch.

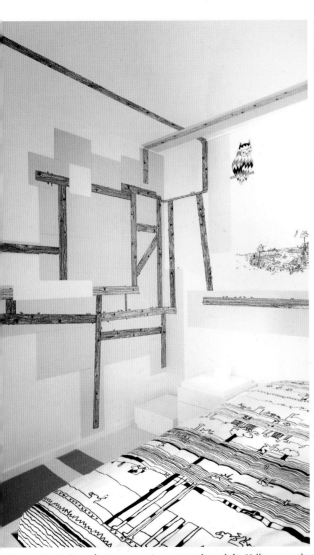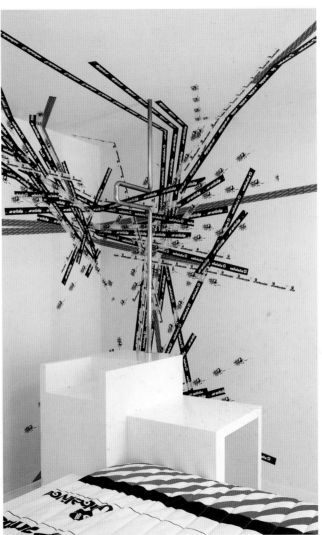

Project Fox in Copenhagen was unique – a car launch for Volkswagen that produced
a new hotel aimed at savvy, young travellers. The curators DGV put a collection of
innovative, contemporary designers together, with each group transforming a number
of rooms and public spaces. This one by André Nossek and Leo Volland of Viagrafik was
planned on computer, constructed using bespoke sticky tape and Edding markers, and
applied direct to the white walls.

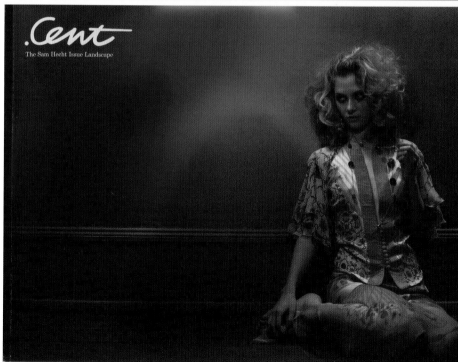

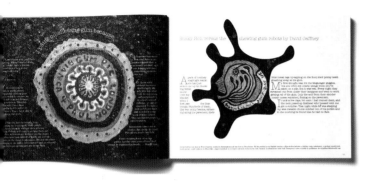

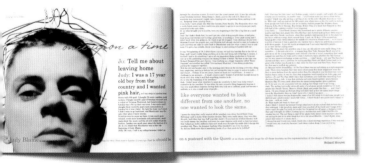

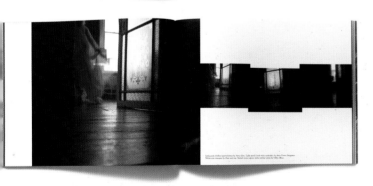

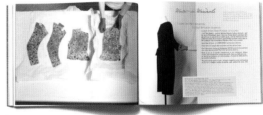

.Cent is a magazine 'for creatives, by creatives', as each issue has a different theme and guest editor, and covers topics as diverse as architecture, theatre, poetry and industrial design. Vivian Cipolla art directed three issues. Wanting to make the magazine more approachable, they changed the format to landscape, allowing each spread to open out and feel less formal. They created a hand-drawn masthead and adopted the font Century Schoolbook for its decorative flourishes.

4 years anni

Four years go by quickly, and at the end of May 2004 I shall be leaving the Italian Cultural Institute in London. Looking back is not always pleasant. Sometimes you get the impression that you did not do enough, or that you did not do well enough. You can feel regret or disappointment: there are always plenty of good reasons for not being satisfied. However, I must say that looking back on these four years in London I see a long and colourful stream of friendship, passion, hard work and fun. Let me say it once more: a lot of hard work but also a lot of fun!

When I got here on 5a June 2002, the Institute was building what in my view was a rather unexplored even lethargic existence. No money. Fairly academic programmes of events. A beautiful venue with a huge amount of innovation to be done. And finally, an audience of devotees who seemed resigned, almost aloof. I must confess that my first instinct was to pack my bags and go back to Italy. But I did n't, and I am happy I didn't.

Quattro anni passano in fretta, e ecco alla fine di maggio 2004 lascerò l'Istituto Italiano di Cultura di Londra. Non sempre guardare alle proprie spalle è un esercizio piacevole. Qualche volta si è colti dall'impressione di non aver fatto abbastanza, o di non aver fatto bene. Si può provare rimpianto o delusione: ci sono sempre mille buone ragioni per non essere soddisfatti di sé. Io devo dire che, se guardo indietro a questi quattro anni passati qui a Londra, vedo una lunga e colorata di amicizie, passione, fatica e divertimento. Lasciatemele ripetere: davvero molta fatica ma anche parecchio divertimento.

events calendar

march

THU 4, 7PM
CLETI RICCIARDI
For the first time in London the artist's glassworks on display
Cleti Ricciardi has played an active role in the most dynamic and significant area of Italian artistic research. Initially interested in surface and painting, she quickly began experimenting with construction and articulation of structures in space, using various materials, including water, wood, glass and air
Open to the public: Monday to Friday
10am – 5pm. Until 26 March
VENUE: ICI

TUE 9, 6.30PM
ARCHITECTURE AND GENDER
Monica Bonvicini, known for her exploration of living environs and defining qualities of space - in London with her installation 'Don't Miss a Sec' at the entrance of Tate Britain - and Katharine Clarke, artist and founding partner of the architectural firm muf, are joined by Stefano Boeri, editor of design and architecture magazine 'Domus', to talk about various ways in which artists can explore art history, gender and architecture
In collaboration with Tate Gallery and Broadway Projects
Box Office: 020 7887 8888 or online at www.tate.org.uk/tickets
Concessions for our members
VENUE: ICI

FRI 12 – THU 25
PIER PAOLO PASOLINI RETROSPECTIVE
Pier Paolo Pasolini was a poet, a painter and a novelist, but he will be always remembered for his films. Cinema, in his words, is a 'non-conventional and non-symbolic language' that expresses reality through reality itself. A retrospective to celebrate a great Italian master of cinematography, in London and on tour throughout the country
In collaboration with Institut Français, Associazione

'Fondo Pier Paolo Pasolini', Cinecittà Holding, the Italian Ministry of Foreign Affairs, the Italian Ministry of Cultural Heritage, the Italian Cultural Institute in Edinburgh, the Italian Consulate in Manchester and S.E.C.I. Italian Section at the University of Kent
For further information www.italcultur.org.uk
Box office: 020 7636 2144
Concessions for our members
VENUE: Cine Lumière, 17 Queensberry Place, London SW7

MON 22, 7PM
ITALIA FANTASTICA
VINCENZO RUGGIERO MEETS MINETTE WALTERS
Vincenzo Ruggiero, professor of Sociology at the University of Middlesex in London, whose 'Crime in Literature, Sociology Of Deviance And Fiction' was recently published by Verso, meets award-winning, bestselling, chart topping crime fiction author Minette Walters whose latest book is 'Disordered Minds' (Macmillan)
VENUE: ICI

SAT 27 MARCH – SUN 9 MAY
THE IMPRINT OF DRAWING
Giuseppe Penone, one of the most significant representatives of Arte Povera, presents a selection of drawings and sketches made between 1988 and 2002. Penone's drawings magnify delicate sensory surfaces of the skin to landscape-like proportions, reflecting upon the bodies' relationship to physical space
Open to the public: Tuesday to Saturday 10am – 5pm, Sunday 11am – 5pm
Event supported by the Italian Cultural Institute
VENUE: Milton Keynes Gallery, 900 Midsummer Bodevard, Central Milton Keynes MK9

WHAT'S NEXT?

Paint and pigments, found graphics, vibrant colours and dynamic brushstrokes were combined together to produce brochures, invitations and posters for a season of events staged by The Italian Cultural Institute. A large 'arrivederci' waves good-bye to the outgoing director, who had been Vivian Cipolla's loyal client.

VideoEx is an experimental film and video festival in Zürich for which Jonas Voegeli
created a series of 'one-off' posters. He arranged film stills into large letter-forms, and
combined them with silkscreen printed information assembled by hand and encased
in clear plastic.

DONNERSTAG.TM & FUSION LOUNGE PRÄSENTIEREN:

DONNER-
BLITZ UND
PULVER-
DAMPF

DO: 29.12.05 / 23:00H
DACHKANTINE FÖRRLIBUCKSTRASSE 109, 8005 ZÜRICH
PARTY AUF DREI FLOORS!

★ **DANI SICILIANO** DJ-SET (K7!, ACCIDENTAL/UK)
– **STYRO 5000** DJ (BRUCHSTÜCKE/ZH)
– **BANG GOES** DJ (BRUCHSTÜCKE/ZH)
– **SERAFIN** DJ (CADENZA, P45/ZH)
– **COSILI** LIVE (STATTMUSIK, P45/ZH)
– **SAMIM** LIVE (TUNING SPORK, STATTMUSIK/ZH)
– **GREGORYTHME** LIVE (BRUCHSTÜCKE/LS)

ELI VERVEINE DJ (SCANDAL!/ZH) **S AIR GROUP DADA** LIVE (ZH) **BOO!** DJ (FUSION LOUNGE/ZH)
INFLIGHT LIVE (BITBOUTIQUE/ZH) **JOY FREMPONG** VOC (FUSION LOUNGE/ZH)
REPOS KEYS (FLAVA SAUCE/ZH) **ROMAN BRUDERER** PERC (P-TRAIN/ZH)
MANU RINDLISBACHER BASS (FUSION LOUNGE/ZH) **FLO GOETTE** BASS (FUSION LOUNGE/ZH)

SUPPORTED BY POPKREDIT / PRÄSIDIALDEPARTEMENT DER STADT ZÜRICH
∗PROPORTION & FEELING: HERMANN & TIMM, ZH

Using thermo-relief printing ink, the raised surface on this flyer for a New Year's Eve
party appeals to the sense of touch and creates an experiential effect.

Darren Wall of Wallzo is a self-confessed obsessive. His love of music and fashion has led him to design projects for young bands and small, indie record labels. He has worked with Spy 51 and Corporate Risk Recordings, and created a truly versatile identity for Hot Chip that has been adapted for album and single releases. He designed this large-scale poster for Unite Against Fascism, using his combination of digital illustration and hyper-real photography.

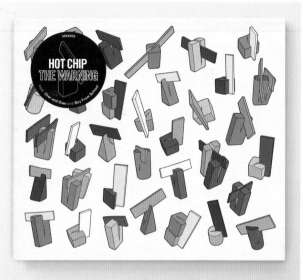

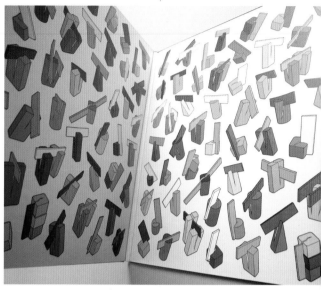

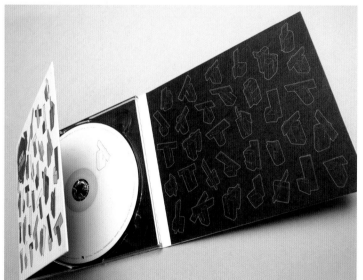

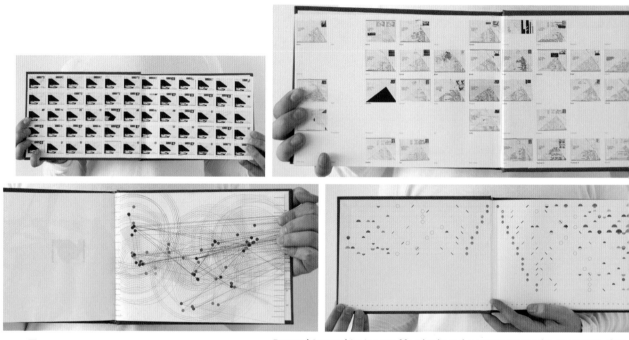

Personal Geographies is a set of four books and posters mapping the experiences of 27 'twentysomethings' from around the world. A survey questionnaire was sent out as a folded A3 sheet, which refolded into a return envelope. The collated maps/answers showed migrations, milestones and reinventions, and how background and experiences framed individuals' perception of the world.

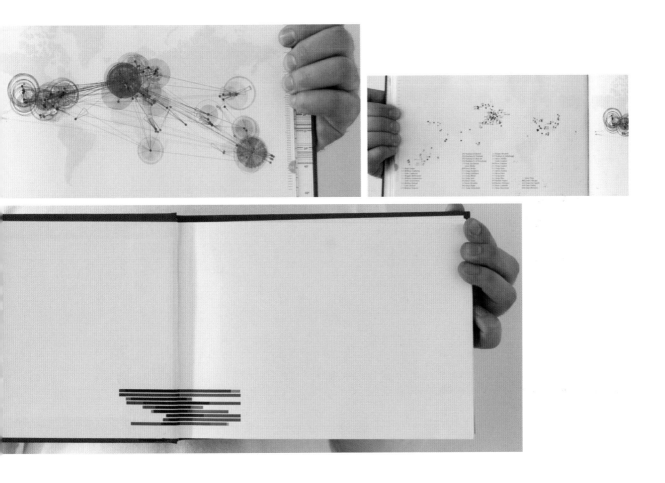

1000 Volt is a film and post-production company based in Istanbul. Bianca designed for them an identity, stationery, packaging and labelling system.

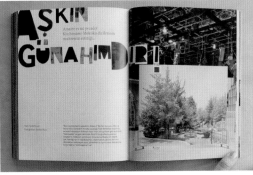

Biz's tenth issue was Bianca's first designing the magazine, so she celebrated the previous nine by cutting letters out of their pages, laying them on a light-box and rephotographing them. She also used the F10 function button on her Mac to take screen shots of overlapping layouts to create the contents page.

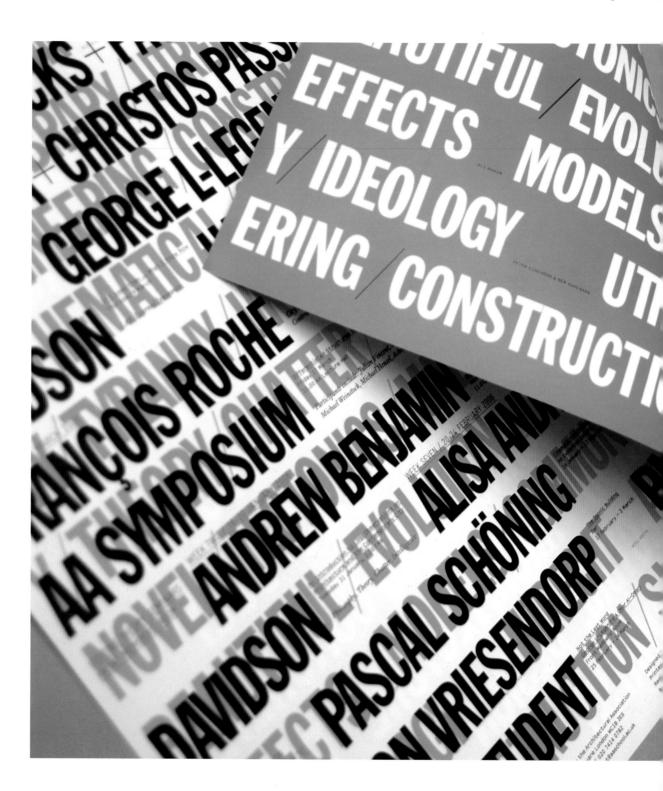

THE ARCHITECTURAL ASSOCIATION SCHOOL OF ARCHITECTURE
STELARC STAN ALLEN CRISTIANO CECCATO PARAME
GEHRY TECHNOLOGIES ANDREW BENJAMIN RMFINDING
SÉBASTIEN MAROT SARAH WHITING GRAMS SUB-URB
JESSE REISER MARK COUSINS DIDI-HUBERMAN LIC
HERNAN DIAZ-ALONSO AA DRL PHASE 2 THESIS JURY MALLEABLE FORM
ALI RAHIM MARK BURRY PETER EISENMAN TECNOL
REM KOOLHAAS JEFFREY KIPNIS + ROBERT SOMOL MUNICA
JAMES CORNER THOMAS DEMAND PETER SWINNEN EIS
AA SCHOOL OPEN JURIES PARVEEN ADAMS MARI MAHR SECTIONAL
DAVID ADJAYE TOYO ITO TAIRA NISHIZAWA PUBLIC
CHRISTIAN MARCLAY ALISA ANDRASEK VICENTE GENE
GUALLART ANDREW FREEAR WIEL ARETS STUDIO UN
CHARLES JENCKS + PAUL FINCH ZAHA HADID
HANIF KARA CHRISTOS PASSAS PAUL SCOTT ERIC OWEN
MOSS GEORGE L-LEGENDRE DONALD BATES PETER
DAVIDSON HANS ULRICH OBRIST STEFANO BOERI MEDIA
FRANÇOIS ROCHE AA/AD SYMPOSIUM PHILOSOPH
AA SYMPOSIUM MICHAEL SPEAKS LOOKING
ANDREW BENJAMIN SARAH WHITING CYNTHIA
DAVIDSON ALISA ANDRASEK MICHAEL SPEAKS CRETE
EFFEC PASCAL SCHÖNING MARI MAHR ARCHITECTURE/THEOR
MADELON VRIESENDORP PHAENO SCIENCE CENTRE ENGINE
TEACHER/STUDENT SURFACE/GOODNESS

KPF

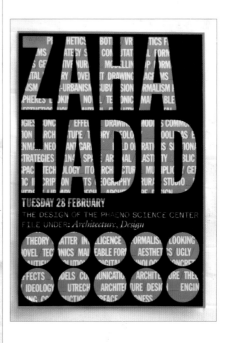

Zak Kyes designs the Architectural Association term posters. This one is AA_T3, and is a typographic 'waterfall' with a 'poetic cloud' of data announcing events and lectures. The 'a-side' presents names, dates and times, while the 'b-side' is an abstraction of keywords, which is also overprinted onto the front.

Specialten is a multi-discipline magazine. The cover reveals its contents, realized as 3D type, in collaboration with photographer Tim Brotherton.

About the authors

Michael Dorrian and Liz Farrelly are the authors of the highly successful *Business Cards: The Art of Saying Hello* and *Business Cards 2: More Ways of Saying Hello*. Michael Dorrian is currently Senior Designer at Start Creative in London. He has co-edited and designed numerous books, including *Highflyers*, *Album Covers from the Vinyl Junkyard*, *Scrawl*, *Scrawl Too*, *Zines* and *Stick 'Em Up*. Liz Farrelly is a well-known design journalist, editor and broadcaster. Her previous books include *Fax You, Wear Me, Scrawl, Scrawl Too, Stick 'Em Up, Brooklyn New Style* and *Zines*.

This poster for the annual experimental writing conference nOulipo, relates to the best-known artwork to come out of the Oulipo (Ouvrier de Litterature Potentielle) movement – Georges Perec's novel A Void. This detective story was written without the use of the letter 'e'.